Wolverhampton

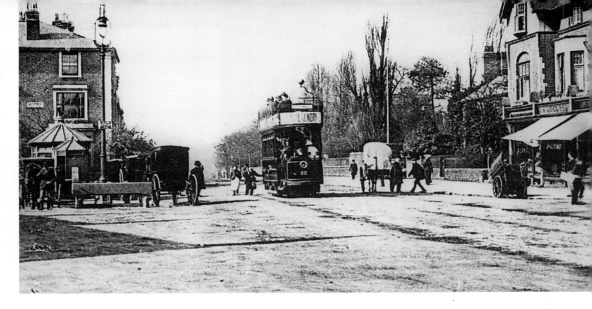

Pure nostalgia...

Above A 1903 open-topped tram, No 22, works through Chapel Ash not long after the opening of the route to Tettenhall. It is one of those glorious sunny Edwardian summer days that were so often captured by photographers, giving us an impression of a kind of innocence in that last decade or so before the guns in Flanders began not only to kill millions of men, but also to destroy for ever the way of life from which they had marched so proudly on their way to the Front. *D. R. Harvey collection*

Below Two World Wars later, on a rainy day in Wolverhampton town centre, with the edifice of the High Level Railway Station on the skyline above the 'country' bus station, a 1948 Daimler CVG6 with a Brush H29/25R body, 513 (FJW 513), emerges from Railway Drive. It is working on the 37 service to Blakeley, which went out of the town by way of Penn Road and through Wombourne. On this miserable day at the end of the 1950s the upper saloon windows of the bus have just begun to steam up, while no doubt, despite the windows all being firmly shut against the elements, someone will be lighting up a cigarette! *A. B. Cross*

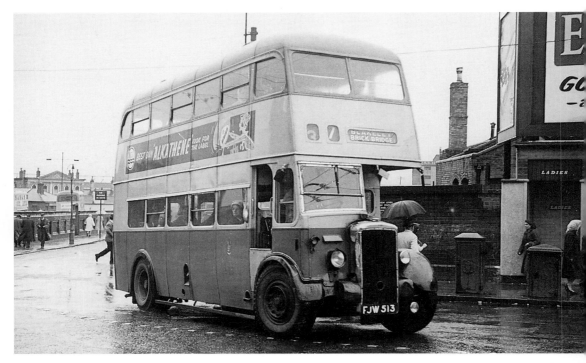

Wolverhampton

A nostalgic tour by tram, trolleybus and bus

Part 1
The western routes

David Harvey
and
John Hughes

· R O A D T R A N S P O R T H E R I T A G E ·
from
The NOSTALGIA Collection

First published in 2001

British Library Cataloguing in Publication Data

A catalogue record for this book is available from the British Library.

ISBN 1 85794 133 0

Silver Link Publishing Ltd
The Trundle
Ringstead Road
Great Addington
Kettering
Northants NN14 4BW

Tel/Fax: 01536 330588
email: sales@nostalgiacollection.com
Website: www.nostalgiacollection.com

Printed and bound in Great Britain

A Silver Link book
from
The NOSTALGIA *Collection*

Abbreviations

AEC	Associated Equipment Company
BCN	Birmingham Canal Navigations
BET	British Electric Traction
BMMO	Birmingham & Midland Motor Omnibus Company
DS&WT	Dudley, Sedgley & Wolverhampton Tramways
ER&TCW	Electric Railway & Tramway Carriage Works
FEDD	Front Entrance Double Decker
GWR	Great Western Railway
LMS	London Midland & Scottish Railway
LNWR	London & North Western Railway
MCCW	Metropolitan-Cammell Carriage & Wagon Company
MoWT	Ministry of War Transport
PSV	Public Service Vehicle
SOS	Shire's Own Specification
UEC	United Electric Car Company
WDET	Wolverhampton District Electric Tramways
WMPTE	West Midlands Passenger Transport Executive

Seating capacity codes

H30/26R	Highbridge, upper saloon capacity 30, lower saloon capacity 26, rear entrance
H-/-RO	As above, but open staircase
H-/-F	As above, but front entrance
B38R	Single-decker bus, capacity 38, rear entrance
B-F	As above, but front entrance
B-C	As above but centre entrance

Contents

Preface

This is the first of a planned trilogy dealing with the road public transport scene in Wolverhampton operated by Wolverhampton Corporation, and the area covered by this volume is roughly that third of the town lying west of a west-to-south-east axis. This takes in horse-trams, horse-buses, electric trams and trolleybuses, and motorbuses on a diverse selection of routes that are extremely varied in their characteristics, including services running through industrial areas, districts of housing of different historical periods, decidedly urban areas and areas that are still profoundly rural.

Each chapter deals with one specific sector of Wolverhampton and shows the different modes of transport through time, running from the various terminal points in the town centre along the routes to their outer destinations. However, this book is not just a look at the trams, trolleybuses or buses running through the town; the photographs have been very carefully selected to show the vehicles within their nostalgic street scenes and in their historical niches. By doing this, the social scene of each era has been captured, and in certain cases can be compared with the view today. This reveals that certain parts of Wolverhampton have hardly changed at all since the 1880s, while other districts have altered beyond recognition.

The main difficulty has not so much been what to put in as what to leave out. Many evocative photographs have been edited out of the completed volume because they did not meet the rigid criteria of adding to the story of that particular route. Wherever possible the photographs have been chosen because they have not been used before, although there are a number that, because of their importance, have been previously published. One of the main problems has been the dearth of suitable photographs taken outside the town centre, specifically on bus routes; this was because the main arterial routes in Wolverhampton were generally operated by trolleybuses and these services were wonderfully photographed by the late Cliff Brown. Hopefully, most of the gaps in the motorbus services covered in this first book have been filled in, though even after much searching no pictures have come to light of Wolverhampton buses in important locations such as Penn Common and Gornal Wood.

The photographs also show the way that transport has materially affected the areas through which it has passed, as well as telling the story of the development and changes in transport in Wolverhampton from the days of the privateer horse-bus operator, through municipal operation, to the early years of West Midlands Passenger Transport's bus operation.

One final point is that on Monday 18 December 2000 Wolverhampton was granted City status ... and not before time! However, throughout the text it is referred to as a 'town', and as all the pictures in the book were taken when it was a town, there seemed no reason to update it.

Acknowledgements

If it was not for the photographers who captured the vehicles on film at a particular moment in time, books that show how a transport system developed over time would never reach the publishing stage. Both authors have their own large collection of photographs, which have been extensively used in the production of this book, but they would additionally like to thank the following for their generous assistance in the assembling of the photographs found herein. Special thanks are due to Brian Baker for allowing us access to his splendid collection of photographs. The collections of Alan Broughall, Clarence Carter, Alan Cross, Simon Dewey, Jan Endean of Eardley & Lewis photographic studios, Robin Hannay, Stan Letts, Roy Marshall, Les Mason, Douglas Nicholson, Robin Oliver, Paul Roberts, Mike Rooum, Ray Simpson, Roger Taft and Deryk Vernon have all been a source of fascinating and most useful photographic material, as well as all those other unknown photographers who supplied the late Bob Mack with negatives. Older photographs include those taken by Bennett Clarke, who specialised in taking pictures of road transport vehicles and street scenes in Wolverhampton throughout the first half of the last century. If anyone has been missed from this impressive list, we offer our sincere apologies.

Many of the trolleybus photographs are credited to the late Cliff Brown, who undertook a photographic survey of the trolleybus system between 1958 and its closure in 1967. This wealth of riches was unfortunately counterbalanced by the lack of suitable motorbus pictures in locations outside the town centre. As a consequence, the photographic collections of the authors have also been trawled to fill in many of these gaps.

We would like to thank Richard Weaver for his sterling work in proof-reading the manuscript, and to Barry Ware, whose advice and helpful comments have always been most valuable. Sincere thanks are also due to Pam Hughes for putting up with both authors as they waded through boxes of photographs on her lounge table, and to Diana Harvey for a similar role as well as her excellent proof-reading, especially in areas of linguistic uncertainty. Terry Russell and Alan Condie provided the splendid scale drawings that further enhance this book, while the tickets came from Douglas Nicholson's collection.

A source of valuable information has been *A History of Wolverhampton Transport*, Volumes 1 and 2, by Paul Addenbrooke, published by the BTHG, which is well worth purchasing as it deals in considerable detail with the traffic developments of the undertaking, while the PSV Circle publication *PD6*, which includes Wolverhampton Corporation, and *2PD13*, on the West Midlands PTE, provided useful vehicle information that augmented our detailed notes on the trolleybus fleet.

Finally, a special word of thanks is due to Paul and Tina Archer of 'The Model' public house, Langley, near Oldbury, West Midlands, for their patience and excellent amber beverages!

David Harvey, Dudley
John Hughes, Wolverhampton

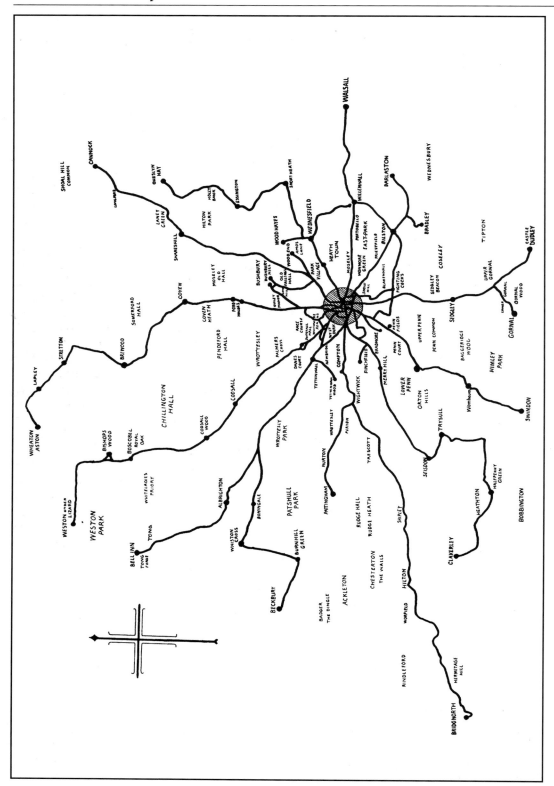

Routes operated by Wolverhampton Corporation Transport Department. The routes included in this book are those serving Dudley in the south to Bridgnorth in the south-west.

Introduction

Origins

The traditional legend is that an Anglo-Saxon king, Wulfhere, founded an abbey dedicated to St Mary on the present-day site of central Wolverhampton in AD659. The area was in the border 'bandit country' of northern Mercia, and from the mid-9th century it was regularly attacked by the Danes. Even the treaty between King Alfred the Great and King Guthrum only brought a temporary halt to the wars. Nearby Tamworth was a frontier town in Mercia, leaving the area to the west as one of fierce invasion and re-invasion as the armies of Anglo-Saxons and Danes alternately vied for local supremacy. In about 911, 'near Tettenhall', King Edward the Elder of Wessex defeated a Danish raiding party that was returning from a foray from the Severn Valley to the west. Just over 30 years later, in 943, Olaf Guthrithson raided Tamworth and effectively kidnapped Wulfrun, sister of the Anglo-Saxon King Edgar (958-975). By the time she reached old age, King Aethelred (Ethelred) had given her lands in the north of Mercia, and nine years later in AD994 she endowed a monastery dedicated to St Mary. This site is now occupied by the present-day Collegiate Church of St Peter. Aethelred's gift of land to Lady Wulfrun went as far as Penn, Smestow Brook and Sedgley.

By the time of the Domesday Book in 1086 'Wulfruna's High Town' had a population of about 250 and was considerably larger that 'Bermingeham' (Birmingham), which could only boast about 100 souls. The church, re-dedicated to St Peter in the 13th century, occupied a site at the highest point in the area, and it was around the church that the little market town grew. The first mention of a market dates from 1179, but it was not until 1258 that King Henry III granted the settlement its own Market Charter, allowing one to be held on every Wednesday, and also an annual fair, which would last eight days over the Feast of St Peter and St Paul. Market Charters were the gift of the monarch and, once assumed,

gave a settlement an enormous advantage, providing access to trade and also encouraging crafts and industry to develop locally.

Unlike many other settlements, Wolverhampton's geographical location on top of a hill meant that only the nearby Pudding Brook, a tributary of the Smestow Brook, supplied water to the settlement. It flowed across what is now the junction of Victoria Street and Worcester Street and was always known as an insanitary area until it was culverted in the 19th century. One advantage the settlement did have was its access to a swathe of upland stretching to the north from Tettenhall to Willenhall. This proved to be ideal in medieval times for rearing sheep, and as England's wealth at the time was based on its wool industry, it was an enormous benefit to the town's traders. Welsh drovers sold their sheep in the market town, and although its growth was fairly unspectacular during the 14th and 15th centuries, it encouraged the establishment of shoe-makers, leather-workers, blacksmiths, fullers, weavers and tailors. The enlargement of St Peter's Church reflected the growing wealth of the town and its families, such as the Levesons, Swynnertons and Rydleys. Despite being devastated by the Black Death at the end of the 14th century, the area around Wolverhampton was supplying about 90 per cent of English wool exports. The prosperity and growth of the town was reflected in the establishment of a grammar school in 1512, as well as the setting up of a gaol and hospital.

The first industry

By the start of the Elizabethan period the first real change in the basis of the town's wealth was beginning to surface. The town lay to the north-west of an area that was later to become known as the Black Country, with coal seams being found as close by as Bilston. The area of the South Staffordshire Coalfield also contained limestone and iron-ore, which were all extracted and led to the development and prominence of

iron-based industries such as cutlers, nail-makers and buckle-makers in the town. Throughout the Civil War period these industries continued to develop in the area, with its Royalist sympathies, at the expense of the by now dying wool trades. The 'Great Fire of Wolverhampton' in 1696, as with the contemporary fire in Warwick, swept away many of the poor-quality and unhealthy medieval buildings and resulted in the redevelopment of the town in the reigns of Queen Anne and the first two Hanoverian King Georges.

The town had turned its back on the medieval wool trade and industrially Wolverhampton's burgeoning ironmasters began to specialise in locks and buckle-manufacturing. The fortunes of the Molineux family as iron-masters dealing in locks, hinges, tools and brassware, exploiting the trade in the 'Slave Triangle', meant that genuine Jamaica rum, for example, became available in the town in the mid-1770s. With the Georgian town developing specialist industries based on metal trades, it began to look towards the Bilston and Dudley areas of the Black Country for its supplies of raw materials, as well as needing links with the rapidly growing entrepreneurial skills being developed in nearby Birmingham. By 1750 Wolverhampton could boast just over 7,600 inhabitants in a tightly knit community stretching barely half a mile in any direction from the Parish Church.

It was the events of the late 18th century and the rapidly encroaching Industrial Revolution that began to determine the future of Wolverhampton. Japanning, enamelling and button-making also quickly developed, with the firms of Chubb and Gibbons both becoming nationally important lockmakers based in the town. The town's industry eventually led to a need to trade and export its products.

Wagons, canals and railways

The turnpiking of roads, by which private trusts were established along a route to maintain a section of road and thereby charge a toll for its use, was proving to be both excessively expensive and difficult to justify. As the condition of the roads rapidly deteriorated with the passage of so many waggons, it became obvious that they were unsuitable for the increasing loads that they were being required to carry. For example, the introduction of stagecoaches through Wolverhampton began in the 1780s, but it took 19 hours to reach London on a journey that was both uncomfortable and frequently dangerous. It was also expensive, costing the princely sum of £1 4s 0d for a single journey.

The problem of transporting heavy goods in the 18th century had been first addressed on a commercial basis by James Brindley with his Bridgewater Canal in Cheshire, completed in 1761. Very soon canals were being dug everywhere to the designs of the early canal builders such as Brindley and James Green, with the Staffordshire & Worcestershire Canal opening on 28 May 1772, linking Wolverhampton to Stourport on the River Severn. The really important canal link was that of the Birmingham Canal Navigations, which on 25 March 1772 opened its main line between Aldersley Junction with the Staffordshire & Worcestershire Canal at a height of 340 feet above sea level. Passing through the centre of Wolverhampton at Broad Street, climbing the infamous flight of 21 locks in the space of 1½ miles, it went through the Black Country, with its vital coalfield, and on to the centre of Birmingham. This 'crooked ditch' was constructed to the designs of James Brindley and followed the meandering contours of the land with a summit height of 473 feet at Smethwick; it was the catalyst for the dramatic increase in the trade between Birmingham and Wolverhampton of, particularly, locally mined coal, as well as the iron-ore and limestone deposits found in the Black Country. Thus, by the time of the Napoleonic Wars Wolverhampton could boast that it was linked to the Rivers Severn, Mersey, Trent and Thames by an extensive narrow-boat system. The problem was that this system suffered from a lack of water due to having to negotiate the high ground between the two important towns. This was solved in 1828 when Thomas Telford's straightened Birmingham Canal Navigations main line, with its 453-feet-high summit, was opened, briefly becoming the equivalent of today's motorway through the Black Country.

The supremacy of this new system only lasted for nine years, for on 4 July 1837 the Grand Junction Railway opened, later to become the London & North Western Railway (LNWR); this linked Wolverhampton to Bescot, Perry Barr and Birmingham to the south and Stafford, Crewe, Liverpool and Manchester to the north-west, although Wolverhampton's first railway station was at Wednesfield Heath, more than 1½ miles from the town centre. This situation was quickly remedied when on 1 July 1852 the Stour Valley line opened between Birmingham and Wolverhampton by a direct route, following the line of the BCN canal; the directors of the latter realised that to co-operate with the fledgling railways would be financially to their advantage, thus ensuring that the canals of the Black Country survived as commercial inland waterways much longer than elsewhere in England. The new LNWR town-centre station was named 'Queen Street' and enabled passengers to travel between Wolverhampton and Birmingham for the princely sum of 2s 6d on a journey that took 40 minutes. On 1 June 1885 this immensely unattractive station was renamed 'Wolverhampton High Level'.

The Oxford, Worcester & Wolverhampton Railway opened the second Wolverhampton station in July 1854 on a new line that went via Bilston, Wednesbury and West Bromwich to Birmingham's new station in Monmouth Drive, later better known as Snow Hill. It would not be until October 1855 that the OW&WR opened its new town-centre station, and this was renamed 'Low Level' in April 1856. This line was one of the last in the country to be built to the 7ft 0¼in 'Broad Gauge', surviving until 1 November 1868 when it was converted to the normal Standard Gauge.

The introduction of these railways not only encouraged the movement of freight around the Black Country and to Birmingham and beyond, but allowed people to move reasonably cheaply around the area by train. Throughout the country the result of all this increase in access was to encourage the development of urbanisation, and Wolverhampton was no exception; from a small Georgian town of 7,454 souls in 1731, it had doubled in size by the end of the 18th century, and had reached 60,860 people by 1861.

Wolverhampton's town centre layout was largely completed by the start of the 1870s, and many of the splendid buildings have survived from that time. From the top of Darlington Street, the town extended eastwards through Queen Square, overlooked by the statue of Prince Albert and the graceful Collegiate Church of St Peter. The Victorian town centre developed along Lichfield Street and through the complex of roads that made up the double road junction at Princes Square. Beyond this complexity of roads was the LNWR's High Level station, and the Low Level station, by now occupied by the Great Western Railway (GWR). Broad Street, the continuation of Lichfield Street and Queen Street, connected the stations with the tightly packed thoroughfares of the town centre such as Dudley Street, Victoria Street and Queen Street. It was not until the construction of that necessity of all towns in the 1960s, the ring road, that the layout of the town's central and inner areas was radically altered.

Street transport: horse-buses, horse and steam trams

The western half of Wolverhampton covered in this volume first saw public street transport in the form of horse-buses from Dudley Street to Birmingham in 1836, some three years after the first-ever service had been introduced. The early horse-bus services were effectively replaced by the opening of the two railway stations in the town centre and the lines into the surrounding areas. A second period of horse-bus operation began in the late 1860s when urban growth away from the existing suburban and other small-town railway stations began. In the western part of the town a route had been established to Tettenhall and Tettenhall Wood by 1871, and by 1882 one Sampson Tharme, who continued in operation until the very end of such transport in 1912, began operation to the Rose & Crown Inn at Penn. Further horse-bus services in the western area went to Compton and along Dudley Road as far as Fighting Cocks, a road junction named after an important Black Country landmark – a public house.

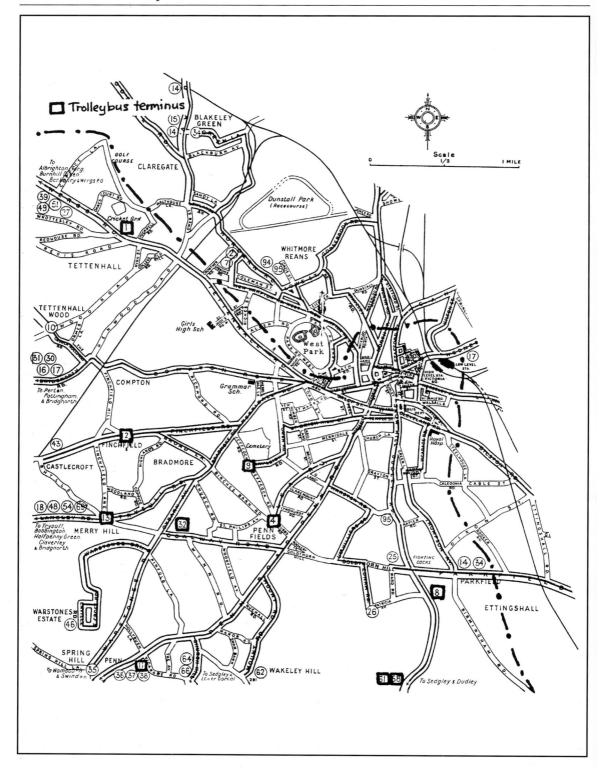

Bus routes and trolleybus termini in Wolverhampton town centre and western suburbs.

The Wolverhampton Tramways Company began operation of horse-trams on a standard gauge track on 1 May 1878, and within a few years was operating three services, one of which, along Tettenhall Road, is included in this volume. Another company, the Dudley, Sedgley & Wolverhampton Tramway, also began operating horse-tramcars on the same gauge of track on 7 May 1883, but very soon, because of the hilly topography, obtained the necessary Parliamentary Order to run steam-powered double-decker trams on the route, which re-opened in this mode on 16 January 1886. After several changes of ownership, the successors of this company passed into the ownership of the BET group. Renamed the Wolverhampton District Electric Tramways, the line between Fighting Cocks, Sedgley, Upper Gornal and Dudley was completed in three stages, and was opened for through running on the new 3ft 6in gauge track on 29 January 1902. This electrified line was operated on the 'normal' overhead system, and after protracted negotiations, on 15 October 1906 Wolverhampton District trams ran between the town and Dudley.

Electric trams

Meanwhile, in 1899, the Parliamentary Bill giving the Corporation powers to construct and operate its own electric tramcar system on the 3ft 6in gauge was given approval, and at this point all should have been plain sailing. Unfortunately, although the Council had twice recommended the use of overhead current collection, the Chairman of the Tramways Committee, Alderman Charles Mander, of the famous paint-manufacturing family, effectively vetoed the use of that method on the grounds that under no circumstances would unsightly traction poles and overhead wiring be used in the town. Having rejected the Dolter Surface Contact System, the Brown Surface Contact system, manufactured by the Lorain Steel Company of Ohio, USA, was found to meet his requirements. An experimental length of track was constructed in Ettingshall Road and was opened by Alderman Mander on 6 February 1902. The first 'proper' service was opened to New Hampton Road on 1 May 1902, the day of

the opening of the prestigious Industrial & Art Exhibition in West Park by the Duke and Duchess of Connaught. Lorain trams began running along Tettenhall Road to Newbridge on 12 June 1902, and are recorded in this volume. Painted green and gamboge, this first major Corporation tram route was quickly extended into Tettenhall UDC on 13 September 1902.

By 1909 the basic Wolverhampton Corporation tram system was complete, with some 13.85 miles of route being operated with an available tramcar fleet of seven single-deckers and 45 double-deckers. Of the eight municipal tram routes, included in this volume are those to Tettenhall, Penn Fields, Fighting Cocks and Dudley via Sedgley. The original New Hampton Road service will appear in the second volume, together with the Whitmore Reans trolleybus service. All was not well, however, with the Wolverhampton District 'Through Service' to Dudley. The company complained that its current consumption on the line was dramatically increased as the Lorain equipment, looking somewhat like the pick-up shoe of a giant electric train set, weighed about 1 ton and was only necessary on the WDET trams on the section of the route from the Fighting Cocks to Snow Hill. Through running finally ceased on 10 January 1909.

All eight electric tram routes operated by Wolverhampton Corporation were constructed on the Lorain Surface Contact system. The last, to Penn Fields, was opened on 10 September 1909 when the fleet strength had reached 49 trams. Only another 12 four-wheeled double-deckers were purchased, and the last of these vestibuled but open-balconied vehicles, tram 61, arrived in 1921. The last, perhaps surprising, delivery of eight modern-looking tramcars was their reversion to single-deckers. These were Brush-built 'Tividale'-style open-plan four-wheelers, similar to those operated by the Birmingham & Midland Tramways Joint Committee.

Wolverhampton's Lorain system, unique in Britain, had a surprisingly long life despite the logistical and operational problems of this method of current collection, which effectively isolated it from the other Company-operated tram routes in the Black Country. As soon as was

practical after the end of the First World War, in October 1919 Charles Owen Silvers, the General Manager, submitted a report that as well as focusing on the poor state of the tram track, also recommended the conversion to the overhead current collection method. Silvers had risen by internal promotion to become the General Manager on 1 December 1915, after the first General Manager, W. A. Lumley, had died as a result of an accident that fatally wounded him during field exercises with a Territorial Army unit. The conversion to overhead current collection began with the Dudley Road route, on 26 March 1921, while the services to Tettenhall and Penn Fields were the last two conversions during the same year, on 5 and 15 October respectively, the conversion costing £375,000.

The problem for Mr Silvers, after the tramway conversion to overhead current collection had taken place, was that while this part of the tramway infrastructure was new, the track was rapidly approaching the point of replacement, and about two-thirds of the fleet was nearing the end of its economic life. Despite the huge expenditure by the Corporation on the overhead wiring, the decision was made to close down the tram system. The only advantage was that much of the new cabling and overhead could be utilised for the preferred option of converting the tram routes to 'trackless trolleys' – trolleybuses – using 'home-produced' electricity, and extending the old tram services on the main arterial roads out towards the town's boundaries.

The tram abandonment occurred in stages, with the eight routes taking slightly over four years to close down, culminating on 26 August 1928 when the Bilston service was abandoned, car 56 performing the final rites. For just five days the Corporation was no longer a tram operator, then on 1 September 1928 it took over the operation of the local tram services worked by the Wolverhampton District Electric Tramways Ltd. Fifteen ex-WDET cars were taken over to maintain the Willenhall, Darlaston and Bilston circular service and the route to Fighting Cocks from Bilston. The 'fleet' consisted of seven 'Tividale'-style single-deckers, three four-wheel double-deckers, and five of the large 70-seater bogie cars, together with 61 staff

and the depot at Bilston, while two of the recently withdrawn Corporation double-deckers were pressed back into service. This strange interregnum lasted until 30 November 1928, when for the second and final time the tram system closed down.

Trolleybuses arrive

The success of the nearby conversion of the Nechells tram route in Birmingham to 'trackless trolley' operation on 27 November 1922 encouraged the Wolverhampton Tramways Committee to visit the city, just 11 weeks after the opening, to inspect this pioneering service. The result was the recommendation that the Wednesfield route be converted to trolley vehicles. The tram route closed on 23 July 1923, and on Tuesday 29 October, after a brief period of motorbus operation, six 40-seat Tilling-Stevens TS6 trolleybuses with centre-entrance, single-deck Dodson bodies began operating to Wednesfield's Pinfold Bridge. Single-deckers were required on this route because of low bridges such as that over Wednesfield Road; the road was finally lowered in November 1943. The next tram route to be converted to trolleybus operation was that to Bushbury. The new trolleybus route was extended to Fordhouses on 9 March 1925, with the fleet increasing to some 32 single-deckers.

The first tram-to-trolleybus conversion covered by this volume was the long service to Dudley, which was converted in four stages beginning at the Wolverhampton end. The trams ceased running to Fighting Cocks on 18 August 1925, and by 8 July 1927 the complete trolleybus service between Wolverhampton and Dudley was being operated by a fleet of trailblazing six-wheeled double-deck Guy BTX vehicles. The first of these new Dodson-bodied vehicles was numbered 33 (UK 633), and entered service on 2 December 1926; it was the first six-wheeled double-decker top-covered trolleybus to operate successfully in Britain, notwithstanding Bradford Corporation's strange experimental twin-steered 522 of 1922. Wolverhampton's 33 was destined to be the only outside-staircase trolleybus in the fleet, yet served as the prototype for the first generation of

some 28 similar Dodson-bodied Guy BTX vehicles delivered over the next three years.

The remaining tram-to-trolleybus conversions illustrated in this volume are the Penn Fields route, opened for trolleybus operation on 11 July 1927 but only running as far as Lea Road's junction with Birches Barn Road and Stubbs Road, about 300 yards short of the original tram terminus at the Penn Road junction, and the Tettenhall service, opened on 29 November 1927. By 1930 Wolverhampton had no fewer than ten trolleybus routes in operation, and with a fleet strength of 70 trolleybuses it was briefly the largest trolleybus operator *in the world*.

Motorbus operation

The Great Western Railway began operating Clarkson steam-buses by way of Compton and Bridgnorth on 7 November 1904; these lasted until 10 July 1915, when the privations of the First World War caused the abandonment of the service. The paraffin-powered steam-buses only lasted until April 1905, when they were replaced by three Milnes-Daimler petrol-engined single-deckers. Earlier, in 1903, Wolverhampton Corporation had inspected a Milnes-Daimler, but local authority motorbus operation began on the Penn Fields service on 1 September 1905 using three Wolseley 20hp over-type double-deckers, which lasted until the route was converted to tramcar operation.

A new Corporation motorbus service began to Compton on 10 February 1914, and was joined by a service to the Rose & Crown, Penn, on 20 May. These services employed four Albion A3 chassis, with strangely-windowed 24-seater bodies built by a local Wolverhampton coachbuilder called Forder. Although many bus services were curtailed at this time, the Corporation did manage to purchase four Roberts-bodied Albion 25hp single-deckers (Nos 3-6) in 1914, but these chassis were impressed by the War Department on 27 October 1914 and were presumably lost 'in some foreign field' or became one of the anonymous lorry chassis that were worked until they stopped. During 1915 three replacement Albions were purchased, and they received the original Roberts bodies from their WD-impressed forebears, while in April 1917, as a result of C. L. Wells selling his Wolverhampton to Stourbridge bus service to Midland Red, one of his pre-war Albions was acquired. For many operators the Tilling-Stevens TS3 chassis was a saviour, as with its petrol-electric transmission it was not considered suitable for the rigours of warfare. As a result a slow but steady trickle of these chassis came out of the Maidstone-based company's factory, and between 1917 and 1919 no fewer than six of these useful single-decker vehicles were purchased. On 16 October 1919 a new service to Bradmore via Great Brickkiln Street was inaugurated, and as the motorbus services began to expand in the early 1920s, so did the numbers of Tilling-Stevens chassis, with initially another 11 normal-control TS3As arriving by 1923.

The delivery of bus 24 (DA 7384) represented a huge advance, being the first normal-control motorbus in the fleet, and was such a success that it was followed over the next two years by another 16 similar TSMs, with seating capacities ranging from 32 to 38. Most single-deckers delivered after 1923 and until 1950 were equipped with roof-mounted luggage racks and ladders, a feature more commonly found on vehicles operating in the more remote parts of the Highlands of Scotland and deepest rural Ireland.

The Great Western Railway service to Bridgnorth was handed over to the Corporation on 1 July 1923, followed on 17 November by routes to Pattingham, Perton, Trysull and Halfpenny Green. An agreement with Midland Red to protect fares within the municipal boundary was made on 22 March 1920, and this eventually became known as 'The Wolverhampton Area Agreement', which mutually protected each operator's fares both inside and outside the town's boundaries. A total of six services were transferred from BMMO to Wolverhampton Corporation during the spring of 1928, including the important link to Wombourne, on 14 May.

Meanwhile the motorbus purchasing policy had changed in about 1926. Services in the western half of the town were introduced to Mount Road, Penn, Finchfield and Merry Hill – all of which were eventually converted to

trolleybus operation – as well as bus services covered in this book to Thompson Avenue and Tettenhall Wood. Until this time all motorbuses had been single-deckers, but in 1926 a Guy CX, No 47 (DA 9047), a normal-control Dodson-bodied 55-seater, also with an outside staircase, entered service. This was so successful that between 1926 and 1929 another 22 CXs entered service, as well as one forward-control FCX and a phenomenally unsuccessful Tilling-Stevens TS15A petrol-electric with a huge seating capacity of 66. By 1929 buses were running outside the boundary to Tettenhall Wood, Wergs, Beckbury and Tong, Compton, Pattingham and Bridgnorth, Trysull, Claverley, Merry Hill and Finchfield, Penn and Wombourne, as well as a service from Sedgley to Upper Gornal and Penn.

Wolverhampton to Dudley

The original route to Dudley was opened by the Dudley, Sedgley & Wolverhampton Tramways Company (DS&WT) as a standard gauge horse-tram route on 7 May 1883 using a centre-groove tram rail. The service started in Snow Hill at Temple Street opposite the Congregational Church and went via Dudley Road to Fighting Cocks. It then climbed up through the Silurian limestones and shales up to well over 740 feet at Sedgley. Having passed through the Bull Ring in the centre of the town, the trams passed the old depot at Valley Road, which was situated about halfway between Sedgley and Upper Gornal. The route continued through the tightly knit community of Upper Gornal, before carrying on along the ridge that separates the valleys of the Tame to the east and the Stour to the west. On reaching Eve Hill, the trams descended towards the terminus in Wolverhampton Street opposite the Post Office.

In horse-tram days this journey took an hour, but this had been reduced to 28 minutes by the end of trolleybus operation. The four-stage conversion to trolleybuses of the 5-mile through route to Dudley on 8 July 1927 extended the route at the Dudley end into Stone Street, but what is surprising is that otherwise the route remained largely unaltered throughout its long Company and Corporation operating days. After conversion to motorbus operation from 5 March 1967, the service terminated in Cleveland Street alongside the Wulfrun Centre. The main alteration to the route took place when the WMPTE, which had renumbered the 58 bus service to 558 in 1977, the additional '5' indicating a Wolverhampton-operated service, took it out of Stone Street and into Fisher Street Bus Station, Dudley. Further service alterations took place after 30 September 1986 when the same bus station was re-aligned on an east-west axis. At the Wolverhampton end of the route, Centro built a new bus station off Piper's Row in 1989.

The history of the public transport route between Wolverhampton and Dudley unfortunately had a period of about 30 years when it became extremely complicated due to the number of local authorities through which it ran, and the problems over operating rights, not only with these authorities but also between the operators and Wolverhampton's intransigence over the use of electric power collection through the almost universal overhead system.

The original horse-tram route operated by the DS&WT was converted to steam traction on 16 January 1886 using Kitson-built locos and double-deck trailers built by Starbuck. They reduced the through running time to just 40 minutes. Although the service itself was successful, the financial remuneration was not always good and the company was acquired by the BET group in 1898.

Having become the Wolverhampton District Electric Tramways on 17 December 1900 as part of the South Staffordshire Light Railway Orders, the steam-trams ceased running on 21 February 1901 after a four-stage staggered abandonment, with the new narrow-gauge electric cars eventually running between Fighting Cocks, Sedgley and Dudley on 9 January 1902. After 14 July 1902 a new service was introduced between Dudley, Sedgley, Fighting Cocks and Bilston. A further extension at the Dudley end of the route occurred on 13 November 1902 via Stafford Street into the Market Place, though by late 1905 the terminus had reverted to Wolverhampton Street. Meanwhile, Wolverhampton Corporation had built its Lorain Surface Contact electric tram route from The Peacock in Snow Hill to Fighting Cocks, opening on 8 March 1904. Any chance of through-running was now impossible because of the problems over current collection, as to convert the WDET trams to Lorain skate equipment would cost £800 for six of the ER&TCW four-wheeled cars.

In early 1905 the Tramways Committee Deputy Chairman, Alderman Craddock, with regard to the service to Bilston, which was also to be jointly worked under the terms of the

negotiations, stated that 'under no circumstances would it allow an alien company to come into Wolverhampton as of right' and that 'under no circumstances whatever would it allow overhead wires to be erected in Wolverhampton'. Surprisingly, negotiations proceeded and on 15 October 1906, after a connecting spur was constructed linking the Dudley Road Lorain-equipped line and the WDET track to Sedgley and Dudley, the latter was able to operate into Snow Hill using dual-equipped tramcars. Wolverhampton Corporation meanwhile could only operate as before as far as the boundary at Parkfield Road, Fighting Cocks. The disappointing revenue being collected by the Wolverhampton District route and the problems of the increase in current consumption due to the extra 1-ton-plus weight of the Lorain equipment, as well as the heavy maintenance costs on the dual-equipped Company tramcars, meant that reluctantly the through service was closed on 10 January 1909.

The lack of subsequent through running was only resolved after the First World War when the new General Manager, Owen Silvers, proposed the conversion of all the Corporation's tramcar routes to overhead current collection. The Dudley route was the first to be completed, opening for through-car operation on 26 March 1921 in conjunction with the Wolverhampton District cars, though in practice they ran the through service into Snow Hill from Dudley, with the Corporation trams running usually only as far as Fighting Cocks.

A complex problem emerged in 1922 when the Corporation petitioned against the Black Country Tramways & Light Railway Bill of that year by which the local BET companies were attempting to purchase all their operating rights from the local authorities through which they ran, such as those in the UDCs of Bilston, Coseley and Sedgley. This was intended to enable the tramway operators to retain their leases until a common expiry date, which was 1950. The municipal management realised that under the terms of the Wolverhampton Corporation Act of 1899 not only did it have powers to operate trams inside its boundary, but could also exercise powers to *purchase* lines within its boundary and could, with the cognisance of neighbouring

councils, purchase tramways that were outside Wolverhampton and were extensions of existing Corporation lines.

Yet again, a company operating trams in the Black Country seemed to have 'drawn the short straw'. If it had not been for hostile local authorities, competing local authority trams, buses operated by virtually anyone, and the expiry of leases, operating rights and conflicting interests, the BET system in the Black Country could have been not only far more extensive, but also more profitable. The collapse of the extensive Black Country tram network that occurred in the 1920s might have been avoided. Companies such as the Birmingham & Midland, the South Staffordshire and the Wolverhampton District would have been able to replace their original tramcar stock with more modern vehicles, notwithstanding the Tividale-designed four-wheel single-deckers of 1919-20. Ironically, Wolverhampton Corporation received eight Tividale-type single-decker cars, numbered 62-69, which proved to be the last trams delivered to it, although in this case they were constructed by Brush of Loughborough and entered service in 1922.

Protracted negotiations with Wolverhampton District Electric Tramways to take over the Wolverhampton to Dudley electric tram service began in 1924, but the complex operating rights through Sedgley and Coseley UDCs and the Borough of Dudley meant that the powers to operate trolleybuses were not given their Royal Assent until 7 August of that year. This would quickly have ramifications for the Dudley tram route. Sedgley depot, 66 employees and six company tramcars on loan were taken over at midnight on 14 August 1925 – no slouching on that score! Again, in a four-stage conversion scheme begun at the Snow Hill end as far as Fighting Cocks on 26 October 1925, and culminating on 8 July 1927, the route between Wolverhampton to Dudley was converted to trolleybuses.

If there was ever a route in the country that was suited for trolleybus operation, this was it! Basically a straight run confined to one road linking two large towns with long climbs and sweeping descents through Sedgley and Gornal, this was the stuff for which trolleybuses were

designed. Shortworkings to Fighting Cocks (8), Sedgley (originally 8A, later 61) and Jews Lane, Upper Gornal, were the only turn-backs, with the through route being originally numbered 8B, but later renumbered 58. The service was operated exclusively by Cleveland Road depot after Sedgley depot closed on 31 October 1938.

This impressive route remained in service until Sunday 5 March 1967 when the 58 route drew down the final curtain of Wolverhampton's trolleybus operation. The Dudley route outlasted all the other trolleybus services operated by Wolverhampton Corporation by more than 17 months, the previous route to close having been the jointly operated service to Walsall via Willenhall, closed on 31 October 1965. The original intention was to close the 58 route during the spring of 1966, but because of the protracted delivery of new motorbus chassis

from Guy Motors, the change-over had to be delayed by more than 12 months.

If the Tettenhall 1 route was the 'jewel in the crown', then the Dudley route was the 'best trolleybus route' on the system; being so suited to this mode of operation, it was a tragedy that it had to close. It was operated by the rebodied batch of Sunbeam W4 trolleybuses, some of whose bodies were barely five years old before they were consigned to the scrapyard. Therefore with a fairly modern-looking trolleybus fleet and a lot of wiring outside the boundary being no more than 18 months old, the route could have continued for many years. Alas, it was not to be, and the replacement Guy 'Arab' Vs with poor build-quality Strachan bodies, which were destined themselves to have a life of barely seven years, took over from the trolleybuses until the end of Corporation motorbus operation.

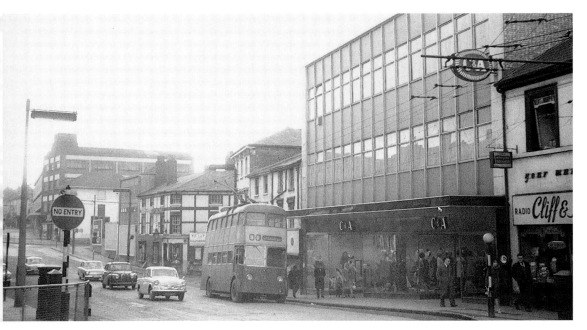

On arrival in Wolverhampton from Sedgley and Dudley on the 58 service, the trolleybuses unloaded at the bottom of Snow Hill outside the premises of C&A Modes. This shop had been built in 1961 and for many years stuck out like a glass-fronted sore thumb in its 19th-century surroundings. Today the oldest surviving buildings are the early-19th-century buildings on the right, on the corner of Temple Street. All the buildings around Bell Street and the trolleybus in Snow Hill were swept away when the Wulfrun Centre was built between 1966 and 1969. In later years a Netto Supermarket occupied the premises that were built for Rackhams departmental store, but they closed in the mid-1990s after years of struggling to trade successfully on the 'wrong side' of Cleveland Street in relation to the pedestrianised town centre. Trolleybus 439 (EJW 439) is a 1947 Sunbeam W4 chassis, rebodied by Charles Roe in January 1961 with an H32/28R configuration. It was unfortunately to have only a short life in this attractively rebodied form, being withdrawn in March 1967 when the Wolverhampton system finally closed. On resuming its duties, it will be driven a few yards forward before turning right into Bilston Street where it will load up outside the Garricks Head public house. *B. Baker collection*

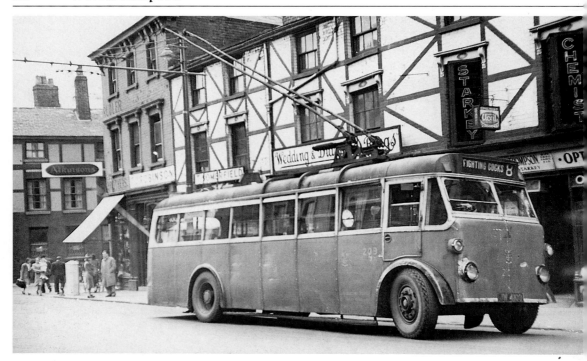

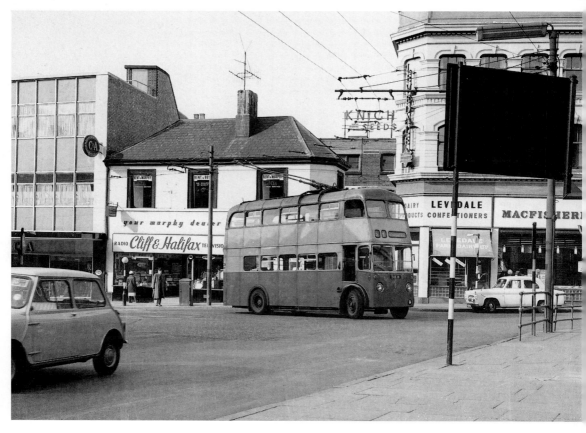

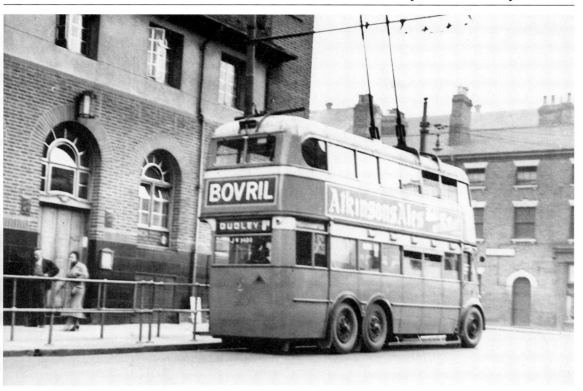

Above left In the 1930s Wolverhampton Corporation bought three batches of single-deckers: four Sunbeam MF1s and four Guy BTs built in 1934, and another three MF1s purchased in 1936. All but the prototype, 206 (which had an extra seat), were fitted with Park Royal B32R bodies and were used exclusively on the Wednesfield service, where the clearance beneath the LMS railway bridge in Broad Street was insufficient for double-deck operation. In November 1943 the road was lowered beneath the bridge, which at a stroke made these 11 single-deckers redundant. Being relatively modern and, in the case of this Sunbeam MF1, 209 (JW 4109), having only been overhauled just over two years before the Wednesfield conversion, these single-deckers had to be retained, and as a result were employed on peak-hour extras, shortworkings and learner duties. The heavy-steering Guy BTs were all withdrawn by 1945, but most of the Sunbeams remained in service until early 1949. No 209, which entered service on 15 December 1934, is seen at the Snow Hill terminus in about 1947. It has, true to form, been working on the 8 shortworking to Fighting Cocks. It is not altogether surprising that it looks a little bedraggled, having received its last repaint in July 1941. *B. Baker collection*

Left Sunbeam W4 418 (DUK 18) turns from Snow Hill into Bilston Street in order to fill up with passengers before starting on its long journey back to Dudley on the 58 service. This was one of the last of the 1945 deliveries of trolleybuses to the Corporation, and it was the only one of that year's trolleybuses not to be rebodied by Park Royal in 1952. Instead it became numerically the first trolleybus to be

rebodied by Charles Roe, in this case in June 1959. The four-door Ford Prefect 100E parked on the right is a contemporary of that rebuilding exercise, the model not being phased out until 1959, although the Mini disappearing along Bilston Street helps to confirm the date of the photograph as 27 September 1964. Some post-war rebuilding of Wolverhampton's town centre has already taken place, as exemplified by the C&A building, but MacFisheries – famous for fresh fish and wonderful fishcakes – is still contained in older, more attractive Victorian premises. *J. C. Brown*

Above Towards the end of the Second World War some of the more 'extreme' wartime measures were removed from the bus and trolleybus fleets; for example, six-wheeled trolleybus 200 (JW 3400), a 1934 Guy BTX with a Birmingham Corporation-style Metro-Cammell H33/25R body, has lost most of its wartime black-out white paint. It is standing in Bilston Street, with the junction of Market Street and Garrick Street in the background. Only the old Garricks Head building on the left remains standing today, while the distant buildings in Market Street were demolished long ago. The trolleybus has been painted in the nearly all-over green livery with one cream band, applied in July 1943 as a wartime economy measure, and is carrying an unusual mixture of beverage advertisements, Atkinsons Ales on the side, and Bovril in the small back panel. It is working on the 8B service to Dudley, which by this time was a route more normally associated with four-wheeled vehicles rather than these elderly six-wheelers. *R. Wilson*

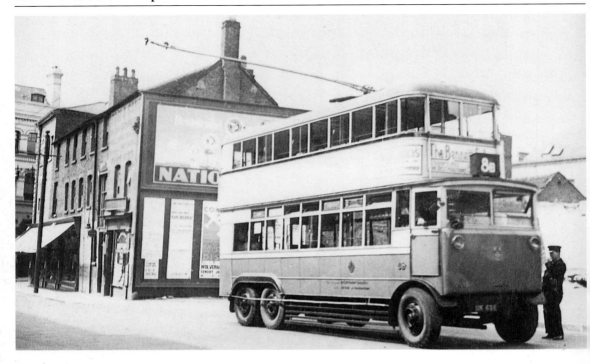

Above Having purchased 32 single-deck trolleybuses in the three years after the opening of the system in 1923, General Manager Owen Silvers turned away from the purchase of Tilling-Stevens chassis and approached the local company of Guy Motors to supply a trial double-decker trolleybus. This vehicle was numbered 33 (UK 633), and was the company's new six-wheeled BTX model. It entered service in December 1926, and such was its success that in the next four years no fewer than 58, with bodies supplied by either Guy Motors itself or Christopher Dodson of Willesden, entered service. The first batch of these impressive though ponderous-looking trolleybuses was numbered 34 to 40; the example seen here, 38 (UK 638), with a Dodson H33/28R body, entered service in September 1927, and is working on the 8B route, parked in Bilston Street before the Garricks Head pub was built. Massive vehicles for their time, they had, unlike the prototype, enclosed platforms, but had bodies that were more akin to totally enclosed trams. *R. Marshall collection*

Above right Standing outside the Ansells brewery-owned, inter-war Garricks Head pub in Bilston Street in about 1948 on the 8 route to Fighting Cocks is one of Wolverhampton's pre-war Guy BT trolleybuses, 280 (BJW 180). Delivered in September 1938, it was one of the last three pre-war Guy trolleybuses to enter service. It was fitted with a Roe H29/25R body at a time when the Leeds bodybuilder was relatively unknown in the West Midlands, and has a straight staircase, rather than Roe's patented type, which accounts for the unusual seating layout. The trolleybus survived in service until the beginning of 1952, then it was used until 1953 as a driver training vehicle together with 277 of the same batch. These attractive-looking vehicles met a strange end as both were sold in May 1954 to Bilston Corporation, cut down to single-deckers and used as mobile polling booths. The long-since-closed Birmingham-based gentlemen's outfitters, Foster Brothers, behind the

trolleybus, had shops throughout the West Midlands, and at this time had large retail premises in a prominent position in Bilston Street. On leaving Bilston Street the trolleybuses turned right into Garrick Street, where for many years there was a tied-off, early post-war abandoned trolleybus wiring that went into Bilston Street, allowing workings into Piper's Row and Victoria Square for trolleybuses transferring from one service to another. *R. Marshall*

Right Electric traction has happily returned to Bilston Street in the form of the Midland Metro. This light rapid transit system was opened on Sunday 30 May 1999 and runs from its St George's terminus in Bilston Street to Birmingham's Snow Hill Station. The route's first 2km are street-operated along Bilston Road, before it turns off at Priestfields to run via Bilston, Wednesbury and West Bromwich along the old trackbed of the former GWR route. Metro car 06, an Italian tram built by Ansaldo Trasporti of Naples, with a seating capacity of 60 and room for another 100 standing, waits at the St George's terminus opposite the main Wolverhampton Police Headquarters on 27 April 1999, during the many months of pre-opening trial running. Behind the tram is the location of the old Dudley trolleybus route terminus in Bilston Street, and a tiny island of unaltered buildings in an area that has been extensively redeveloped. The Garricks Head public house on the corner of Bilston Street and Garrick Street has long since closed, but the building remains as the premises of the Birmingham Mid-Shires Building Society. The building has been truncated and the gap between it and the Foster Brothers building has been filled by an access loading point. In Dudley Street, in the background, the only old building to remain is MacFisheries (see page 21), which is now a clothing boutique. This section of Bilston Street is now pedestrianised, but traction poles have returned to the street after a period of 32 years. *D. R. Harvey*

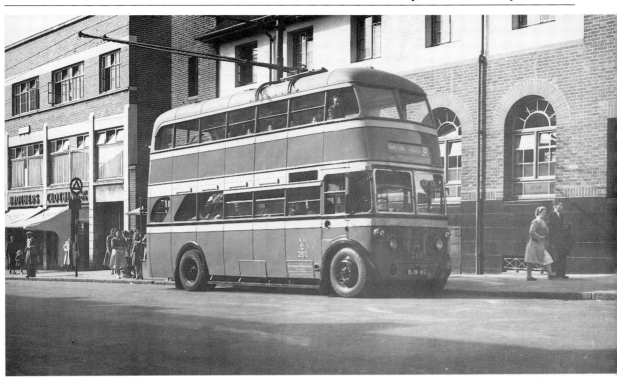

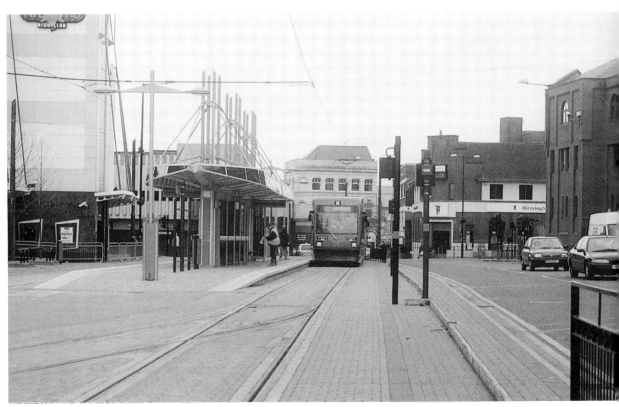

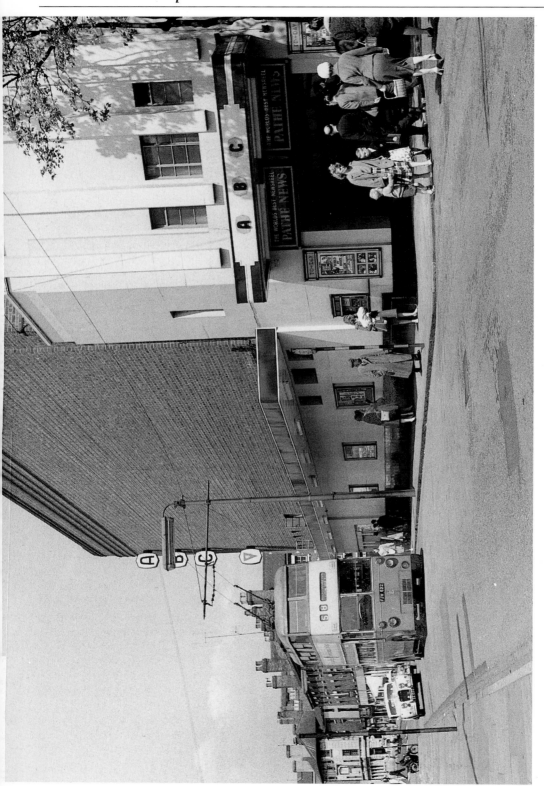

On leaving the Bilston Street terminus, the 58 trolleybus service turned into Garrick Street and passed the old Savoy Cinema, which by May 1961 had become the main ABC cinema in the town. Although extensively renovated, it remains today as the Atlantis Night Club. Sunbeam F4 622 (FJW 622), a Park Royal-bodied trolleybus that entered service in April 1949, passes alongside the cinema at its Old Hall Street corner; the feature film being shown is a long forgotten one entitled *World By Night*. The late-1990s Bilston Street redevelopment scheme, which included the retention of the cinema building, also included the main Wolverhampton police station and the terminus of the Midland Metro. Behind the trolleybus is a rather splendid Jaguar Mark VII, with the distinctive registration SS 1000. *J. C. Brown*

Turning from Garrick Street across the Cleveland Road junction with Snow Hill on 27 March 1961 is one of the 8-feet-wide Guy BTs, 632 (FJW 632), working on the 58 service to Dudley. Park Royal bodied a total of 99 Guy BTs and Sunbeam F4s between 1948 and 1950 for Wolverhampton Corporation. They all had composite bodies and were externally very similar, though they could be distinguished by close examination of the front apron in relation to the front wings and the size of the rear wheel hubs. Following the trolleybus, beneath the shadows of the overhead, is a Burton-upon-Trent-registered Standard Flying Eight saloon that was first registered in July 1940, having the next registration to one of that town's single-deck Guy 'Arab' buses. The trolleybus is passing Wolverhampton's impressive Free Library, opened on 11 February 1902. Its facade was built with a strange mixture of mullioned windows and yellow terracotta banded stonework, reflecting the anti-Gothic Arts and Crafts revivalism of the William Morris-influenced style of architecture. Unfortunately the muddled styling on the entrance portico, with the twin decorative cupolas at roof level, rather spoils the overall effect. *J. C. Brown*

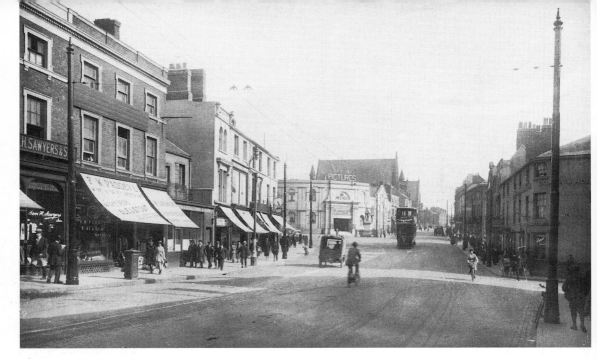

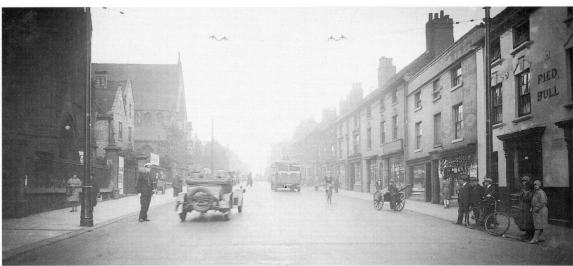

Top A top-covered double-decker tramcar, fitted with enclosed vestibules, rumbles down Snow Hill at the junction (on the left) with Cleveland Road, on its way into the town centre from Fighting Cocks. The tram and the tram route have both been equipped for overhead current collection, dating this view to after 21 March 1921. The trams would only continue until 18 August 1925, when a substitute motorbus service covered the section as far as Fighting Cocks. The whole of the tram service to Dudley took almost exactly a year to close down, and the replacement trolleybus route would not be finally completed as a through service until 8 July 1927. On this warm summer's day the shops on the 'sunny side of the street' have their canvas blinds drawn down, including Paddey's wine and spirit shop. The statue to the left of the tram is that of Charles Pelham Villiers, who was the town's MP for 63 years and died on 16 January 1898; it survives today and resides in West Park. Behind the statue is the old Agricultural Hall, which despite its name had a seating capacity of over 2,000 and a large concert organ, which was played by the town's excellent organist, Reginald Goss Custard, as well as being used for recitals by the more internationally known Marcel Dupré and Charles-Marie Widor. By the time the old Lorain Surface Contact system for the trams had been replaced, the building had become the Agricultural Hall Cinema, the first picture house in the town centre. In later years the building was demolished and replaced with the Gaumont Picture House. In the background the untowered presence of the churches in Snow Hill dominate the skyline. *B. Baker collection*

Above The conversion of the tram routes to Sedgley and Dudley was a protracted affair, beginning with the Snow Hill

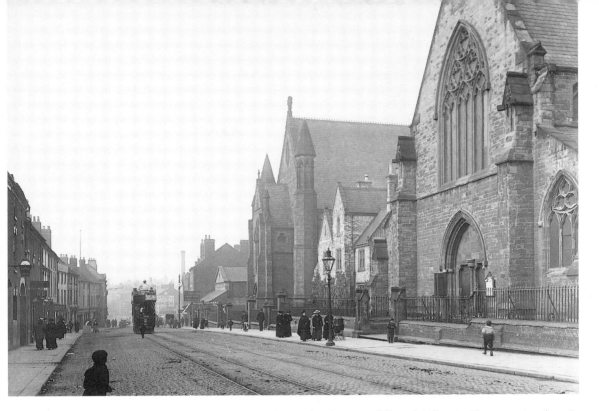

to Fighting Cocks section on 26 October 1925 and eventually completed on 8 July 1927. The conversion was undertaken in four sections during this period, and as a result the poor passengers completed their Dudley journeys using the remnants of the tram route, the sections temporarily covered by motorbuses and, of course, the new trolleybuses. The trolleybuses were all single-deckers until 1926 and were initially operated from Cleveland Road depot, then after 10 February 1930 the old Wolverhampton District Electric Tramway depot at Sedgley was also used to garage them. Trolleybus 26 (UK 626), seen here, a single-deck Tilling-Stevens TS6 with a Dodson B36C body that entered service in 1926, originally had 'solid tyres', but by November 1928 all the fleet were running on pneumatic tyres. This Tilling-Stevens chassis model could be supplied either as a bus or as a trolleybus, but in either case it could be characterised by the high, almost vertical flight of steps that gave access to the saloon. It is working on the 8A route and is descending Snow Hill, having passed the Roman Catholic church of St Mary & St John on the left. The Wolverhampton-registered artillery-wheeled tourer going up the hill is typical of the kind of two-seater being produced in the mid-1920s, resembling a Wolseley 10hp of about 1924. *B. Baker collection*

Above Descending Snow Hill on the short section of double-track and travelling towards the Wolverhampton tram terminus is open-top, double-deck tramcar 30. This was the last of the six trams purchased from G. F. Milnes in the spring of 1904, which were mounted on Brill 21E trucks and, like all the Corporation's open-toppers, were equipped with two large lamps mounted on elaborate iron brackets to illuminate the upper deck at night; unlike the previous 16 double-deckers in the Corporation's fleet, they had reversed staircases. These six trams were among the last tramcars built by Milnes, formerly of Birkenhead but latterly of Hadley in Shropshire, which went into liquidation not long

after they were delivered. Milnes had been a major player in the construction of horse and steam tramcar bodies, but was unable to compete profitably in the Edwardian electric tram 'boom' years with the likes of Brush and the Dick, Kerr group. It was the latter's United Electric Car Company that eventually took over the Milnes Castle Car Works in Hadley. Car 30 has passed St Mary & St John, built in 1851, while on the other side of Snow Hill are early-19th-century buildings, some of which survive to this day under the protection of a preservation order. Outside the Catholic Church and its Presbytery is a small gas street light, while beyond Snow Hill Congregational Church and to the right of the tram is an early electric carbon lamp. This suggests that this was about the time when electric lighting in the town centre was just beginning to be phased in. Visible between the tram tracks are the electric contact studs for the Lorain Surface Contact method of current collection. Tales of horses being electrocuted when they stood on a contact are apocryphal, but although the advantage of not having any overhead electrical wires might have been initially attractive, the maintenance costs began to spiral. By 1920 the Corporation was either going to abandon the isolated system altogether or convert to overhead wiring for current collection. It chose the latter!

In the distance, beyond the trolleybus terminus, is Dudley Street, which was one of the main shopping streets in the town centre. It was only in the 1930s that new impressive premises were constructed for retailers such as Marks & Spencer, Freeman, Hardy & Willis, Burton and George Mason. To the right of the tram and beneath the gable-end advertisement for C. D. Nokes's House Furnishers, is the famous Villiers statue outside the Agricultural Hall on the corner of Cleveland Road. Today this view is obscured by the Wulfrun Shopping Centre, which was completed in 1970 and enabled the remnants of Dudley Street leading to Queens Square to be eventually pedestrianised. *J. Hughes collection*

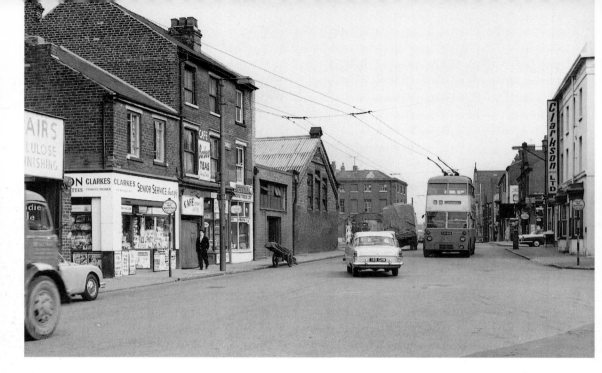

Above At the top of Snow Hill the Dudley trolleybus route passed George Street, on the site of what is today part of St John's Ring Road, and almost immediately the thoroughfare became known as Dudley Road. Today only the three-storied late-18th-century restored terraces on the corner of George Street have survived. A standard feature of Wolverhampton's 8-feet-wide trolleybuses was that they were equipped with white steering wheels, as shown by Park Royal-bodied Guy BT 605 (FJW 605), which has just passed Melbourne Street on the right as it travels out of the town. It was along Melbourne Street that John Marston set up his Sunbeam safety cycle factory, and the Melbourne Vehicle Works became part of the vehicle empire that collapsed spectacularly in 1934. The large open space in the foreground is the beginning of Birmingham Road, formerly Green Lane, which led out to the Birmingham New Road, opened by HRH Edward, Prince of Wales, in November 1927.

On the corner on the right, by the 'No Waiting' sign, are the elegant 19th-century premises occupied by the ground-floor surgery of Dr W. Wallace. He was known as 'The Horse Doctor', not because of his veterinary skills but because he was a keen equestrian. Opposite the trolleybus, the low building with the corrugated iron roof is the Fordham Perry factory, where toilet cisterns and sewer pipes were manufactured. The first of the shops on the left next to the factory is Manning's, who at this time are selling Wolf power drills, which pre-dated Black & Decker by a number of years. Next door, just behind the pedestrian, is Sloane's cafe. Perhaps things haven't changed that much in the intervening years, for where there are factories there is sure to be someone making cups of tea and bacon sandwiches. Of course, to go the whole hog (excuse the

pun) the best sandwich you can buy from such an emporium is indeed a BEST – bacon, egg, sausage and tomato. If you bought a sandwich you would also need a paper to read while you ate, so Clarke's newsagents, advertising Senior Service, Player's and Bachelor cigarettes, would be the next port of call before going back to the factory to have the lunch break, the sandwich, a cup of tea, a quick read of the newspaper and a swift 'cough and a drag'!

This view of Dudley Road was taken on 10 May 1961. The Bristol-registered six-cylinder Ford Zephyr and the 2.4-litre Mark1 Jaguar, partly masked by the speeding Commer QX lorry on the extreme left, contrast with the window-cleaner's handcart parked outside the cafe. The site of the buildings on the left is now occupied by the St John's Retail Park, whose boundary railings are attractively adorned by the script-written names of many of the vehicle manufacturers who were based in Wolverhampton. *J. C. Brown*

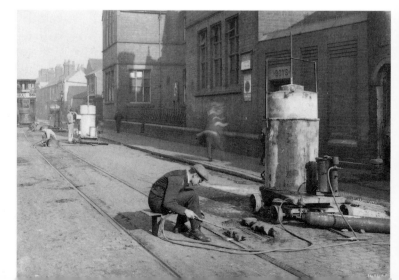

Below left Maintenance of the track and overhead on most electric tram systems was vital in keeping the wheels turning. In Wolverhampton, however, with its Lorain system of surface contact, only the former was necessary. The Victorian Dudley Road Schools, on the right, with their separate Boys and Girls entrances, closed in 1986 but survive today as offices for Wolverhampton Corporation's Social Services Department. The track welding is taking place on the single track section between Mason Street and Drayton Street, and waiting in a passing loop, carrying advertisements for Luce's Bread, is Corporation tramcar 18, the last of six double-deckers built by G. F. Milnes in the summer of 1902. By this early 1920s view it had been top-covered, vestibuled and rebuilt with 180-degree direct staircases.

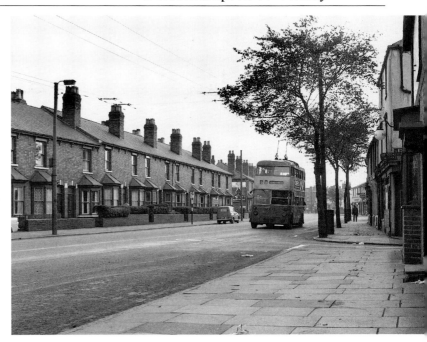

This track work in Dudley Road must have been undertaken in connection with the conversion from the Lorain system to the more conventional overhead wire method of electric current collection. This section of the Dudley Road service to its terminus at Fighting Cocks was re-opened on 26 March 1921, allowing Wolverhampton District trams to run from Sedgley and Dudley into the town centre at Snow Hill, while the Corporation continued to be restricted to the local and more frequent Fighting Cocks service. The conversion work was done by hiring in what was called 'direct labour', and it is interesting that at this time of appalling post-war unemployment the school buildings are also being used by the Board of Trade as a Labour Exchange. This section was then converted to trolleybus operation on 26 October 1925, so it hardly seems worthwhile to have converted the tram route to overhead operation for just four years' operation. Most of the houses in the background date from the 1880s and 1890s, and look likely candidates for redevelopment, but it was those opposite that were demolished in the 1960s, leaving this side to survive. *J. Hughes collection*

Above right Coming along Dudley Road towards the town centre on the 58 service on 27 September 1964 is Sunbeam F4 trolleybus 465 (FJW 465), one of the Park Royal H28/26R-bodied vehicles of 1948 and one of the final seven of its class to remain in service, lasting until 1965. It is travelling past Sedgley Street with the British Queen public house on the corner. The houses on the left, with their bay windows and small walled gardens, date from the last decade of the 19th century and were an improvement over the older terraces in Dudley Road, further in towards the town centre. The small road junction with the Bird's Eye advertisement on the gable-end of the house is Cousins Street, which led to one of Wolverhampton's 59 cycle manufacturing works. *J. C. Brown*

Right During the Second World War, because of the amount of war-work being undertaken in the town's many factories, Wolverhampton Corporation was allocated a large number of buses and trolleybuses built with bodies to the Ministry of War Transport's specification. No fewer than 26 motorbuses and 38 trolleybuses were received between 1942 and 1946, and one of the 1946 batch of 'utility'-bodied Sunbeam W4s, 420 (DUK 820), is seen here speeding along Dudley Road near Fighting Cocks at Dudding Road on its way to Dudley. It is carrying its original wartime Park Royal body, which would be replaced in 1958 with a new composite one constructed by Charles Roe. The driver has eschewed the use of his trafficators and is using a hand signal instead. The trolleybus is displaying the 8B route number, which dates this view before 13 June 1949, when the route was renumbered 58, and is carrying on its front an advertisement for the well-known Wolverhampton Steam Laundry, while along the offside is an advertisement for 'Tizer The Appetizer', a soft drink that has seen a renaissance in recent years. *D. R. Harvey collection*

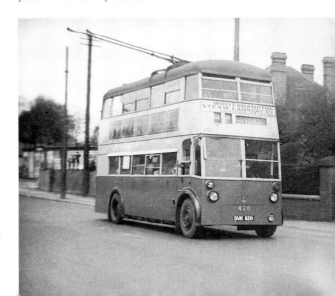

Below The first-ever Guy six-wheeled trolleybus was delivered to Wolverhampton Corporation in December 1926. Fitted with a Dodson H33/26RO body and numbered 33 (UK 633), it was the first successful six-wheeled trolleybus to enter service in this country and, for its time, it had a fairly low-height chassis construction, although the steps on to the rear platform rather belied this. This trolleybus was the only one in the fleet to have an outside staircase, but with its seating capacity for 59 passengers it had a distinct advantage over the contemporary tram. It was also the first bus in the fleet to be equipped with pneumatic tyres, and had brakes on all four back bogie wheels, although not on those on the front axle. No 33 was withdrawn in 1936 and, because of its historic importance, was donated to Guy Motors in December 1937. Unfortunately it was broken

up in the early years of the war as part of the 'war effort' for scrap metal. It is seen here in Dudley Road, near Fighting Cocks, when working on the Sedgley and Dudley service, where it spent most of its operational life. *B. Baker collection*

Bottom The junction of Dudley Road and Goldthorn Hill Road was better known as Fighting Cocks, which was the name of a succession of public houses that dominated the intersection. A small shopping centre developed in Dudley Road on the Wolverhampton side of the junction at the end of the 19th century, although the row of shops seen here behind the Austin Mini and the Standard Vanguard Phase III was not built until the 1920s. The two trolleybuses passing each other on the 58 service on 27 August 1964 are two of the Roe-rebodied Sunbeam W4s, with 448 (EJW 448) pulling away from the stop with its trafficator flashing on its way to Dudley, and 432 (DUK 832) travelling in towards Wolverhampton. The public house on the left, the Old Ash Tree, remains today, but ironically the Fighting Cocks was finally demolished in the early 1990s after being closed for many years, and replaced by an Aldi supermarket. *J. C. Brown*

Above right Two electric tramcars appear to be about to use the same section of road at Fighting Cocks, but nothing could be further from the truth! The tram standing on the left at the end of Dudley Road is a reversed-staircase Milnes open-topper belonging to the Corporation, and it is at its terminus at Fighting Cocks. It is running on the Lorain stud surface pick-up system, which was not compatible with other methods of current collection, unless the tram was dual-fitted. This briefly became the norm in the Corporation's operating territory, so Wolverhampton District trams could operate into the town, but it added well over a ton in weight to the tramcars, which reduced their performance and increased their current consumption. The almost refreshing lack of traction poles and overhead on the

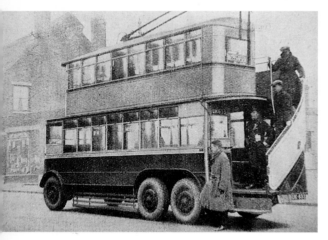

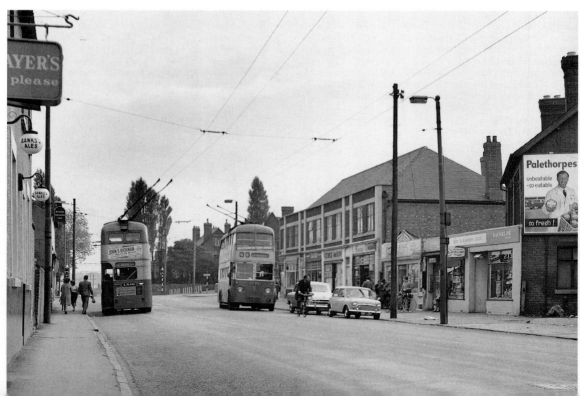

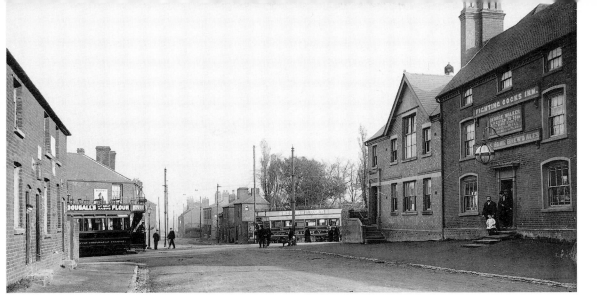

left is most noticeable, and the tram is not fitted with a trolleypole.

The tramcar on the right is Wolverhampton District Electric Tramways bogie car 23, built by Brush Electrical in 1902 with a capacity for 70 passengers. These trams were fitted with GE 58 30hp motors and had Brush B-type trucks fitted with the pony wheels leading. None of these large bogie cars were fitted with Lorain skates, so the tram will turn right into Parkfield Road before setting out for Bilston. The two electric tram routes were linked on 15 October 1906 when a new section of track was put in place across the junction from Dudley Road into what was then known as Gibbons Road and is now Wolverhampton Road East. The ten dual-fitted Company four-wheeled tramcars from the 1-13 class had Lorain contact skates as well as their original overhead equipment, so they could run the through service from Dudley to Snow Hill. This left the Corporation trams to operate on the Fighting Cocks shortworkings. The Dudley through service ceased on 10 January 1909 as the Company considered that the revenue was insufficient, and it was not until 26 March 1921 that it was restored, but this time using overhead wiring. Behind the Corporation tram is a corner shop carrying an advertisement for Ogden's tobacco, while on the right is the original Fighting Cocks Inn, a Georgian building that, in common with many Black Country pubs, brewed its own beers. It was replaced in the 1920s by the public house that would survive until well after the trolleybuses had disappeared. *J. Hughes collection*

Below The 1921 Dudley Road conversion to overhead current collection enabled Company cars to run once again into Snow Hill and reconnected the direct service between Wolverhampton and Dudley. By 15 October of that year, when the Penn Fields route was completed, all eight of the Corporation's tram routes had been finally converted at a cost of £375,000. Looking towards the town centre from Wolverhampton Road East near Dudding Road, the tree-lined road has a feeling of Edwardian opulence. In the distance, at the terminus in Dudley Road, is a Corporation Milnes double-decker tramcar working as far as Fighting Cocks. By this time the tram had been much rebuilt, being equipped with a vestibule, a reverse staircase, a top-cover and a trolleypole. A solid-tyred van is parked on the corner of Parkfield Road and is presumably delivering to one of the shops around the junction as there is no driver in the cab. *J. Hughes collection*

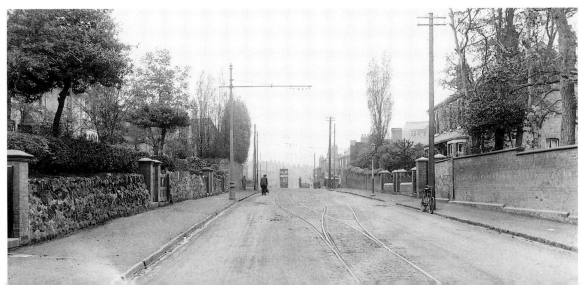

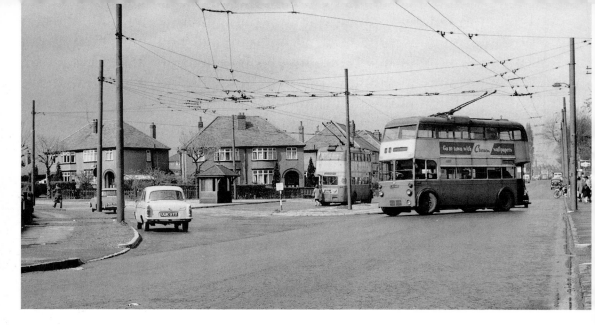

Above After its conversion to trolleybuses, the Fighting Cocks service, by now numbered 8, became a shortworking of the Sedgley (8A) and Dudley (8B) routes. As the trolleybuses could not turn at the Parkfield Road junction, a turning circle was constructed at Dudding Road. In May 1961 trolleybus 495 (FJW 495) is working on the short Fighting Cocks turnback, which was the direct successor to the former Corporation tram service. This Park Royal-bodied Guy BT trolleybus entered service in June 1949, and its body, as with all 99 supplied by the Southall-based manufacturer, could be distinguished as being 8 feet wide by its white steering wheel. The 1930s semi-detached houses on the Goldthorn Park Estate contrast with the Edwardian terraces on the east side of Wolverhampton Road East. Around the Greenly Road junction on the extreme right is a small area of industrial development, and just visible is one of those long-forgotten features of life 40 and more years ago, a petrol pump with the diamond-shaped illuminated lettering of the Cleveland brand. The garage was owned for many years by A. W. Broome, who was the proud owner of an early 1930s Sunbeam car, a marque that had a long Wulfrunian history. Petrol at this time cost barely 2 shillings (10p) a gallon, but was so lacking in purity that one would think twice about running a cigarette lighter on it... It was not altogether surprising that unsophisticated cars such as

the side-valve two-doored Ford Anglia 100E parked at the entrance to Dudding Road had such long lives, yet had to be rebored about every 40,000 miles. *J. C. Brown*

Below left This view is historically interesting as standing in the terminal loop at Dudding Road in Wolverhampton Road East on 12 April 1947 are two of the last batch of six-wheeled trolleybuses purchased by the Corporation. No 227 (JW 7327), working on the 25 service to Willenhall, and 228 (JW 7328), operating on the Fighting Cocks service, both entered service in December 1935. They had Guy BTX chassis and were fitted with attractive Brush 58-seater bodies. After their arrival only one more six-wheeled trolleybus was purchased, 245, a Sunbeam MS2. Precisely why six-wheeled trolleybuses fell out of favour in Wolverhampton so quickly can only be surmised. The more complicated drive-lines to the rear bogie, tyre scrub on the four rear wheels and, perhaps most importantly, their seating capacity being only four more than a much less expensive and manoeuvrable four-wheeler must have weighed heavily in favour of the shorter vehicles. Both trolleybuses would remain in service until 1949 when the delivery of the 8-foot-wide Park Royal-bodied Sunbeam F4s and Guy BTs saw off most of the pre-war stock. After 1949, when the 25 service was transferred to its new turning circle at Ward Road on Goldthorn Hill Road, the Dudding Road loop saw less use, but during the rush hour was a hive of activity. The Fighting Cocks 8 service turned back at this point, while all in-bound trolleybuses from Dudley also pulled into the turning circle. In the distance is the open space that was subsequently occupied by Parkfield Secondary School. *R. Hannay*

Above right Trolleybuses in the snow were not a good thing! Although they sat 'four-square' and heavily on the road, the driver had little to control his electrical charge once grip and traction were lost. There was obviously no clutch to slip, and he had to rely on his acquired skills by balancing the throttle, footbrake and the 'trolleybus driver's friend' – the handbrake – to keep his charge moving. The winter of 1962-63 was very bad, and the heavy snowfalls made driving conditions very treacherous for everyone. Roe-rebodied Sunbeam W4 425 (DUK 825) stands in Wolverhampton Road East beyond

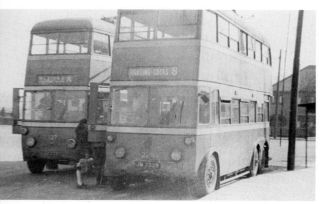

Dudding Road at the head of a queue of traffic that apparently stretches back to Fighting Cocks! Behind the snow-covered 425 is another trolleybus of the same type, whose driver, perhaps thinking more about his health than the frosted-over cab windows, has sensibly shut the sliding cab door. The line of vehicles caught in the traffic jam would make anyone nostalgic for the 1960s positively drool, including a Morris 1100, a Ford Anglia 100E, a Wolseley 1500, a Ford Classic Capri 109E, a Vauxhall Victor FB, an Austin A35 Countryman with its door open, and an almost new Hillman Super Minx waiting in front of the milkfloat. Behind the milkfloat is a Duple-bodied coach, which could either be a Trooper if mounted on a Ford 510E chassis or a Bella Vega if fitted to a Bedford SB chassis. More significant is the lurking silhouette of a full-fronted Metro-Cammell-bodied Guy 'Arab' IV motorbus, which has been put on to the Dudley route to augment the struggling trolleybuses. In these conditions the trolleys would have really laboured on the steep climb up to Sedgley. *J. C. Brown*

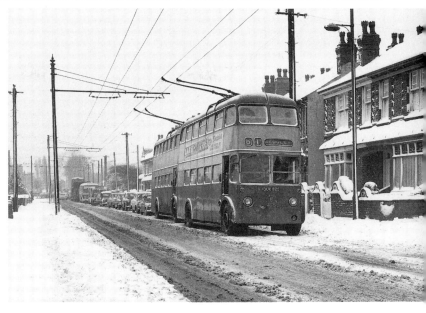

Below In more clement summer weather on 29 June 1964 Roe-rebodied Sunbeam W4 418 (DUK 18) pulls away from the stop in Cinderhouse Bank in Wolverhampton Road East, Ettingshall, near the Wolverhampton-Dudley boundary, working on the 58 service. It is about to begin the climb towards Sedgley, passing beneath a point where electrical power was fed into the overhead by means of feeder cables. These were situated about every half-mile along the trolleybus route so that voltages would remain constant. In turn, the trolleybus driver would have to coast past this point

otherwise he would blow his circuit breakers and the trolleybus would grind ignominiously to a halt; once thus 'beached', he would have to reset his electrical equipment before moving away. The area behind the trolleybus was extensively used for coal-mining until the early years of the 20th century, with Ettingshall Park Colliery occupying the site behind the houses on the left. Sedgley Park Colliery occupied the land at the bottom of the hill on the left, while opposite was a brickworks, another industry to exploit the local clay. The houses on the right, with their characteristic metal-framed windows, date from the early post-war years. When they were built, a lot of uncharted mine shafts were discovered and had to be capped. *J. C. Brown*

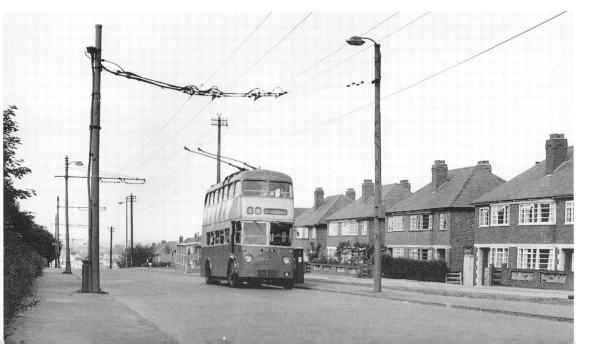

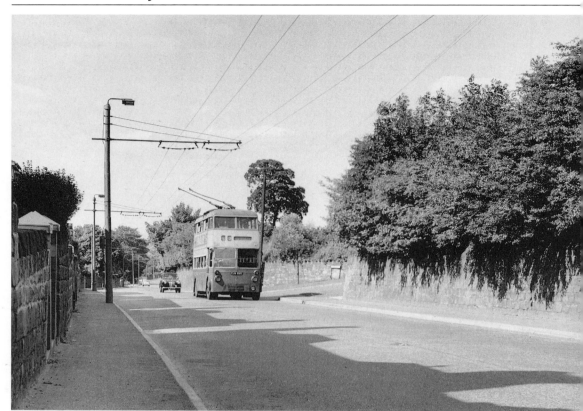

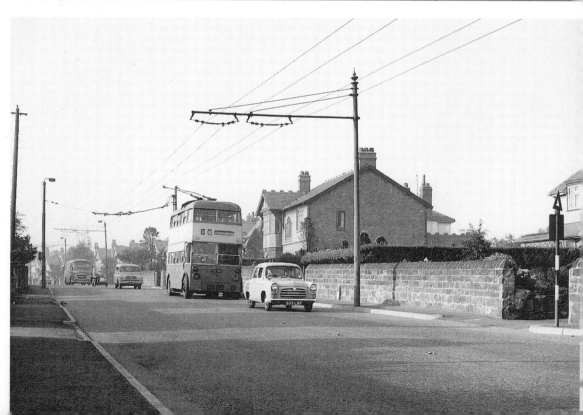

Left On 29 June 1964 Park Royal-bodied Sunbeam F4 626 (FJW 626), new to the Corporation in April 1950, storms up the hill in Wolverhampton Road towards Sedgley past a side road known as The Vista. It is being followed by an Austin A30 car, which with its 803cc engine might have been hard pressed to keep up with the trolleybus on this steep but steady climb. No 626 completed a major body and chassis overhaul in August 1963, but despite this it was withdrawn on 8 August 1965. This tree-lined road, the A459, has hardly changed today, having grown up as a turn-of-the-century 'ribbon' development. The long, almost inter-urban Wolverhampton to Dudley service seemed to epitomise all that was best about trolleybus operation, with a stiff climb in one direction and, on returning, an exhilarating run down the hill, allowing the trolleys to really 'stretch their legs'. What a pity that the route succumbed in March 1967! In today's petrol or diesel-powered public transport world, this environmentally friendly route would have been a wonderful model for the re-introduction of this form of electric traction. *J. C. Brown*

Below left That glide down the hill from Sedgley suited trolleybus operations splendidly. Even today, when driving a car, it is tempting to get all the passengers to put their arms in the air (to provide power), knock the car out of gear, and coast down Wolverhampton Road from Beacon Hill towards Parkfield School and just pretend! On 20 August 1964 Sunbeam F4 465 (FJW 465), a Park Royal-bodied 54-seater that entered service in October 1948, follows a Ford Anglia 100E down Wolverhampton Road on the 58 service. It is coming out of Sedgley, passing High Park Crescent, and is doing just what one is supposed not to do in a car, gliding 'at a goodly rate of knots' downhill. It had been decided in 1962 that the 8-feet-wide Guy BT and Sunbeam F4 trolleybuses would receive little or no major maintenance and that any vehicle incurring major mechanical failure or accident damage would be taken out of service. No 465 would be withdrawn on 8 August 1965; however, that is nearly a year away, and it still looks remarkably sprightly and in good condition as it is followed down the hill by a Bedford Dormobile CA utilibrake (what would be known today as a minibus), a motorcycle combination and one of Don Everall's Plaxton-bodied Ford Thames Trader coaches. *J. C. Brown*

Right Standing in the Bull Ring opposite the Red Lion Inn in Sedgley, in the last years of the 19th century, is a steam-tram-and-trailer set. The vehicles were built for the Dudley, Sedgley & Wolverhampton Tramways Company for the opening of its steam-powered service on 10 January 1886. The gauge of 4ft 8½in was inherited from the previous horse-tram service opened in May 1883. The horse trams had proved troublesome because of the hilly nature of the route, hence the introduction of mechanical traction. Five Kitson inside-cylindered steam trams were purchased, and a similar number of double-deck trailers acquired from the Starbuck Car & Wagon Company of Birkenhead. Originally these had top-deck canopies with open sides, but from about 1891 glass windows were fitted, although within a short period of time a few window glasses were removed to reduce resistance to side winds. The

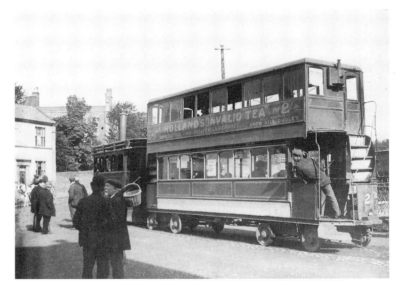

Sedgley and Upper Gornal sections of this long inter-urban service were very exposed – one car had been blown over – and it took the steam tram 40 minutes to go from terminus to terminus, while it only took about 7 minutes to get to Fighting Cocks from Snow Hill. The top deck design was, however, very modern for its day, with its profiled roof-line.

The conductor on the back platform looks hopefully towards the clusters of men standing in the road for prospective customers as Trailer 2 waits before being hauled away towards Wolverhampton. The Starbuck trailers had a seating capacity of 54, with knife-board seating in the upper saloon and perimeter seating downstairs. Careful examination of the tram and trailer reveals what appears to be a telephone-like device mounted on the left-hand bulkhead under the rear staircase. The man in the beret is carrying an empty wicker basket over his shoulder, suggesting that he might be going to Roden's bread and cake

shop next to the Red Lion Inn to the right of the trailer car. Beyond the steam tram locomotive is Hilton's House, which by this time was no longer just a farmhouse as the owners had converted the outbuildings for storing builder's merchant supplies. Beyond it, along High Street, is the Georgian mansion that was known as – though in reality never was – The Manor House, demolished in 1968.

The Dudley & Wolverhampton Tramways steam-operated service closed on 21 February 1901, and during that summer the necessary electrical infrastructure was installed, while the tram track was relaid to the Black Country standard 3ft 6in gauge. The Company had electrified the section from Dudley to Sedgley depot on 3 October 1900, but it would be 24 October 1901 before the electric tram service would reach the Bull Ring. The rest of the line to Fighting Cocks was eventually opened on 9 January 1902. *J. Hughes collection*

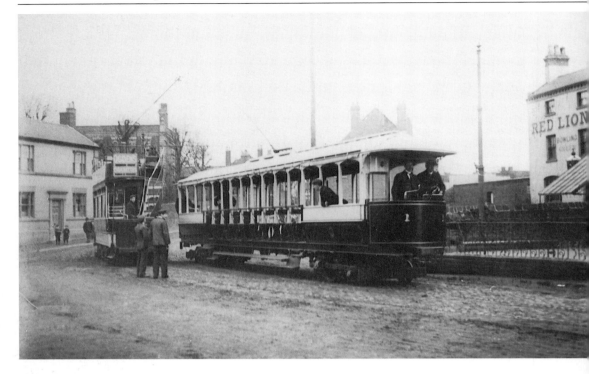

Above Sedgley's Bull Ring at the beginning of the 1900s still had Hilton and Caswell's Georgian farmhouse in High Street standing in front of the farm outbuildings and their builders' yard. High Street leads away from the Bull Ring and climbs up the hill beyond Bilston Street before beginning the long descent towards Parkfields and Fighting Cocks. To the right are the railings in front of Zebulon Butler's Fancy Repository, then the yard of the Red Lion Inn. Beyond that, above the single-decker tram, is a row of houses built in the last years of the 19th century to replace an old farmhouse. The Red Lion was Sedgley's coaching inn, having been built about 1750 on the turnpike between Wolverhampton, Dudley and Birmingham, and remains today as an impressive public house.

One of the original Wolverhampton District 1-13 class of four-wheelers built by ER&TCW with short canopies and to a three-window design has arrived in Sedgley from Dudley in about 1902. This double-decker is in company with a distinctly unusual arrival, Kinver Light Railway single-decker car 1, an open-combination maximum-traction-bogie tram built for the KLR by the Brush Company of Loughborough and delivered in time for the Easter holiday services of 1902. Kinver developed as a turn-of-the-century 'tourist' centre at the edge of the spectacular Kinver Edge – a sandstone ridge that still affords today pleasant walks through wooded hills – and traffic was thus extremely seasonal, Bank Holidays and weekends in those balmy Edwardian summers being extremely busy. By contrast, the winter services on this rural route were restricted to a skeleton service.

Car 1, painted in Munich lake and cream livery, was one of three similar trams that, with their turtle-back roofs, bore more than a passing resemblance to the three original unvestibuled 38-seaters supplied in 1893 by G. F. Milnes & Co to the Douglas & Laxey Coast Electric Tramway on the Isle of Man. The main differences were that the Kinver cars were much longer at 44ft 6½in, were originally unglazed and unvestibuled, but most unusually had an eight-bay toast-rack central section. There are no leaves on the trees, so this is probably autumn 1902, suggesting that the Stafford Street link line in Dudley between the Dudley & Stourbridge Company tracks in High Street and those of the Wolverhampton District Company in Wolverhampton Street had been opened, otherwise the Kinver tram would have had to have travelled to Sedgley via Tipton, Wednesbury, Bilston and Fighting Cocks. Later the tram was taken over by the D&S and was renumbered 49, surviving until the KLR closed in February 1930 as a result of competition from Midland Red buses and affordable motor cars. The appearance of the men on the single-decker suggests that this was probably a route clearance trial. The Kinver Light Railway ran these trams on excursions and Sunday School specials, but their length and the D&S enclosed 'Cradley' bogies rather restricted their use on parts of the Black Country system. *B. Baker collection*

Opposite page Standing in a similar spot, the driver of trolleybus 415 (DUK 15), working on the 58 route to Dudley on 31 March 1961, patiently waits at the 'utility'-type bus shelter to receive the signal from his conductor to proceed. On the forecourt of the Red Lion Inn on the right is a Ford Zephyr Mk II 206E, a Ford Consul Mk II 204E and a rear-engined Renault Dauphine. On starting, the trolleybus will take the overhead to the right, which will take it into Dudley Street. The overhead around the traffic island in the middle of the Bull Ring was used by shortworking trolleybuses turning back to either Wolverhampton or Dudley. Just off the picture to the left is the Clifton Cinema; opened in 1937 and after many of its latter years being used as a bingo hall, it was converted in 1998 into a cinema-theme public house.

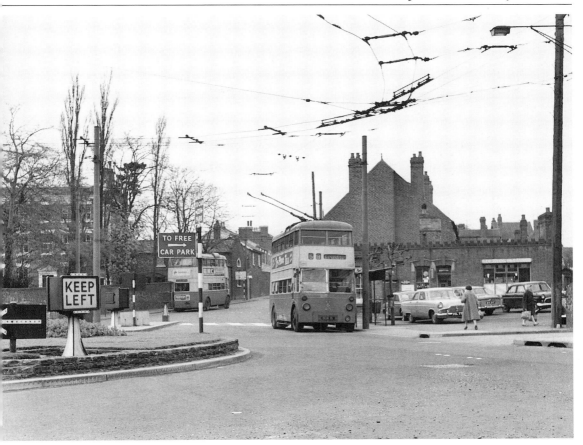

Trolleybus 415 entered service in July 1945 with a wartime Park Royal body and was one of 16 such trolleybuses rebodied in 1952, again by Park Royal; by 1961 it had another four years of service in front of it. Parked in High Street alongside the wall of the Manor House and travelling towards Wolverhampton is an FJW-registered Guy BT trolleybus.

By 9 July 1999 the Bull Ring in Sedgley is recognisably the same as when trolleybus 415 was waiting at the stop outside the Red Lion Inn, and it is even identifiable as the same place at which the first electric trams arrived on 24 August 1901. Yet, as Travel West Midlands MCW 'Metrobus' II 2492 (POG 492Y) passes the forecourt of the Red Lion, very little actually remains except for the road layout, although the traffic island seems to have shrunk between 1961 and 1999. The shops on the right next to the Vauxhall Rascal van are those that in 1901 were occupied by Zebulon Butler's Fancy Repository. In High Street, the Manor House as well as Hilton's farmhouse have long since disappeared, to be replaced by the

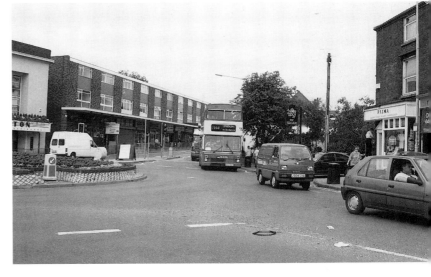

unadventurously styled block of shops. The Clifton Cinema building can now be seen, and having survived its long sojourn as a bingo hall is now a 1930s theme pub, styled as a cinema. *J. C. Brown/D. R. Harvey*

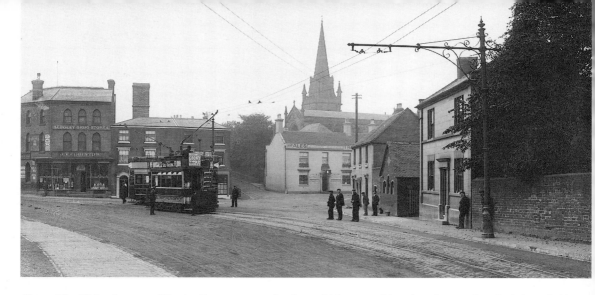

Above The Wolverhampton District Company completed the electrification of its route between Dudley and the Wolverhampton boundary at Fighting Cocks on Friday 9 May 1902. Not long after, in the summer of that year, two of that company's electric tramcars wait in the passing loop of Sedgley's Bull Ring. The smaller three-windowed, open-top tram carrying the advertisements for McDougall's self-raising flour and Cook's Drapery Store in Dudley is car 13. This was the last of the 13 trams ordered from ER&TCW by the previous Dudley & Wolverhampton Tramway Company, and is painted in a Munich lake and cream livery, a colour scheme much favoured by tramway operators of the period. It is facing Dudley Street and will eventually carry on to Dudley. Behind it is car 21, one of the large 70-seat trams built by the Brush Company of Loughborough in 1902. They were mounted on reversed Brush 'B'-type maximum-traction bogies, which was intended to allow the bodyweight to be over the driving wheels, but which frequently caused flat spots on the pony wheels. Derailing was also a problem on the frequently indifferent Black Country tram tracks, which were subjected to the vagaries of mining subsidence. Behind the tram is J. T. Egginton's Sedgley Drug Store, which dominated the corner of Dudley Street and the Bull Ring from the late 1880s until it was demolished in 1971. Next to it, masked by the tramcars, is the local doctor's house. Beneath the spire of All Saints, the Parish Church of Sedgley, much rebuilt in 1829, is the Georgian-fronted Court House. Although this had become an inn during the 19th century, it had originally been the manorial court house. Indeed, for many years, rather strangely, it was used concurrently for both functions until 1925, when it heard its last case. *J. Hughes collection*

Below Looking across the Bull Ring from the Red Lion Inn yard in about 1928 shows how little the centre of Sedgley has changed in nearly 30 years. Egginton's shop has hardly altered, while the doctor's surgery next door has become a tobacconist and sweet shop, although it had been a greengrocery just after the end of the Great War. Next door again is the large grocery store owned by the splendidly

named A. Sproson Vinrace, whose shop frontage is totally masked by the Ford Model T lorry speeding on its way to Dudley. Looking imperiously over this scene is the tower of All Saints Church, providing religious comfort and stability, while the Court House has only recently ceased its judicial role and is now more concerned with the needs of the inner man. Outside the butcher's shop of Carni Fox, whose slaughterhouse is behind the premises, a queue of people wait to board the single-deck trolleybus that will take them to Wolverhampton; it is 26 (UK 626), a 1926 Tilling-Stevens TS6 fitted with a Dodson B36C body, which has recently been fitted with pneumatic tyres. These 50hp trolleybuses were hardly elegant-looking beasts, but they were reliable, and gradually their spartan presence on the route was accepted as something of an improvement over the trams. Just behind the trolleybus is a Midland Red SOS 'S'-type 32-seater single-deck bus.

This will have come from either Penn or Wombourne by way of Gospel End through the narrow entrance into the Bull Ring in front of the Court House. *J. Hughes collection*

Below Looking across the Bull Ring from opposite the Court House (off the picture to the right), at the junction of Gospel End Street and Ettymore Road, reveals how little the centre of Sedgley has changed after another 35 years! On 27 July 1964 Sunbeam W4 trolleybus 411 (DJW 941), a Park Royal-rebodied vehicle, has descended Dudley Street and is about to negotiate the large traffic island that by this date seems to be occupying all of the centre of the Bull Ring. It is being followed by a Hillman Super Minx, while travelling in the opposite direction is a Triumph Herald Estate. Behind the 1962 Ford Zephyr 4 saloon is Egginton's much-expanded shop, which by now has taken over the whole block and has become Sedgley's answer to ... well, not quite Rackhams, but it is far nearer a small department store than the chemist's shop it had been 60 years before. The whole of the shop frontages from Dudley Street to the corner of Dean Street were modernised at the turn of the 1960s and it was a great pity that this block was demolished in 1971. The premises behind the traffic island, which at one time had housed Butler's Fancy Repository and Roden's bread and cake shop, are occupied by Lloyds Bank, Clarke's Radio and the Tipton & Coseley Permanent Building Society. Small, locally based mutual building societies such as this were based around the Black Country towns, and were perhaps considered to have a better personal savings and investment service than the large national banks. Clarke's, meanwhile, is offering Murphy televisions for rental as well as offering radios and electrical goods from the long-forgotten Ecko company. *J. C. Brown*

Behind the tram at the top of the hill is the Grand Junction Inn, dating from the first years of Queen Victoria's reign; its name is a reference to the railway company that built the first main line between Wolverhampton and Birmingham. It occupies the corner of High Holborn to the right, leading towards Dudley some 3 miles away, and Tipton Street, which passes through Woodsetton, home of Holden's brewery, Swan Village and Tipton. The double-fronted shop on the left has windows more redolent of the Bronte period, while two little lads, both in knickerbockers, are the epitome of 1890s Black Country fashion. It is noticeable that most of the houses in the street are equipped with large wooden shutters on their lower-floor windows. Hiding in the archway is a young boy and a dog, but what is that hanging on the hook on the side of the front door next to the archway? Could it be a ham joint? *D. R. Harvey collection*

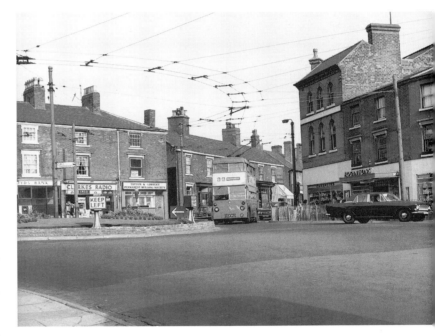

Bottom In the last years of the 19th century the best way to travel by road public transport between Dudley and Wolverhampton was by steam-tram. Although much maligned as 'fire-spitting monsters' and 'dirty smelly things' by proponents of the electric trams that would succeed them, throughout Birmingham and the Black Country steam-trams successfully pioneered cheap and reliable street tramways for just over 20 years. When kept in good working order, the small four-wheeled steam locomotives, with their roof-mounted condensing apparatus, enclosed wheels and tall chimneys, were briefly the wonder of their age. Here one of the Dudley & Wolverhampton Company's five Kitson steam trams pulls its rebuilt double-deck Starbuck trailer down Dudley Street towards the Bull Ring.

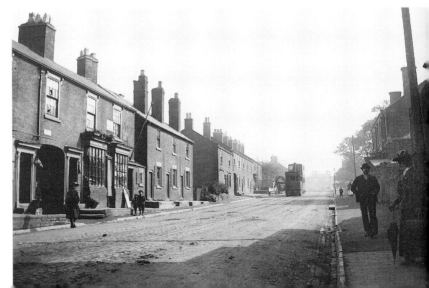

Below Standing in Vicar Street, Sedgley, in the shadow of All Saints Church at the beginning of July 1960, during its one week of demonstration, is Wolverhampton Wanderers' yellow-and-black-liveried Guy 'Wulfrunian' FDW, 8072 DA. In the front nearside windscreen is a paper label that simply states ON HIRE. 8072 DA was the second 'Wulfrunian' to be built and was bodied by Roe with an H41/31F body whose capacity was reflected in the registration number. The bus has worked into Sedgley on the 64 service to Straits and Gornal Wood. The driver's slouched pose could suggest exhaustion, as the independent air front suspension, when being driven with a full load, contributed to extraordinarily heavy steering. *S. R. Dewey*

Bottom Travelling along the tree-lined Dudley Road from Upper Gornal towards Sedgley on 29 July 1964 is trolleybus 646 (FJW 646), a 1950 Guy BT with a Park Royal H28/26R body that would be withdrawn on 8 August 1965. It is obviously a pleasant summer's day as the trolleybus passes The Ridgeway on a section of road that runs along the Sedgley-Northfield ridge, along the south-west side of the Upper Tame Valley and forming part of the main watershed of England, as well as separating the two main sections of the Black Country. It is made up of Silurian limestones and shales, which have several peaks, including Sedgley Beacon, Wren's Nest Hill, Castle Hill in Dudley and the highest eminence at Turner's Hill, which rises to 866 feet. To the right, the land falls away very steeply down an escarpment towards Baggeridge and Cotwall End. This area to the north-west of Sedgley was one of the last parts of the South Staffordshire Coalfield to be exploited, with Baggeridge Colliery opening in 1905 and only closing on 1 March 1968. The result was that this area retained its agricultural nature, as industrial development had already reached its peak in the existing areas further south and east of the ridge. By way of contrast, the Tame Valley, on the east side of the main road, slopes away more gently towards Coseley and Tipton and into the heart of the area that developed during the Industrial Revolution to become known as the Black Country. This section of Dudley Road was developed in the second half of the 19th century as a high haven away from the coal-mines, iron smelters and heavy industry, and as a result many large villas were built here. It also marks the end of another curious local phenomenon; photographs of

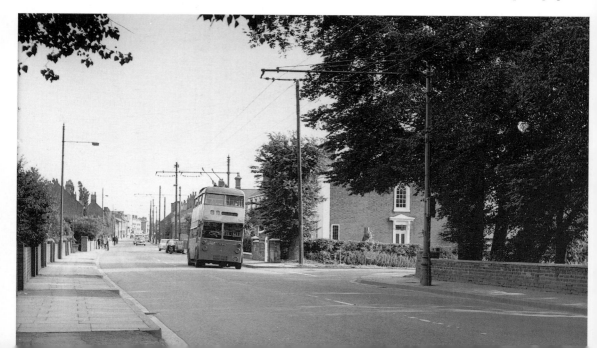

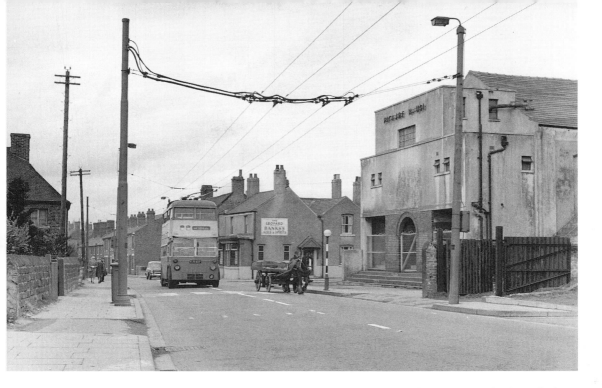

trolleybuses coming into Sedgley up the hill from Fighting Cocks show that some of the surviving older houses and a lot of their boundary walls are made from the locally quarried limestone. On approaching Upper Gornal, these stone structures die out quite rapidly, so marking the southern boundary of this method of construction. *J. C. Brown*

Above Continuing towards Upper Gornal in Dudley Road, the main A459, Guy BT trolleybus 637 (FJW 637) overtakes a slow-moving horse and cart on a zebra crossing outside the derelict Picture House, one of the first silent cinemas in the area. Despite its closure over 40 years ago, the building is still in use as a showroom and warehouse for County Wallpapers. Between the cinema and The Leopard pub, which today is still a thriving Banks's house, is Valley Road. It was in Valley Road, behind the site of the much later cinema, that the Dudley, Sedgley & Wolverhampton Tramway opened its depot for the horse-tram service in May 1883, but it was later used by the Company and its successors for steam and electric trams. After being taken over by Wolverhampton Corporation, it was closed for three years between 30 November 1927, when the last trams ran, and February 1930. On re-opening it became a trolleybus depot for another eight years. Above the trolleybus are the electrical feeder cables for this section of the route, which were fed from a nearby electric rectifier house next to Sedgley depot. To the left are two walls constructed from the local Silurian limestones. *J. C. Brown*

Below The re-opening of Sedgley depot for the trolleybuses working on the 8 route on 10 February 1930 caused a major operational problem. As the depot's yard was to small too allow the trolleybuses to turn around, a simple expedient was the installation of a turntable. Of the four trolleybus turntables used on systems in the UK, Wolverhampton had two, the other being in Bilston depot yard. The other two were at Longwood in Huddersfield and at Christchurch on the Bournemouth system. Being manoeuvred on the turntable is six-wheeled trolleybus 51 (UK 5951), a Guy BTX with a 60hp Rees-Stevens Turbo motor and a Dodson 61-seater body fitted with an enclosed staircase. It was one of the first trolleybuses in the fleet to be equipped with front-wheel brakes, and entered service in November 1928. It was sold for scrap to Cashmores of Great Bridge in October 1938, coincidentally the same month that Sedgley depot was finally closed. *D. R. Harvey collection*

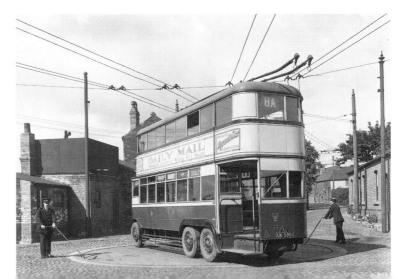

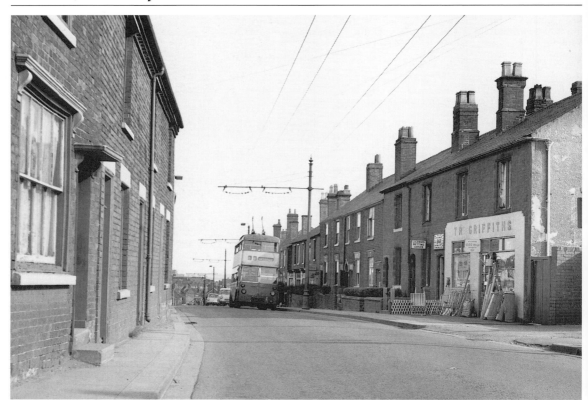

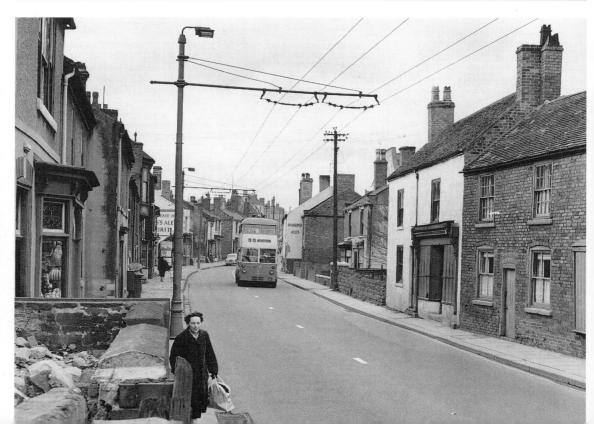

Left Taking the turn from Clarence Street, Upper Gornal, into Dudley Road near Moden Hill on 27 July 1964 is Sunbeam W4 trolleybus 417 (DUK 17). Its chassis was delivered to Wolverhampton Corporation in July 1945, and it was the last of 16 trolleybuses to be rebodied by Park Royal, re-entering service in this guise on 7 May 1952. The trolleybus has climbed up Clarence Street from Upper Gornal and is passing through an area of Victorian terraced houses; those on the left opened straight on to the street and have long since been demolished. T. R. Griffiths, an ironmonger selling Esso Blue paraffin – remember the television advertisement cartoon for 'The Esso Blee Dooler'? – has all manner of galvanised ironware, trellises and deck-chairs displayed on the pavement. Today it is a fish and chip shop. Next door is the local bookie – remember that only a few years earlier off-course betting and 'running a book' had been illegal. This was a road of public houses, which was no accident as throughout the 19th century the whole of Upper Gornal was devoted to coal-mining and the extraction of iron-ore, limestone and sand. This hot and sweaty work demanded that cheap refreshment was made available, so the 'home-brew' house grew up. In areas where there were iron-smelting furnaces, the factory employed a pot-boy whose sole job was to go to the local home-brew house with a large flagon, get it filled with beer and return to the sweating workers to refill their mugs with the foaming brew. To the right of Mr Griffiths's shop was the Cottage of Content pub, which is now a delightful Mediterranean-style restaurant, the Cafe Casita, while opposite the trolleybus is the Jolly Crispin, the oldest pub in Upper Gornal today. *J. C. Brown*

Below left Trolleybus 651 (FJW 651), a 1950 Park Royal-bodied Guy BT, is on its way through Upper Gornal going to Dudley in 1961, and has just passed the C of E Parish Church of St Peter, built in 1838 in Kent Street. It is a sobering thought that, when built, this church was serving a parish of basically agricultural farmland with a few mines and quarries scattered across it. Originally Kent Street was called Sheepcot Walk, a name reflecting the type of agriculture that took place in the area. In the early 1870s the better-sounding present-day name was somewhat curiously substituted. Near the church on the right is a Hanson's public house, while nearly opposite is the Shakespeare Inn, dating from about 1830; at the time of writing, this Bank's house is closed, awaiting a buyer. On the extreme right is the Britannia Inn, originally built in 1780 as a row of cottages but which by 1832 had become yet another of the 'home-brew' houses that lined Kent Street and Clarence Street. Known as 'Sallies', this old hostelry is presently owned by Batham's Brewery, which is interested in resuming permanent brewing at the pub. A peculiarity of Black Country pubs of this age is that there was frequently a butcher's shop next door, which is still the case today at the Britannia Inn.

The green and yellow trolleybuses were a breath of fresh colour in an otherwise fairly drab industrial area. Upper Gornal's growth was dependent upon the wide variety of nearby extractive industries and their associated metal trades. The area was well-known for its fireclay, which was made into bricks at kilns such as those nearby at the Jews Lane junction. To the west of Upper Gornal in the Dibdale and Lower Gornal areas were a number of collieries, the last of the open-cast mines remaining open until 1974. Additionally the area developed nail-making and chain-making industries as well as the manufacture of fire-irons and bellows. The spin-off today is the large number of old malthouses in the area, masquerading as pubs. *J. C. Brown*

Below At the Dudley end of Upper Gornal is the junction with Eve Lane, which goes northwards down a steep hill towards Coseley, while opposite, to the south-west, Jews Lane links Upper Gornal to Lower Gornal. It was in the throat of Jews Lane that the last trolleybus turning circle before Dudley was to be found. The conductor of Guy BT trolleybus 495 (FJW 495) stands by with the bamboo trolley-pole as his driver squeezes his charge around the tight turning circle on 2 May 1961. Photographs of trolleys making this manoeuvre are extremely rare; indeed, this turning circle was about all that was left of an interesting extension to the Wolverhampton trolleybus system that was never constructed. As part of the September 1935 Committee meeting, it was proposed to build a new trolleybus route from the Jews Lane junction via Robert Street, Lower Gornal, and Zoar Street to Abbey Street, Gornal Wood. A Ministry of Transport officer inspected the line of the route and required that trolley vehicles would have to have special braking arrangements in order to operate down the steep hill. Despite having Sedgley UDC's backing, Midland Red's objections were enough to persuade the Corporation to withdraw this section of the 1936 Parliamentary Bill, and as a result Lower Gornal never got its trolleybus service. The turning loop was outside the Green Dragon public house, and the normal early morning shortworking that used it was given the service number 61. Behind the trolleybus, silhouetted against the skyline, is O'Neill's Machine Company, built on the site of one of Upper Gornal's old brickworks. One of the area's last brickworks is to be found today at Shut End to the south-west of Gornal Wood. *J. C. Brown*

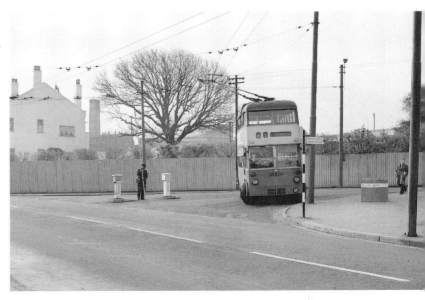

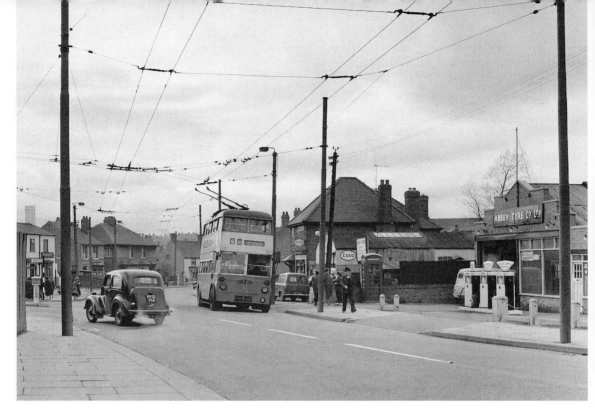

This page Sunbeam F4 618 (FJW 618), a Park Royal H28/26R-bodied trolleybus delivered to Wolverhampton Corporation in March 1949, pulls away from the last bus stop in Kent Street, Upper Gornal, which in a few yards becomes Burton Road. The smoking Dudley-registered car about to turn into Jews Lane is a very late Ford Anglia E494A 8hp first registered in April 1954. As well as tyres, the Abbey Tyre Company on the right also sells Cleveland petrol from three pumps belonging to the pre-self-service age. Next door is another garage, which not only undertakes body repairs, but also sells the rival Esso petrol. On the extreme left is the Green Dragon public house, where the overhead loop at the junction of Jews Lane is visible.

By 30 June 1999 the Abbey Tyre Company has been demolished, while the corrugated building next to the shop owned by Chad body repairs has lost its facility to sell petrol. Yet despite the passage of nearly 30 years, the junction in Kent Street is still recognisable. On the other side of the road the utility bus shelter has been replaced by a much more substantial structure. The bus working on the 558 route is Travel West Midlands MCW 'Metrobus' Mk II 2521 (POG 521Y). The 73-seat 'Metrobus' was first bought in 1979 by its original operator, West Midlands PTE, and was the PTE's standard double-decker in both its Mk I and Mk II guises until Metro-Cammell closed its doors on bus building at Washwood Heath in early 1990. *J. C. Brown/D. R. Harvey*

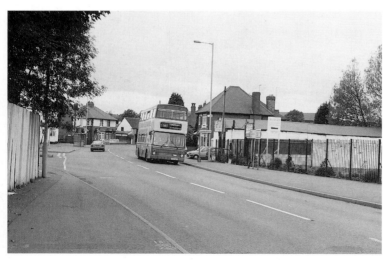

Above right When the trams were first introduced in 1901, the area between Upper Gornal and Shaver's End on the outskirts of Dudley was still agricultural. At first this might appear to be surprising, as the area was known for its intensive mining, mineral extraction and brickmaking, yet this was an anomaly found throughout the Black Country. Large areas between the villages and towns, as well as between the areas of mineral extraction, were still rural, essentially remaining as agricultural land until well into the post-war period. In fact, along this part of Burton Road the only significant cluster of buildings was at Woodseller's Farm. Burton Road runs south-east along the ridge between Sedgley and Dudley at a height of over 700 feet, and the last

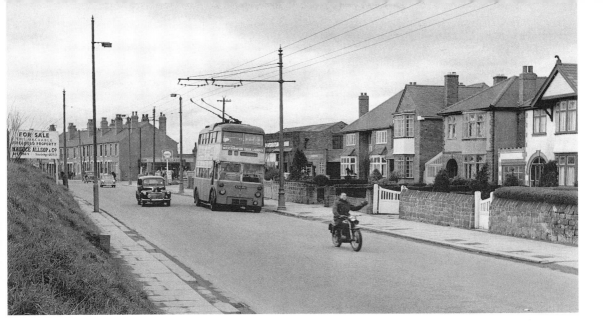

development took place in the Edwardian period. The distant terraced houses, standing behind the approaching Mini and 'sit up and beg' Ford Anglia, mark quite a dramatic end to 'industrial-type' housing. Nearer are the 1930s bay-windowed detached and semi-detached houses that begin around Old Park Road and continue along Burton Road towards The Broadway, which was officially opened on 1 May 1935 as a by-pass from Castle Hill. For those old enough to remember, some of these houses could have been models for a child's 'Bayco' Building Set – about Kit 3. The motor-cyclist is either waving at the camera or indicating to turn into Old Park Road; he is riding without a crash helmet – most exhilarating but potentially dangerous. Together with the Vauxhall Velox LIP, he has just overtaken Dudley-bound Sunbeam F4 trolleybus 614 (FJW 614), which had an 8-feet-wide Park Royal H28/26R body. *J. C. Brown*

Superintendent. In the spring of 1964 the re-wiring of the Burton Road section is being undertaken using Guy 'Warrior' tower wagon 2 (WDA 302); built by Robinson, a Wolverhampton bodybuilder, it entered service in 1959, and after the formation of the WMPTE was used on the former Walsall Corporation trolleybus system. Roe-rebodied Sunbeam W4 trolleybus 445 (EJW 445) inches its way past running on the wrong line; this was the final rebodied Sunbeam W4 to re-enter service on 14 February 1962, but unfortunately it was withdrawn after an accident on 18 January 1965. In the right background is the roof of the impressive Burton Road Hospital, built in 1859 as the Dudley Union Workhouse and finally demolished in 1997 to be replaced by a large prestigious Bryants housing development. Unfortunately, it was discovered that the old Workhouse had itself been built over some 19th-century infilling and the resultant methane had to be extracted from the site. *J. C. Brown*

Right A meeting of the Wolverhampton Council in March 1961 formally approved the decision to gradually replace the extensive trolleybus system because of the impending need to renew many of the trolleybuses and the somewhat time-expired infrastructure. This decision was inevitable as British trolleybus chassis construction had dwindled to virtually nothing, and one of the major suppliers of electrical overhead, Alfred Wiseman of Birmingham, had recently withdrawn from the market, leaving only British Insulated Calender Cables (BICC) still manufacturing overhead wire. In order to keep routes with a long life expectancy in working order, the span wiring from abandoned routes was re-used. Unfortunately, the condition of the wiring on the whole Dudley route had deteriorated so much that it had to be replaced within two years of the intended final closure, much to the annoyance of Mr Eric Ball, the Corporation's Overhead Line

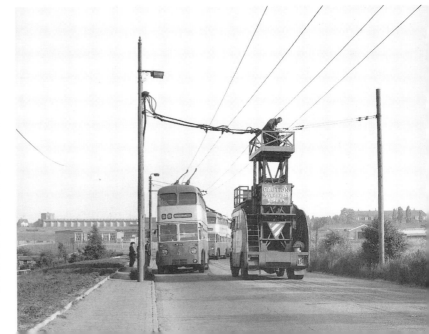

Top It is 1968 and 202 (MDA 202E), one of the Strachan-bodied 21 Guy 'Arab' Vs that had entered service in March 1967, travels into Dudley on the 58 service. Although only a year old, the upper saloon panelling is showing signs of rippling, always a bad sign that all is not well under the surface. These Strachan bodies were really dire and it was a measure of the 'good old reliable' Guy chassis that this bus, after withdrawal in 1973, finished up being exported to the China Motor Bus Company of Hong Kong in 1974, being initially rebodied in 1975 with a CMB H45/33D body, then again by Alexander in December 1982. The impressive structure behind the bus is the Shaver's End pumping station and reservoir, built in 1929. The South Staffordshire Waterworks Company reached Dudley with fresh water supplies from its abstractions in the Lichfield area in 1862. This was in response to cholera epidemics that hit the Dudley area in 1832 and 1849 when local supplies became adulterated with raw sewage. Necessary renovation of Shaver's End occurred throughout the late 1990s, as it still serves the area as one of the highest points from which fresh water supplies are resourced. Behind the bus is Burton Road Hospital with its impressive iron-railing-topped walls. In its Workhouse days, this had been the boundary of Dudley Borough; in late 1902 Wolverhampton District Electric Tramways operated a shuttle service of about a mile from the GPO terminus in Wolverhampton Street to a passing loop outside these same walls, a destination referred to as the 'Workhouse Gates'! *P. Roberts*

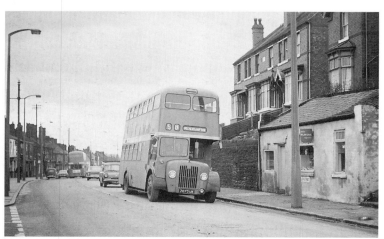

Middle The section of the route between Shaver's End and Eve Hill along Salop Street has changed out of all recognition since the abandonment of the 58 trolleybus route. About to leave the bus stop opposite Nith Place is Weymann-bodied Guy 'Arab' V 73 (7073 UK), which entered service in June 1963; it is on the 58 service and left Dudley's Stone Street terminus only about 3 minutes earlier. Following the bus is a Ford Anglia van and a Ford Zephyr 4 Mark III 211E. This area of Dudley was developed from the 1840s, and, by the time the WDET electric trams were introduced in 1901, Salop Street had become an area of tightly knit terraced houses and shops that not only lined this main road, but also a complex of side streets. The five elevated houses survive in much the same condition at the time of writing, as does, perhaps surprisingly, the little shop with the Players cigarette advertisement on the right. Hidden by the bus is the British Oak public house, which, in true traditional Black Country style, still brews its own beer. The properties on the left, being passed by the motorbus travelling into Dudley, were demolished as the old Dudley Teacher Training College expanded; today it is the Dudley campus for the University of Wolverhampton, but is scheduled to close in 2002. *P. Roberts*

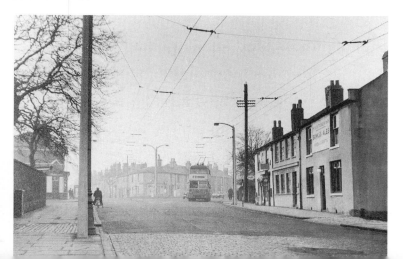

Opposite bottom Coming into Dudley from Salop Street at Eve Hill and passing St James's Church at the top of Wolverhampton Street in late 1958 is an 8-foot-wide Park Royal-bodied Guy BT trolleybus. St James's was consecrated in 1840, and stood virtually isolated on the top of Eve Hill; by the mid-1870s housing had developed along Salop Street towards Shaver's End, effectively surrounding the church. The trolleybus has just negotiated the Himley Road junction, lined by Victorian terraced housing behind which is St James's Junior and Infant School, Eve Hill, which survives today at the superb Black Country Living Museum, having been dismantled brick by brick and re-assembled on the Tipton Road, Dudley, site. To the left, beyond the moped rider, the Grange public house stands on the corner of Grange Road; straight ahead is Himley Road, which drops very steeply off the Sedgley Ridge towards Lower Gornal. On the right is Ye Olde Struggling Man public house, which survives today as a fish and chip shop, though mercifully the bus-body-rattling cobbled sets in Wolverhampton Street have been replaced. *Dudley Local Studies Library*

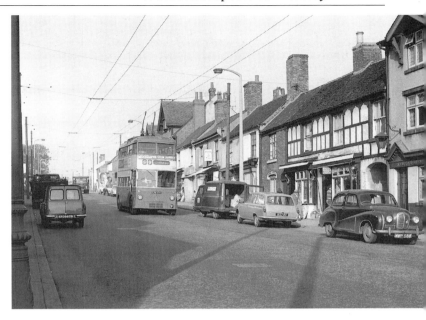

This page Wolverhampton could hardly be accused of not supporting local industry when buying trolleybuses. As well as purchasing Guys, it also bought 19 pre-war Sunbeam six-wheelers, 45 pre-war Sunbeam four-wheelers, 60 of the wartime W4 model and finally 49 post-war F4 vehicles. On 10 October 1964 the last Sunbeam trolleybus to be delivered to the Corporation, 630 (FJW 630), a Park Royal-bodied F4 model that entered service in May 1950, travels down Wolverhampton Street and approaches the angled junction at Stafford Street; Wolverhampton Street drops

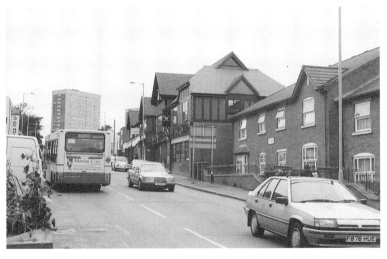

steadily downhill, losing nearly 50 feet in height in less than a quarter of a mile. In earlier days Stafford Street had tramlines that were originally installed to allow works journeys by the trams to Tividale, but by this time the corner was dominated by the local Midland Counties Dairy's distribution centre. The shop behind the Austin A40 Somerset on the right is a corn merchant selling 'Eltex Poultry Appliances'. In front of the Ford Cortina Estate is a Standard Atlas van, a model that never achieved the popularity of the Morris J2 or even the Thames 15cwt van; a personal memory of the Atlas is that it had the most appalling brakes! Within three years, replacing 192 sub-standard properties deemed unfit for further use in 1962, the three famous Eve Hill blocks of flats would be constructed, dominating the skyline behind the Austin FF series lorry until their spectacular demolition in 1999.

On 30 June 1999 a Wright-bodied Volvo B6LE of Travel Merry Hill, R596 YON, climbs up Wolverhampton Street towards Eve Hill and its famous flats, Prince of Wales Court, Millfield Court and Butterfield Court, claimed to be the highest structures west of the Ural Mountains in Russia. The flats achieved further fame when they were featured on the cover of the LP record *Led Zeppelin IV*. Three weeks later, on Sunday 18 July 1999, the two larger blocks, Prince of Wales and Millfield Courts, were blown up and reduced in 3 seconds to a huge mound of broken concrete in a spectacular controlled demolition. The Hanson's public house and the block that included the pet store were swept away in the early 1970s and the site is now occupied by Chaddesley Court, a recent sheltered housing scheme for the elderly. The tall gabled-ended building remains together with the rest of the three-storied houses on the left, despite having distinctly chequered recent careers. *J. C. Brown/D. R. Harvey*

Below Beyond Stafford Street, the descent of Wolverhampton Street lessens and the houses begin to funnel in on the narrowing thoroughfare, reflecting the older nature of this section between Stafford Street and The Inhedge. Guy BT trolleybus 604 (FJW 604), delivered in October 1949, passes the impressive Regency-styled frontage of the West End Hotel on 2 June 1961. It has recently left the Stone Street terminus on its way to Wolverhampton on the 58 service and has just passed a Dudley-bound, similarly Park Royal-bodied trolleybus. The West End Hotel was demolished when its lease ran out, which was doubly sad as for over 30 years the corner site in Stafford Street was never built upon and was only used as a second-hand car lot. At the time of writing the open space is abandoned and still 'publess'. All the buildings on the left and those opposite with the advertising hoardings remain today. The Rover P4 going towards Dudley town centre is about to overtake a parked Hillman Minx Series III and is following a Vauxhall Victor F, of the type that had the exhaust pipe coming out of the rear bumper. *J. C. Brown*

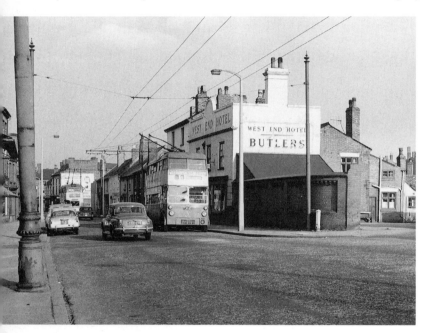

Below left Sunbeam W4 trolleybus 435 (EJW 435), one of those rebodied with attractive 60-seater Charles Roe bodies, has just passed The Inhedge in Wolverhampton Street, leaving Dudley on the 58 service during 1964, and is passing a series of Georgian and Victorian premises that were demolished later in the decade, including the large, impressive Dudley Institute building, built in 1863. In the background is the Crown Hotel, a splendidly 'inspired' piece of Victoriana, while on the opposite corner of Priory Street is the General Post Office. This building is only two years newer than the former Lloyds, Barnetts & Bosanquet Bank Ltd built on the opposite side of Wolverhampton Street in 1877, and which is still in use today as Lloyds-TSB's main branch in Dudley. At the Black Country Living Museum it is still possible to ride on a Wolverhampton trolleybus. A similar vehicle to this one, 433 (DUK 833), the last of the original 'utility'-bodied Sunbeam W4 trolleybuses delivered in 1946, has been beautifully restored by the Transport Group and is a real pleasure to drive, thanks to the efforts of John Hughes, Rob Smith, Keith Bodley and the late Dr E. R. Clark and others too many to mention. *J. C. Brown*

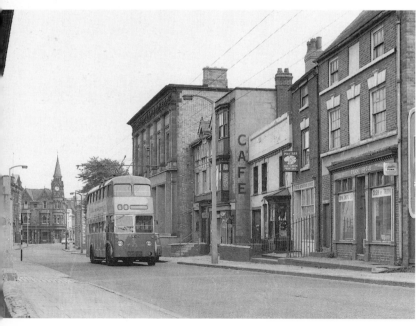

Opposite page above After his accession to the throne in January 1901, the Coronation of Edward VII and Queen Alexandra was postponed because of the King's acute appendicitis that necessitated an emergency operation just days before the original date. They were eventually crowned on 9 August 1902 and the country both celebrated his recovery and the event itself. The bunting and the Union Jack flags are in evidence along Wolverhampton Street, looking towards the distant WDET terminal stub opposite Parson's Street. Hidden by the tram and dominating the corner of The Inhedge is the graciously styled two-storey Queen Anne-period Finch House. With its eight bays and four-bay pediment, it was completed in 1707. On

the left is a row of impressive Georgian brick buildings leading towards the Post Office of 1879, although its stone front dates from its rebuilding and expansion in 1909. It was finally closed when a new post office was built in the redevelopment of the Market Place, and in September 2000 re-opened as Nulla Nulla, a bar and night-club. At the junction of Priory Street is the extravagantly styled Crown Hotel of 1898, with its etched and stained-glass windows, which, although renovated, lost its status as a hostelry and by 1999 had become the Crown Chippy, only to close in early 2000. In April 2001 it re-opened as The Spareroom, another new bar and night-club.

The electric tram route on which tram 30 is operating, to Sedgley and Fighting Cocks, was finally opened on 9 January 1902, and through running to Bilston was achieved on 14 July. Brush-built tramcar 30 entered service in 1902, and was a real giant for its day, being a 70-seater. These trams were open-topped with reverse staircases and had their Brush 'B'-type bogies fitted in the reverse position, with the small pony wheels leading. This caused the pony wheels to be regularly under repair for flat spots when they were working on the hilly Dudley route, and derailments were also more common. Eventually car 30, together its four class-mates, were re-equipped as four-wheelers with modified Brush AA trucks, which were extended to 10 feet long. *Dudley Local Studies Library*

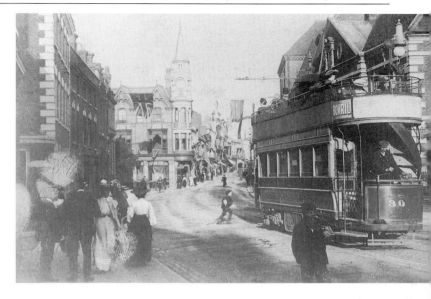

Right Looking in the opposite direction from the one-way section of Wolverhampton Street, with the Crown on the right, the impressive nature of the street's architecture can be appreciated. It contains some of Dudley's most attractive Georgian buildings, reflecting that for many years this was a prosperous residential area. Many of these 18th-century buildings have survived to the present day, although they are all now offices.

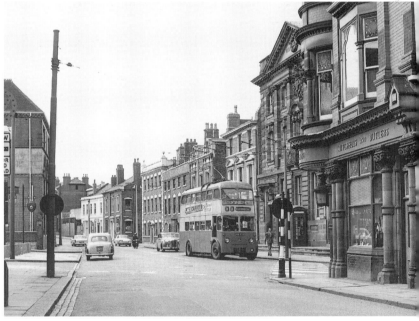

Sunbeam W4 428 (DUK 828), which was notoriously sluggish, was one of the eight trolleybuses rebodied by Charles Roe in 1958, and is turning slowly left in front of the Post Office into the narrow confines of Priory Street, which years later would become one-way, but away from town. The trolleybus is almost at the end of the long journey on the 58 service from Wolverhampton on 12 July 1964. The cars in this view represent a period of transition from those developed in the early post-war period to more forward-looking models. The silver Jaguar Mk VII, dating from the early 1950s, definitely belongs to the former category; with its 3½-litre engine it was capable of a 'genuine ton', but weighed just under 2 tons and handled like a tank. The car on the left is a Manchester-registered side-valve-engined Hillman Minx Phase IV, with a distinctly scaled-down 'American-styled' body, again representing late-1940s designs. In the distance, going out of Dudley, is a Ford Zephyr 4 Mk III 211E, built in about 1962. Following the Jaguar, having just passed Parson's Street, is one of Ford's great failures; ranking alongside the American Ford Edsel, the Classic 109E, with its Anglia-styled reverse-slope rear window and four headlights, was only in production between 1961 and 1963, as sales were very disappointing. It was something of a cul-de-sac as far as car development at Dagenham was concerned, being quickly superseded by the amazingly successful Mark I Cortina. *J. C. Brown*

Below Trolley 437 (EJW 437) is about to turn from Priory Street into its terminus in Stone Street. This Sunbeam W4 chassis was delivered in April 1947 but was rebodied with a Roe H32/28R in 1962, one of the last seven trolleybuses to be so treated. On the right is the present-day Dudley Art Gallery, which has been the home of some superb exhibitions in recent years, including displays on the intricate local geological structure and its subsequent exploitation in the Industrial Revolution. More surprising was an exhibition about the ill-fated White Star liner RMS *Titanic*, whose anchor and chains were made by Hingleys in nearby Netherton. The building was opened in 1884 and was the town's Free Library and School of Art as well as the Art Gallery. It originally had an ornamental mock bell turret above the stark-looking tree on the corner, but this extravagant piece of Victorian architectural 'rhubarb' was removed in 1953. The dials on the corner are a set of meteorological instruments donated in 1927 by James Smellie in recognition of his wife, who had been Mayoress during the previous year. In the background, in Wolverhampton Street facing Priory Street, is the site of Horseley House, a lovely three-storey 18th-century building in its own grounds, and the former home of the Hughes family. It was purchased by Dudley Corporation in 1955, pulled down in 1958 and replaced by a block of offices. *M. Collignon*

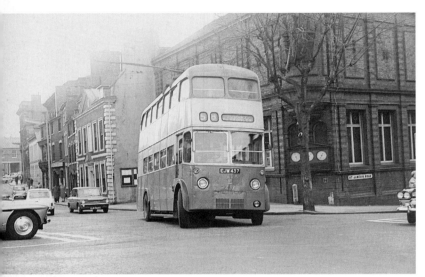

Below Journey's End! The Dudley terminus of the 58 route was situated in Stone Street, into which trolleybuses made a right turn from Priory Street. The building in the background is the Town Hall with its War Memorial Tower, opened on Tuesday 16 October 1928 by the Prime Minister, Stanley

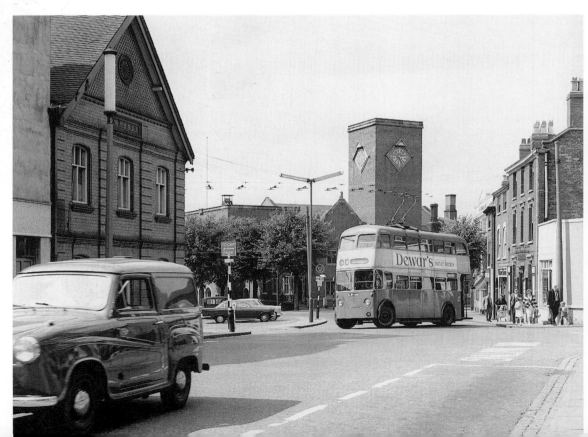

Baldwin. Trolleybuses coming from Wolverhampton unloaded outside the Saracen's Head and Freemason's Arms Hotel. This former coaching inn, with its impressive Regency front, was originally owned by the Hanson family; in the mid-19th century one of the family's daughters, Julia, inherited and ran the Dudley brewery in Stafford Street until her death in 1894. It was eventually acquired by Wolverhampton & Dudley Breweries in 1943, and was closed down in 1991. Turning into the terminus opposite the old Market Place on 12 July 1964 is Roe-rebodied Sunbeam W4 trolleybus 448 (EJW 448); this trolleybus entered service in December 1947, becoming one of the last of this wartime model to be delivered to a British operator before being succeeded by the F4 type. Despite its modern appearance, 448 would only survive until the closure of the route less than three years later. This attractive style of body was used by Charles Roe for the rebodying of trolleybus chassis between 1955 and 1962 and was supplied to four other operators. This vehicle was rebodied in 1961, and, without the Wolverhampton trademark of dented panels, it is about to reach the cobbled surface of the loading-up bay that also serves as a car park, as it does today. Parked facing Stone Street is a Ford Zodiac Mk II, while behind it is a Ford Consul Mark II 204E low-line model. The van travelling up Stone Street is an Austin A35. *J. C. Brown*

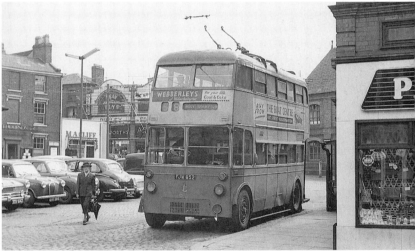

Top right The view from Stone Street, opposite the Fountain Arcade into the Market Place, shows the extent of this 'hidden' trolleybus terminus. Situated on the other side of Dudley's town centre from the main bus station in Fisher Street, the trolleybuses terminated their journey from Wolverhampton only about 200 yards from the Market Place. The long row of shelters stands against the old Fire Station, while the wooden building with the round-topped windows on the right had been the Public Weighbridge office, which would disappear in 1967 with the trolleybuses. Waiting on the cobbles for its departure time on 12 July 1964 is Roe-rebodied Sunbeam W4 442 (FJW 442), while parked in the almost empty car park is a Hillman Minx Series III and Ford Zodiac Mk III, both only about a year old. The Dagenham-built car was regarded as being a really fast, fairly cheap vehicle, being capable of 100mph with its 2½-litre engine. *J. C. Brown*

Above right The Stone Street Market Place was the site of a glasshouse until 1886, when it was demolished and replaced by fish and vegetable markets. Next door was the town's Fire Station, erected in 1892 but by about 1960 being used as a leather goods shop specialising in handbags. It was against the old Fire Station wall that the heavy-duty bus shelters were erected. To the left of the waiting trolleybus is the Fountain Arcade, opened in 1926. Stone Street was, like the rest of the area, originally mainly lined with Georgian buildings, some of which are on the left on the corner of Tower Street, but unlike those in Priory Street these were in such an appalling state that they were demolished. The centre of the cobbled square remains in use as a car park, and contains Austins aplenty: an A55 Cambridge of March 1959, an A35 van registered in Staffordshire of 1957, an A40 Somerset and a very rare A70 Hampshire, dating from July 1953. After this line of Longbridge products is an almost new white-painted Ford Popular 100E saloon and a Morris Cowley van. The trolleybus loading up for its return journey to Wolverhampton is 8-feet-wide Park Royal-bodied Guy BT 652 (FJW 652) of 1950, which would be withdrawn in 1965. That was a bad year for Wolverhampton's trolleybus system, as it saw the end of all the newest Sunbeam F4 and Guy BT trolleybus chassis when the jointly worked Walsall service was closed. *D. A. Jones*

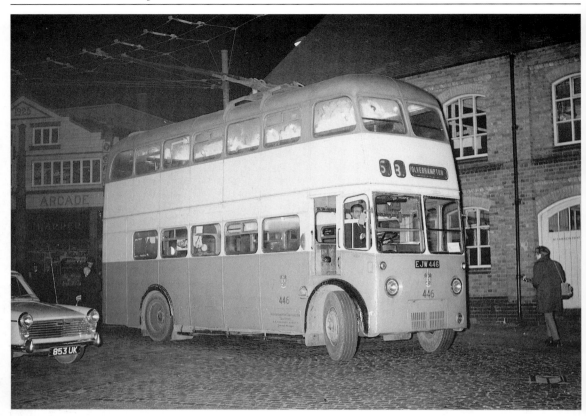

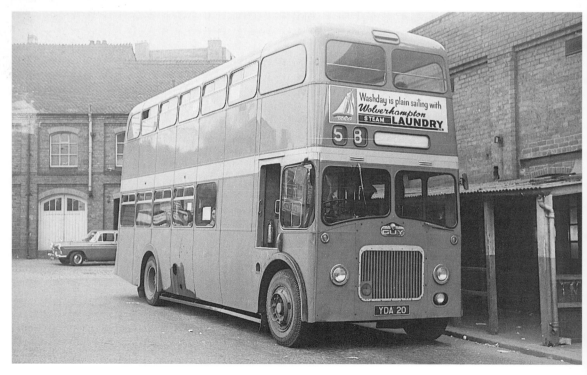

Left This really was 'The Last Trolleybus'. On Sunday 5 March 1967 trolleybus 446 (EJW 446) pulls on to the cobbles of Stone Street Market Place for the very last trolleybus journey to operate on the Wolverhampton system. This 60-seater Sunbeam W4 had only been rebodied by Roe in 1962 and in theory should have had many more years of life left in it. As the last trolleybus to work in Wolverhampton, it was retained by the Corporation for over a year inside Bilston depot for possible preservation. Unfortunately, it was sold for scrap to Gammells of Dudley Fields, Walsall, in September 1968. At 11.12pm 446 left Dudley and returned to Wolverhampton, and on its arrival in Cleveland Road was attached to the towing vehicle, which took it to Bilston depot for storage. The five trolleybuses inside the depot were reversed out and taken to a yard on Bilston Road. No 451 was the last trolleybus in Wolverhampton to be moved under its own power. The depot supply was then switched off. *J. C. Brown*

Below left Diesel buses took over the operation of the former trolleybus service on Monday 6 March 1967, but Corporation operation of the 58 route was only to last until 30 September 1969, when all municipal bus services were taken over by West Midlands Passenger Transport Executive. This rare view of a Corporation-owned bus working on the 58 service shows 20 (YDA 20), the first of 20 Guy 'Arab' IVs with Gardner 6LW engines, standing in Stone Street turning circle in 1968. These buses were the precursors of a massive order placed with Guy Motors in 1961 for 150 'Arab' IVs and Vs to replace the trolleybuses, although only the next 49 had this full-fronted body style. No 20 was fitted with a Metro-Cammell 72-seater body and entered service in December 1959; it remain in service, albeit repainted in WMPTE blue and cream, until 1975. *M. Collignon*

Off the beaten track

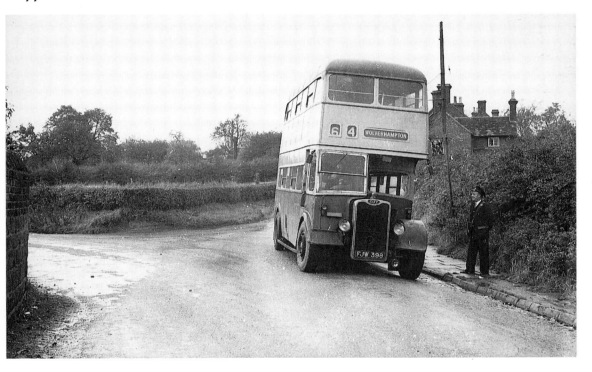

The terminus of the 64 route, which began operation in 1950, was in Straits Road at the junction with St Michael's Road, which is on the left. The route reached this country lane terminus having left Upper Gornal at Jews Lane and passing through Ruiton and Lower Gornal before heading out to Straits Green Colliery and on to the by now almost derelict Straits Farm, where it turned round in St Michael's Road. The farm can be seen behind the bus and was finally engulfed by the 1960s housing estates. The Straits terminus was in Midland Red territory, as agreed with that company in 1930. It is an interesting thought that if there had been agreement among adjacent Councils in about September 1935, a trolleybus service following this motorbus route might have terminated here (see page 43). As it was, the Corporation took over the operation of some of the routes in the area in January 1936 and further rationalisation resulted in this 66 route terminating in this rural setting. Even nearly 50 years later, although the road is lined with 1960s housing and extends into a large housing estate on the right, at the end of St Michael's Lane there are still open fields on this back-road route towards Himley. The bus is 398 (FJW 398), a Guy 'Arab' III 6LW fitted with a composite Brush body of May 1949, is standing at the terminus on a wet day in 1956. This was a most unusual combination of body and chassis, which in post-war years was only ordered by Wolverhampton and the Northern General group of companies based around Newcastle. *S. E. Letts*

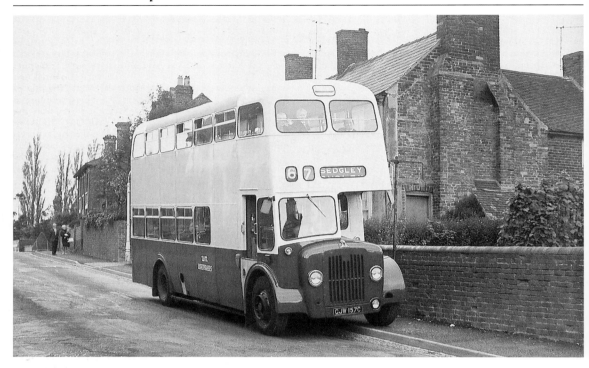

Above The 67 service, having crossed Penn Common, went by way of Gospel End on its way to Vicar Street, Sedgley. At Gospel End it passed near the entrance to Baggeridge Colliery, the last working deep coal-mine in the South Staffordshire Coalfield. Baggeridge was the 'swan-song' of coal-mining in the Black Country, being the last new colliery to be opened. At its peak it employed over 1,500 miners and survived until 1 March 1968, when geological problems rendered it economically unviable. Some 18 months later 157 (GJW 157C) stands in Gospel End before moving off to Sedgley and Lower Gornal. This bus was the first of the 25 Guy 'Arab' Vs of 1965, the only Wolverhampton example to be bodied in Birmingham by Metro-Cammell. It was also one of the very first ex-Wolverhampton buses to be repainted in the blue and cream livery of the newly formed WMPTE, with a khaki roof but the front and rear domes painted cream, a style that was not perpetuated for very long. This helps to date this photograph of the immaculate-looking bus to about November 1969. The cream-painted street light behind the bus was of a type found within the Staffordshire county boundary, and the old cottages have long since been demolished. Today, although still narrow, Gospel End Road has been transformed into the A463 road between Sedgley and Wombourne. *P. Roberts*

Below left Not long before Baggeridge Colliery closed, Weymann-bodied Guy 'Arab' V of 1965 vintage, 170 (GJW 170C), stands in front of the colliery buildings when working on the 64 route to The Straits. Baggeridge Colliery was opened in 1905 after the discovery of a rich 30-foot seam of coal on the western side of Sedgley Beacon at Gospel End. It had long been thought that the 'Brooch' and 'Thick' seams existed here, but it was only in 1902 that they were located at a depth of 2,000 feet. An example of just how extensive the mining based on this pit was is that the second Rose & Crown public house in Penn Village, built in the 1920s, had to be demolished 60 years later because of subsidence caused by the long-abandoned mine workings stretching from the colliery's pit-head some 3 miles away! The bus is loading up with colliery workers at the end of another shift in about 1967, and will take them into the 1950s housing development at The Straits before going on to Gornal Wood. *D. Nicholson*

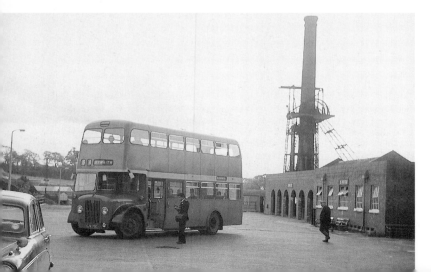

Penn and Oxbarn Avenue

The main Penn Road route was, like Compton Road, one of the few main roads leading from the town centre not to be operated by electric traction. A horse-bus service to the Rose & Crown Inn, on the corner of Church Hill, Penn, was started in 1882, operated from Queen Square by Sampson Tharme, who maintained the service until 1912. After certain attempts around this time to operate successfully along Penn Road to Kingswinford and Stourbridge, notably by C. L. Wells, on 20 May 1914 the Corporation began operating its 25hp Albion single-deckers on the route as far as Penn. Unfortunately, the four vehicles, numbered 3-6, were impressed by the War Department on Tuesday 27 October 1914 and the motorbus service was therefore suspended. It would not be until Saturday 18 August 1917 that the service as far as the Rose & Crown was re-introduced, using Tilling-Stevens TS3 petrol-electric single-deckers. Complicating the use of Penn Road is the fact that beyond the town boundary are important villages such as Wombourne, Seisdon and Trysull, and these were served at an early stage by the Great Western Railway and the fledgling Midland Red Company.

The main road route to Penn Village via Lea Road continued to be operated by the Corporation's single-deckers until the first of the new generation of six-wheeled normal-control Guy CX motorbuses were introduced in 1926, which although dramatically altering the service were considered to be inferior to contemporary trolleybus operation elsewhere in the town. As a result, on 10 October 1932 the Penn Fields service was extended once again along Stubbs Road, whereupon, reaching Penn Road, it turned right out of town and proceeded to Spring Hill Lane. This left the section of Penn Road from Lea Road to Goldthorn Hill, previously served by motorbuses, without any service operated by the Corporation with the exception of those going to the villages beyond the town's boundary. This situation remained until a new route to Oxbarn Avenue (32) was initiated on 11 February 1934. This was wired to go straight up Graisley Hill over the section of Penn Road from Lea Road as far as Rookery Lane, which had not been previously covered by trolleybus operation. At the Coalway Road junction, trolleybuses turned right and continued along Coalway Road, passing through an area of late-1920s housing, as far as its junction with Oxbarn Avenue and Warstones Road, which was destined to be served in later years by the 35 motorbus route.

On 8 April 1935 the main Penn Road service, numbered 11A, with the shortworking 11 to Mount Road, was instigated. This abandoned the Penn Fields 'loop' around Lea Road and Stubbs Road and followed the Oxbarn Avenue 32 service wiring as far as Goldthorn Hill before embarking on the long journey beyond the Rose & Crown Inn at Church Hill to the new, huge turning circle at the terminus at Spring Hill Lane. Whereas the Penn Fields tram and trolleybus service had always served an earlier Edwardian development, the Penn Road route initially served very little beyond the old village at Penn, although 1930s residential developments around Spring Hill and on the Warstones Estate to the western side of the by now extended trolleybus route rapidly provided the 11 service with sufficient revenue-paying passengers.

The Penn Road service left Victoria Square and headed through the town centre by way of Lichfield Street and Queen Square before descending Victoria Street and heading out through the mid-19th-century urban development through Worcester Street and into Penn Road. Here the route passed St Paul's Church before the junction with Lea Road, where the Penn Fields tram and later trolleybus service turned off the main road. It then climbed though a tree-lined section of Penn Road bounded by limestone walling, over Graisley Hill, with its impressive houses such as The Mount, before descending again, past the Royal

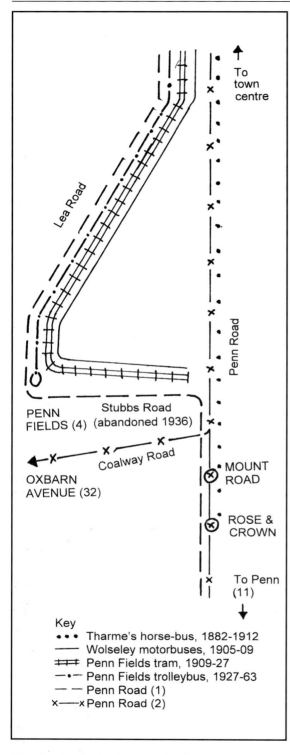

To town centre

Lea Road

Penn Road

PENN FIELDS (4)

Stubbs Road (abandoned 1936)

Coalway Road

OXBARN AVENUE (32)

MOUNT ROAD

ROSE & CROWN

To Penn (11)

Key
- ••• Tharme's horse-bus, 1882-1912
- ⸺ Wolseley motorbuses, 1905-09
- ╫╫╫ Penn Fields tram, 1909-27
- —•— Penn Fields trolleybus, 1927-63
- ‒ ‒ Penn Road (1)
- ×⸺× Penn Road (2)

Map showing the development of the Penn Road bus, tram and trolleybus routes (not to scale). See also pages 96-7.

Orphanage Grammar School, set in its own impressive grounds on the eastern side of the road, to the junction with, initially, Rookery Lane. This is opposite Stubbs Road, which had played an important part in the development of early motorbus and tram services and the first trolleybus services in the Penn Road area. Almost immediately afterwards is the Goldthorn Hill-Coalway Road junction. Up to this point along Penn Road the housing is almost exclusively impressive Victorian villas, but upon reaching Coalway Road the urban landscape changes dramatically, with early inter-war houses in the form of terraces, semi-detached villas and detached housing lining the road.

At Coalway Road the 32 trolleybus route to Oxbarn Avenue turned right and went through the last of the Victorian-built housing before emerging into an area of somewhat unusual 1920s semi-detached private housing. This continued to the terminus of the route at the junction with Oxbarn Avenue and Warstones Road. Here the 32 trolleybuses turned back at a traffic island, though at some time after its 1934 opening consideration was given to the route's extension to join up with the terminus of the 13 trolleybus service on Trysull Road at Five Ways, Merry Hill. The Oxbarn Avenue trolleybus route was the first on the Corporation's trolleybus system to be withdrawn, not being re-instated on 22 May 1961 after the resumption elsewhere of the trolleybus routes affected by the temporary closure of Victoria Street in the town centre.

The main road route along Penn Road, once beyond Coalway Road, soon reached the only turnback point on the overhead at Mount Road, which in pre-war days had been given the service number 11. Once beyond Mount Road and The Mount public house, the trolleybus route continued towards Penn Village and the old horse-bus and later motorbus terminus at the Rose & Crown public house at the junction with Church Hill. After 1961, the section from Pennhouse Avenue to Pinfold Lane, opposite Penn Hospital, was converted to dual carriageway and the old Upper Penn area, with its cluster of village shops and pubs, was lost, being subsumed into little more than an extension of 1930s and early 1950s suburbia. Lining the rest of the trolleybus route along Penn

Road to the row of very 1930s-looking shops at the town boundary at the Spring Hill Lane terminus was a somewhat piecemeal ribbon development that grew up throughout the 1950s and 1960s. This section of the A449 reflected that period as its growth was somewhat stifled by the impending redevelopment associated with the proposed widening of the road. Penn Road's outer section was only converted to dual carriageway after the demise of the trolleybuses on the Penn Road route, which occurred after 9 June 1963. The replacement bus service, operated by Guy 'Arab' IV and V double-deckers, remained virtually unaltered until the take-over of the Corporation's bus-operating assets on 1 October 1969 by the West Midlands Passenger Transport Executive. In addition, throughout the days of the operation of Wolverhampton Corporation trolleybuses along Penn Road, that service had been followed by the Corporation's country bus services to Wombourne, Trysull and Seisdon, as well as Midland Red's 'main-line' 882 bus service to Kingswinford and Stourbridge and its 883 and 884 services to Kidderminster via Wall Heath and Kinver.

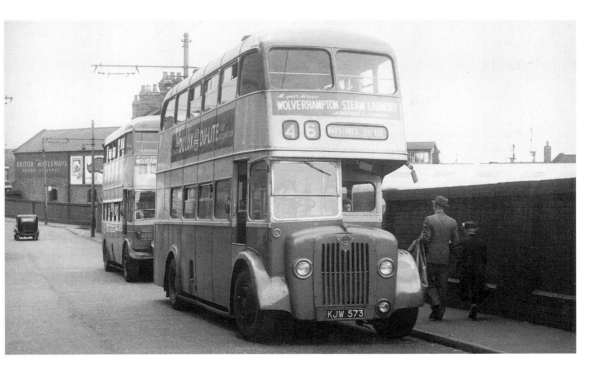

The Warstones Estate 46 motorbus service used Railway Street as its town centre terminus. Parked opposite the entrance to Chubb Street and the Chubb Building on 27 June 1957 is 573 (KJW 573); it is standing beneath the trolleybus wiring coming from Broad Street towards Victoria Square, which was usually used only for non-passenger-carrying operations. The double-decker is a 7ft 6in-wide Roe-bodied Guy 'Arab' IV with a Gardner 6LW engine. These four-bay composite-construction bodies were built on Wolverhampton Corporation's first buses fitted with concealed radiators. Behind it is an earlier Park Royal-bodied Guy 'Arab' III, also working on the Warstones Estate route. Over the wall to the right is the Birmingham Canal Navigation's basin and the Can Lane Wharf, which was the original name of this street. Beyond the canal are the elevated railway lines going to the North West from High Level Station. In the background, on Broad Street, is a British Waterways warehouse with a huge Guinness advertisement on its wall. *D. R. Harvey collection*

Below Looking in the opposite direction along Railway Street on 4 August 1962, the first of the 1949 batch of Sunbeam F4 trolleybuses, 608 (FJW 608), is standing alongside the splendid Chubb Building, which dated from 1899 and was the headquarters of the lockmaker of that name, for many years one of many based in the town. The trolleybus entered service on 3 March 1949, and its introduction coincided with the withdrawal of the Park Royal-bodied Sunbeam MS2s of 1935. No 608 was withdrawn on 3 November 1963 when the mass abandonment of the Amos Lane, Low Hill and Wednesfield trolleybus routes took place, causing an immediate surplus of vehicles. The policy was to withdraw the 8-foot-wide FJW-registered trolleys, as their composite-structured Park Royal bodies were rapidly becoming time-expired. This resulted in 608 becoming one of 23 Guy BTs and Sunbeam F4s taken out of service on that winter Sunday, having been used for the last time on the previous day. Immediately behind the trolleybus is Chubb Street and the amply proportioned Prince Albert Hotel.

The Birmingham registered Austin Eight car heading towards the distant Victoria Square is about to overtake Guy 'Arab' IV 49 (4049 JW), working on the Warstones Estate 46 service. *J. C. Brown*

Below left Trolleybus 481 (FJW 481), the last of the 1948 Sunbeam F4s, entering service on 6 November of that year, has left the town terminus in Railway Street and is turning into Broad Street working on the 11 service to Penn on 10 June 1962. This Park Royal-bodied trolley was exactly one year away from withdrawal, being one of 15 withdrawn after the abandonment of the Penn Road services. On the left is a 1962-registered Morris Minor 1000, and behind the trolleybus is the British Waterways warehouse, built alongside the Birmingham Canal just into Wednesfield Road. The warehouse was owned by Fellows, Moreton & Clayton, who were canal freight carrier; as well as owning many of the boats, a large number of their boat horses were also stabled here, used for hauling unpowered narrow-boats up the nearby flight of locks, the Wolverhampton '21'. Between the start of Wednesfield Road and the canal warehouse is the Broad Street canal bridge, built in 1879 and now residing in the Black Country Living Museum. On the railway bridge carrying the tracks from the High Level Station, and bearing a Butlers Ale advertisement, is a rake of carriages in the familiar ex-LMS dark red livery. *J. C. Brown*

Opposite above Having travelled up Broad Street, Park Royal-bodied Guy BT 498 (FJW 498) turns into Princes Square working on the 11 service to Penn on 8 August 1962. It would later become the last trolleybus to Penn Fields on Sunday 9 June 1963, the day on which Jim Clark won the Belgian Grand Prix at Spa. It was withdrawn on 8 August 1965 when the Bilston, Darlaston and Whitmore Reans trolleybus routes were abandoned. It is sales week at Berrymans shoe shop, attracting the attention of a hatted lady

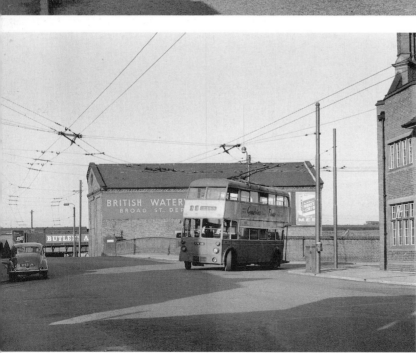

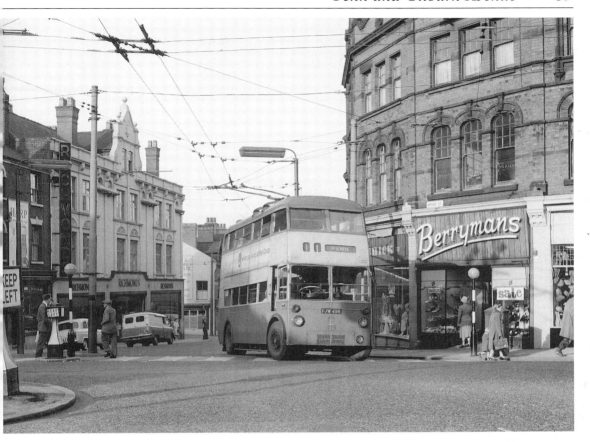

in the shop doorway. Parked outside the vaguely Flemish-styled Richmond furniture store on the left is a Ford Anglia 100E car and a Bedford CAL van. All the buildings in this view of the Broad Street junction have survived into the 21st century. *J. C. Brown*

Right The terminus of the Mount Road 62 service was in St James's Square, a back-street square off Horseley Fields that it shared with the Wolverhampton to Walsall trolley-buses. The early Victorian terraced housing is, by the mid-1950s, beginning to look extremely shabby, with only its door and window pediments giving a clue to its former glory. The whole of St James's Square was demolished in about 1982, disappearing beneath Middle Cross, which was constructed to link Horseley Fields with Wolverhampton's Ring Road. The 62 bus route, operating from Bilston Street garage, duplicated the Penn Road trolleybuses until, on reaching Mount Road, it turned along it as far as its terminus at the junction with Wakeley Hill. The service was introduced on 20 March 1950 and was later to become a shortworking of the re-organised Sedgley bus services. The single-decker is

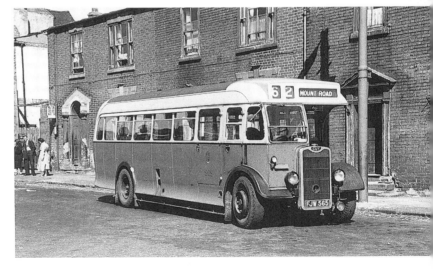

the attractive-looking 565 (FJW 565), a Guy 'Arab' III fitted with a Guy B34R body and dating from 1949. As with all of the Corporation's 'Arab' IIIs, whether Gardner 6LW-engined double-deckers or Gardner 5LW-engined single-deckers, this bus has a Wilson pre-selector gearbox, which was unusual for the 'Arab' III model. *R. Hannay*

Below In order to avoid duplicating the 58 trolleybus to Sedgley, the 66 motorbus service, despite starting in the same part of the town centre, headed out by way of Penn Road rather than Dudley Road and Fighting Cocks. This was just one of many route details that seemed somewhat confusing to anyone who was a stranger to the town. The logic, however, was impeccable, protecting the revenue of the fixed trolleybus services and encouraging the Transport Department to give its motorbuses a 'wandering brief'. The newly introduced Mount Road service 62 effectively became another shortworking of the 64-67 group of services after mid-June 1950, and the 66 became the complete route from Wolverhampton to Gornal Wood, while the other service numbers were a rationalisation of the old 28 and 30 routes. Not long after all this happened, the first of the 1950 Brush-bodied Daimler CVG6s stands in Snow Hill on 12 October 1951, about to embark on the sinuous route to The Straits. The Foster Brothers shop on the distant corner of Bilston Street is where the Dudley trolleybuses turned to pick up passengers, while opposite the parked bus is where they dropped off their in-bound charges. The bus is parked outside the well-known Tweedie's Scout &

Guide shop, while behind it are three-storey 19th-century retail premises. The shop with the large rectangular sign is the Warwickshire Furnishings Company; in later years this frontage collapsed during refurbishment and killed a passing pedestrian, and the shop was left unrepaired until the whole block was demolished to make way for the Wulfrun Centre. In the same block was Hughes & Holmes, an ironmonger that still trades in the town today, and Miller's, the jewellers, whose shop had a prominent clock on its street frontage. Today Miller's has modern premises in the Wulfrun Centre in Cleveland Street. *J. C. Brown*

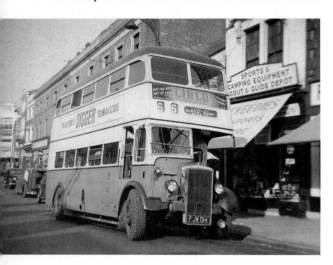

Below left The new trolleybus service to Penn was introduced on 10 October 1932, and part of it was a shortworking as far as Mount Road, Upper Penn. Confusingly, this shortworking was numbered 11 while the full route was numbered 11A. The route ran over the Penn Fields wiring as far as the terminus at the end of Lea Road, then turned left into Stubbs Road before regaining Penn Road about three-quarters of a mile from where it originally turned off (see the map on page 56). The section of Penn Road between Lea Road and Stubbs Road was wired at this time for trolleybuses, but was only to be used 'in emergency and to avoid congestion'. Nevertheless, when the Oxbarn Avenue (32) trolleybus service was introduced on 11 February 1934 it used the main road for the first time. Passenger complaints about overcrowding and over-riding on the Penn Fields section led to the direct main-road route being used for both the 11 and 11A services from 8 April 1935, and after maintaining a Sunday-mornings-only service, the Stubbs Road wiring was physically isolated at either end on 13 October 1936 and poor old Stubbs Road yet again lost its passenger service. The wiring was, however, left intact, although it was physically isolated in 1946, and could be energised very quickly, though access by gravity was something of a problem. After this closure, the Mount Road turnback on the 11 route also saw a loss of use, as it was now no longer required so frequently.

Standing in Victoria Square when newly in service is six-wheeled Sunbeam MS3 96 (JW 3396), which has been captured on film displaying 'MOUNT ROAD 11'. It has a Birmingham Corporation 'lookalike' MCCW H33/25R body and was numerically the first of five of this new low-chassis-framed trolleybus with this style of body to be operated by Wolverhampton Corporation. Unfortunately the Sunbeam Motor Car Co Ltd hit grave financial problems early in 1934 and the MS3 chassis was quietly dropped, with Sunbeams having built just one prototype, a modified MS2, and 11 production vehicles. Only two of the 11 went to an operator other than Wolverhampton, namely to Portsmouth as 13 and 14 (RV 4659 and 4662), while the prototype, OC 6567, built for Birmingham but strangely not with a Birmingham-style Metro-Cammell body, also turned up with Wolverhampton, becoming No 222 in the Corporation fleet. *J. H. Taylforth collection*

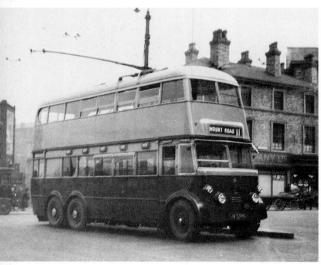

Opposite above Waiting in Victoria Square at 11.51am on Saturday 11 February 1939 is 262 (BDA 262), another of the 1938-built Guy BT trolleybuses. It is working on the Penn service and is displaying the route number 11A, which was altered to plain 11 in the June 1949 route renumbering. The Charles Roe bodies fitted to this batch accommodated 29 passengers in the upper saloon and 25 in the lower, all in a vehicle that weighed 6 tons 19 cwt 2 qtrs. To the right of the trolleybus is a Butlers Ale sign hanging outside the Prince Albert public house. Only two days earlier the Government had set in motion a plan to give everyone in potential danger

from air-raids access to a £250 Anderson Shelter. Yet while this grim prelude to war was being acted out, on the billboard on the corner of Fryer Street are advertisements for classic comedy films – George Formby's 1935 film *No Limit*, which was on at the Odeon, Dunstall, and the 1938 Laurel & Hardy feature *Blockheads*, showing at both the Olympia and the Coliseum cinemas. Beneath the end wall of the Prince Albert Hotel, further films are being advertised, including Claude Rains in his 1938 film *White Banners*, at the West End Cinema, Coleman Street, Whitmore Reans, which was later to become The Rex. Meanwhile the teenage singing star from Canada, Deanna Durbin, was starring in *Mad About Music* at The Globe Cinema in Horseley Fields, which was later to become The Carlton. *D. R. Harvey collection*

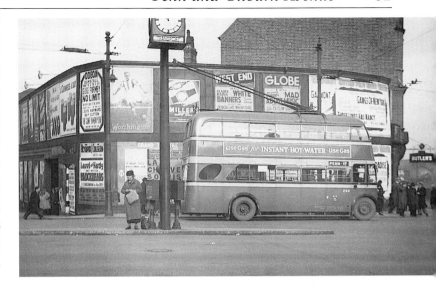

Below Having just about entered Victoria Square from Lichfield Street, Park Royal-bodied Sunbeam F4 608 (FJW 608) appears to have been abandoned across the entrance to Fryer Street. Behind the trolleybus and the Morris LD 1-ton van is the impressive-looking Sir Tatton Sykes Hotel. Meanwhile the cab-owner washes down his Coventry-registered Morris Oxford Series II taxi, oblivious to any possible problem just a few feet away from him. The taxi, in its black and white livery, looks as if it might be more at home somewhere like Athens, where all taxis are painted in this colour scheme. Also parked beneath the Corporation Transport Department's Victoria Square clock is one of the quite rare Standard Vanguard Sportsman 2088cc saloons, of which only 901 were built between 1956 and 1957 when this two-tone 90mph car was in production. The clock, which figures so prominently in all the Victoria Square views, now resides in the Black Country Living Museum in Dudley. *J. C. Brown*

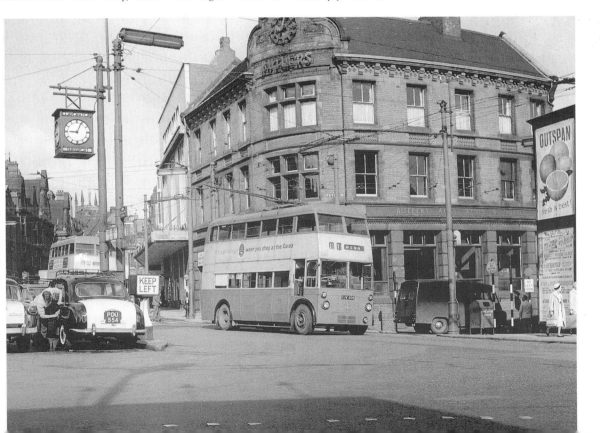

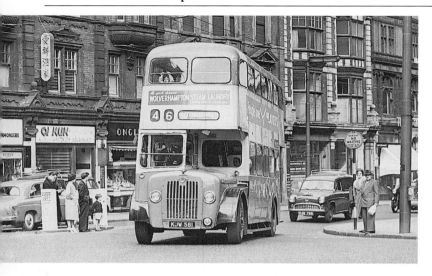

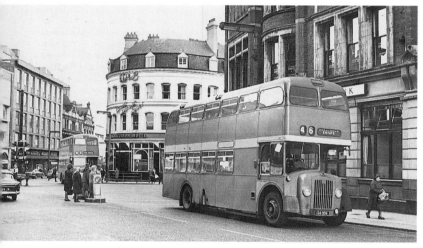

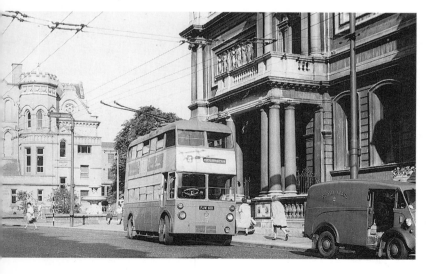

Top Passing the Grand Theatre on its right, the 46 bus service to Warstones Estate travelled up Lichfield Street from Victoria Square and arrived in Princes Square. Being 'driven' by a little girl in the upper saloon, and sporting a Wolverhampton Steam Laundry advertisement above the destination box, the bus is Guy 'Arab' IV 581 (KJW 581), one of a batch of seven Birmingham-style 'new-look'-front vehicles, with the radiator concealed behind a stylish metal cowling. The seven, which entered service early in 1954, were fitted with Metro-Cammell lightweight 'Orion' 56-seater bodies with a straight staircase. No 581 is approaching the elegant Royal London Mutual Insurance building on the corner of Stafford Street and Lichfield Street, which still dominates this part of Princes Square. On the left and above the Vauxhall Velox EIP six-cylinder saloon is the Oi Kun Chinese restaurant, with Parry's ironmonger's shop next door. Following the bus is a 1958 Shropshire-registered Austin A50 van. *J. C. Brown*

Middle The overhead trolleybus wire had disappeared several years before as Guy 'Arab' V 134 (134 DDA), working on the 46 service, travels into Lichfield Street. It is one of the 25 forward-entrance buses delivered between December 1963 and January 1964. These 72-seater trolleybus-replacement vehicles were the last buses delivered to the Corporation with Park Royal bodywork, thus ending a regular ordering policy with the North London bodybuilder stretching back to 1934. These buses could always be easily identified by their extremely large windscreens. The bus behind, crossing Princes Square, is a later Metro-Cammell-bodied Guy 'Arab' V working on the 4 route to Penn Fields. The Criterion Hotel in Princes Square is looking extremely smart, while in Lichfield Street the newish five-storey building on the left is the Wolverhampton & District Building Society's premises. Just to the left of the disappearing Hillman Super Minx is a building on the corner of Lichfield Street that had a large illuminated advertisement for Capstan cigarettes. *D. R. Harvey*

Opposite bottom The Museum and Art Gallery in Lichfield Street was built between 1883 and 1885 to the design of Julius Chatwin, the well-known Birmingham-based architect. It was constructed in the Italianate style, having pairs of polished pink granite pillar clusters, with granite and Portland stone for the main structure and friezes of caryatids. Its £10,000 cost was paid by a local builder, Philip Horsman, who was actually building the premises that he was secretly funding. His philanthropy was eventually recognised by the erection of the Horsman Fountain, which stands in the old graveyard of St Peter's Collegiate Church immediately to the rear of the parked trolleybus. Beyond is the Barclays Bank building on the corner of Lich Gates. The parked trolleybus is Guy BT 601 (FJW 601), which has worked along Penn Road on this warm summer's day in 1961 on the 4 route and is standing behind a Royal Mail Morris-Commercial J-type 10-cwt van. This popular van was first exhibited at the 1948 Commercial Motor Show, although it was another year before it went into volume production at Adderley Park. This particular van was the later JB-type model, marketed as the 'express delivery van' with a new ohv engine, four-speed gearbox and rubber wings. *J. C. Brown*

Below Climbing the hill though Queen Square in about 1929 is one of the Guy BTX trolleybuses, working on the return leg from Stubbs Road, Penn Fields, on the 4 service. It is being followed by an almost new Guy CX normal-control six-wheeler from the 1928 batch, being employed on the 11A motorbus service along Penn Road as far as the town boundary at Spring Hill, which would be replaced when the trolleybuses were introduced on 10 October 1932. Coming up Darlington Street in the distance is 66 (UK 5366), a Tilling-Stevens TS15A. It is fitted with a Dodson body, which appropriately enough carried 66 passengers; this was

the last Tilling-Stevens to be supplied to the Corporation in 1928. Queen Square was originally High Green, and it was here on 27 January 1606 that Thomas Smart and John Holyhead were executed for harbouring some of the last Gunpowder Plot conspirators.

The statue of the mounted Albert, the Prince Consort, looks benignly over the bustling Square; it was unveiled by Queen Victoria in 1866, her first official public engagement following the death of her beloved husband. It was on this journey by rail that on reaching the edge of the Black Country she instructed one of her ladies-in-waiting to draw the blinds on the carriage windows so that she did not have to look at 'this terrible place'. It is probable that this tale is apocryphal, as after Prince Albert's death the Queen tended to travel on long journeys with the blinds drawn anyway! The statue cost £1,150 and was sculpted by Thomas Thorneycroft. The subterranean toilets behind the railings alongside and in front of the statue were built in 1902 for the Wolverhampton Art & Industrial Exhibition and were among the first in the country that had facilities for ladies. The Wolverhampton Corporation electric tram system was also opened at this time specifically for this important local event.

The impressive building behind the trolleybus on the corner of Exchange Street belongs to the National Provincial Bank, but had been built as the County of Stafford Bank. Next door, at 38-38A Queen Square, is Green & Hollins men's and boys' outfitters. The ground floor of the building had formerly been the Electric Theatre, one of the first picture houses in the town. The buildings on the corner of Victoria Street and Darlington Street are occupied by Tylers, a boot and shoe retailer, whose name can be seen proudly emblazoned on its upper floors. This old building was soon to be demolished to be replaced by Burton's main Wolverhampton gentlemen's outfitters store. *B. Baker collection*

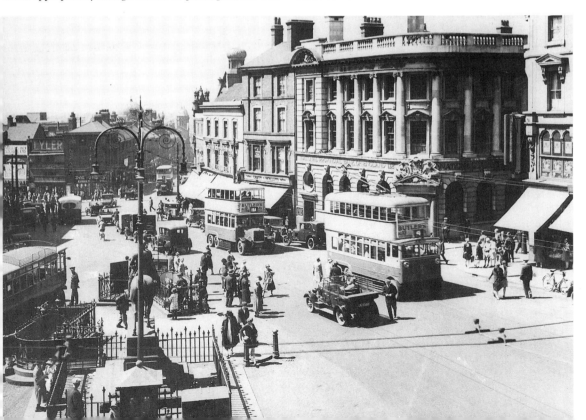

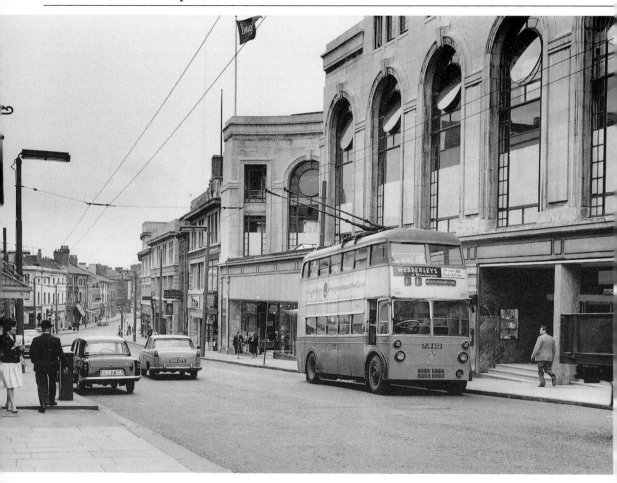

More than 30 years later, in 1961, Victoria Street has not yet been substantially altered. The Queens Arcade was taken over by Mander (Holdings) Ltd in 1962 and demolished within a few years to be replaced by the huge Mander Centre. This was built on the site of Mander's paint and varnish factory, which had been established on the site in the 1770s by Benjamin Mander. On the other side of the road was Beatties department store, which was a significant development in Wolverhampton, being comparable to and contemporary with Lewis's store in Birmingham. It replaced an earlier large-windowed shop that had been known locally as the Midland Shopping Centre. James Beattie began trading in 1877 as the Victoria Drapery Store and gradually expanded until a new department store was built in Victoria Street in 1912. These large, three-storey premises were replaced in 1929 with the larger Art Deco building seen here, with its port-hole ventilators in the tall upper-floor windows.

By 1960 Beatties had also taken over the premises occupied by Jeanette's ladies' fashion shop and F. W. Bradford, the drapers, after the death of Frederick J. Bradford the previous year, but even this was insufficient. In 1992 the former Burton's building was also taken over. To the left of the Smethwick-registered Ford Popular 100E is the canopy of the early-19th-century Star & Garter Hotel, one of Wolverhampton's most prestigious hotels. The solitary car travelling down the hill towards the distant Cleveland Street junction is an almost new Austin A110 Westminster, and beyond its roof is one of the two F. W. Woolworth shops in the town centre. On Thursday 20 April 1961 the driver of 652 (FJW 652), a 1950 Park Royal-bodied Guy BT trolleybus, pulls away from the stop outside Beatties before turning right into Queen Square; it is a bit *infra dig* that the trolleybus is carrying an advertisement for the Co-op. *J. C. Brown*

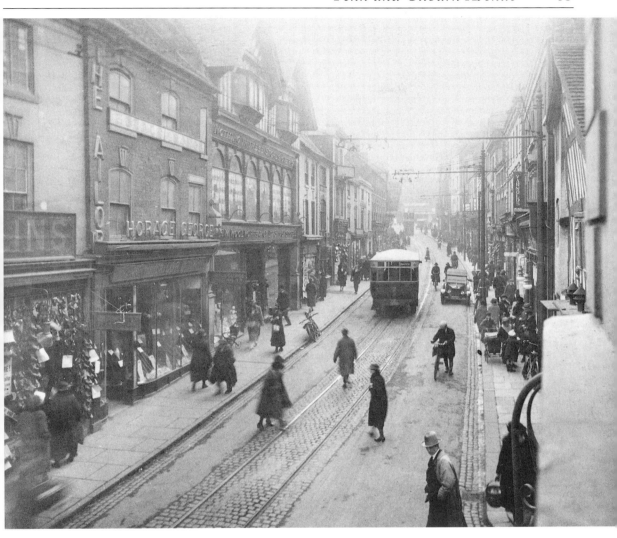

Victoria Street survived as a product of late-19th-century urban development until the buildings began to become time-expired towards the end of the 1920s. The street had become a thriving shopping area by the early 1920s, with Horace George's tailors shop displaying numerous rolls of worsted cloth in its window suitable for making up into gentlemen's suits. Next door is the sixpenny bazaar of F. W. Woolworth, while on the right is Hughes's bakery shop in the half-timbered building that claims to date from AD1300, although visual evidence suggests that it is Elizabethan. Whatever its age, it is the only half-timbered building to have survived in the centre of Wolverhampton. Travelling into the town centre is motorbus 8 (DA 1551), a normal-control Tilling-Stevens TS3 with a locally built Fleming B30R body, which entered service in 1918. It is running on 'solid' tyres, but its original body, with a clerestory roof, has been replaced. This occurred in 1924, which helps to date this view of Victoria Street to about 1925. At the top of the hill, opposite Beatties old store, is a top-covered tram, equipped with a trolleypole, working into the town centre on the Penn Fields service. After 1915 the Penn Fields tram route was given the route number 4, and on 15 October 1921 it was converted from the Lorain Surface Contact stud system to the more conventional overhead method of power supply, making it the last route of the eight operated by the Corporation on the Lorain method to be converted. Between the tram tracks there is evidence of where the Lorain studs have been taken out and filled in with new cobbles. The Penn Fields tram service was only to survive for another six years, being converted to bus operation on Monday 21 March 1927. *B. Baker collection*

Below Just beyond the old timber-framed Elizabethan building in Victoria Street on the corner of St John's Street was the junction with Bell Street. Don Everall's main travel agency was located in these corner premises for many years. Mr Everall started operating coaches in Wolverhampton in July 1926 and expanded into other interests, including several travel agencies, a tour organiser and the main Ford car agents in the town, as well as operating a regular air service between Wolverhampton and Birmingham. Descending Victoria Street past Halford's cycle shop on the 4 route to Penn Fields is Sunbeam F4 trolleybus 619 (FJW 619). On its left, with its canvas sun blinds pulled down, is the Wholesale Bargain Stores, which shared the early Victorian premises with the Don Everall travel shop. This trolleybus would be broken up at Cheslyn Hay in 1964 by the local scrap merchant, who was, ironically enough, Don Everall! *J. C. Brown*

Bottom Victoria Street descended from the high ground in Queen Square into a valley, then continued as Worcester Street on the other side of the Cleveland Street junction. This junction was where Pudding Brook, medieval Wolverhampton's only source of water, was forded; by the 18th century the stream had become terribly polluted, and during that period it was culverted, disappearing underground and leaving only the valley sides as a reminder of its course. In the background is the climb out of the valley up Victoria Street towards the distant tower of St Peter's Parish Church. The trolleybus is standing at the Cleveland Street traffic lights on 3 November 1962, and once the lights have changed it will move forward into Worcester Street on its way to Penn on the 11 service. It is masking the Skinner Street junction from where the original 1905 bus service started, and is passing a block of commercial and retail premises built in the years before the outbreak of the Second World War. The shops at the bottom end of Victoria Street belonged to small, family firms such as County Wallpapers and Woodall's Shoe Service rather than the larger stores in the town centre. Parked outside the shops is a Bedford CA 12-cwt van, while in front of it is a Morris Minor 1000 Traveller. It was the construction of a pedestrian subway for access to the retail markets near this junction in Victoria Street, with Salop Street to the left, that necessitated the temporary closure of the Penn Road group of services. This occurred after 23 January 1961 and closed the four affected trolleybus services for four months. The trolleybus is Sunbeam F4 616 (FJW 616), which entered service on 12 March 1949 and was fitted with a rather noisy double-reduction back axle in December of that year. It was used in May 1963 on an enthusiasts' tour of the system and, together with trolleybus 433, was donated for preservation. Unfortunately, whereas 433 now resides at the Black Country Living Museum and is beautifully repainted and in full working order, poor old 616 languishes in a condition that defies restoration. *W. Ryan*

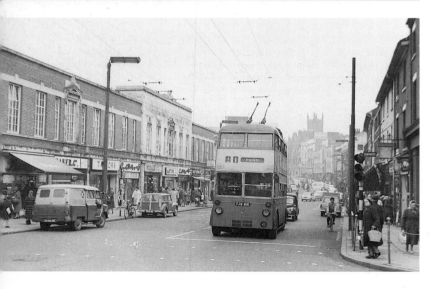

Opposite above Looking as if it would be there 'for ever', the Fox Inn on the corner of Penn Road and School Street, formerly known as Little Brickkiln Street, has a mock-Jacobean look about it. It was opened in 1930, but was destined to have a life of only just over 30 years. The whole of this town-end section of Penn Road was swept away during 1963-64 when the second stage of the Wolverhampton Ring Road was built. Not only was the Fox Inn demolished, but so were the row of shops beyond. Travelling into Wolverhampton is trolleybus 601 (FJW 601), an 8-feet-wide Guy BT with a Park Royal body; it is working on the 4 route from Penn Fields, while the unidentifiable trolleybus behind it is operating on the 'main road' 11 service. Between the two trolleybuses is a Ford Zodiac 206E, whose driver appears to be itching to use the power of the 2½-litre engine to get past 601, which, having overtaken the parked

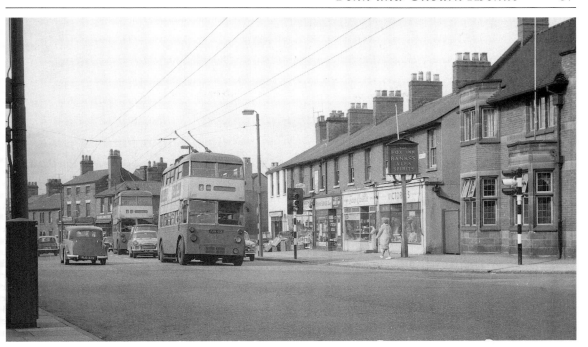

Morris Oxford Series II, is about to pass the green traffic lights. Travelling out of town towards Penn is a London-registered Triumph Renown Mk I TDB, with the distinctive 'razor-edge' styling that was only found on this model and the smaller, slightly later Triumph Mayflower. *J. C. Brown*

Right Having left the School Street junction with the Fox Inn on the corner, seen above the Austin A30 car travelling out of town, Penn Road curved slightly to the left. This was the start of a long straight section of the route that took the trolleybuses to Lea Road, where the Penn Fields route turned off the main road. On the right is the stone-built St Paul's Church with, behind the trees, its vicarage, first occupied bt the Rev W. Dalton. The church, which stood in front of the Sunbeam car factory, was demolished in late 1963 when the Ring Road was being constructed. Following the A30 car behind the trolleybus is an Austin FX3 taxi-cab. Accelerating past the church and managing to make the

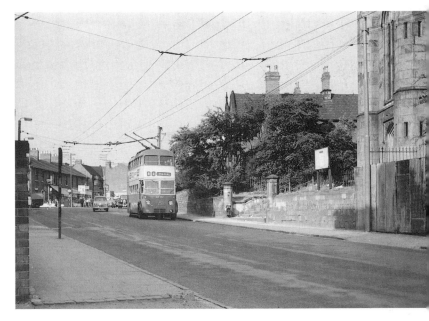

slack overhead wave a little between the first long section of hangers after the power feeder point is trolleybus 432 (DUK 832). This was a 1946 Sunbeam W4 chassis that received an elegant Charles Roe body and re-entered service on 6 October 1959. Some 468 Sunbeam W4s and the identical Karrier-badged equivalents were constructed at Fallings Park and entered service with operators across the country between February 1943 and July 1948, when this model was the only trolleybus available throughout the Second World War. After late 1948 the model was reclassified F4, although there were few practical differences in the chassis design. The intention was that the chassis of 432 would be preserved at the Birmingham Museum of Science and Industry, but the scheme fell through and the vehicle became a donor of numerous parts for its preserved sister 433, which now resides at the Black Country Living Museum. No 432 was eventually sold by the WMPTE in November 1970 and had the unfortunate distinction of being the only Wolverhampton trolleybus to go to that doyen of South Yorkshire bus scrap dealers, Wombwell Diesels. *J. C. Brown*

Below Beyond the Lea Road junction, Penn Road climbs up towards Goldthorn Road. The old stone walls, using local limestone, are typical of this western side of Wolverhampton, but become less common as one travels eastward into the Black Country. Behind the walls is the Wolverhampton Die Casting Company, one of whose claims to fame was that it made the flying letter 'A' that was affixed to most of the early post-war Austin cars. Although only about a mile outside the town centre at this point, the tree-lined Penn Road in 1959 was still a quiet routeway towards Wombourne and Kidderminster, although by now it was numbered the A449. Behind the wall on the left is a large house called The Mount. Guy 'Arab' IV 22 (YDA 22) storms up the hill working on the 46 route to the Enville Road terminus in the Warstones Estate, although it is still displaying the 'UNDERHILL ESTATE' destination, its starting point. This full-fronted,

MCCW-bodied bus was later the subject of a unique rebuilding exercise that converted it to a 'tin'-fronted half-cab configuration, which looked most odd as it utilised the existing radiator apron and the interior bonnet! Trolleybus 429 (DUK 829), a 1946 Sunbeam W4 that re-entered service in October 1958 having been rebodied by Charles Roe, is working on the 'main road' 11 route to Penn. *S. R. Dewey*

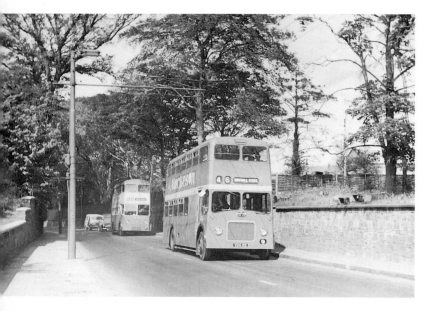

Bottom On a sunny 23 June 1962 a Corporation trolleybus travels into Wolverhampton along Penn Road with a line of traffic behind it. They have all just passed the junction with Oaklands Road, which has a Belisha beacon on the corner. Further away, through the trees beyond Goldthorn Terrace on the left, is the Goldthorn Hotel, and around the distant bend is the Royal Wolverhampton School. The trolleybus is Guy BT 493 (FJW 493), which is beginning to show some front panel damage since it received what was its last overhaul some 14 months earlier. As was very common, the green and yellow livery of the Park Royal body has the additional embellishment of an advertisement for the Wolverhampton Steam Laundry. Straddling the white lines in the centre of the road and apparently about to overtake the trolleybus is an early 1953, Warrington-registered Ford Prefect E493A. Going out of town is a locally registered, late-1938 Austin Big 7, whose driver might have been a little put off by the antics of the approaching Prefect! Just visible behind the Ford is a Hillman Minx Series III, while at the distant zebra crossing is a Humber Hawk and a Standard Pennant of about 1959 vintage. Today the road, although recognisable, is much wider, and the site on the left is dominated by a Safeway supermarket. *J. C. Brown*

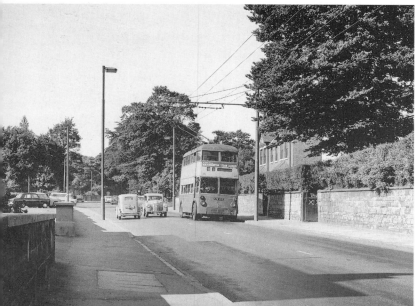

Opposite top Having climbed the 50 or so feet from Graiseley House on Penn Road, after Goldthorn Road, the main road begins to gradually drop down towards the junction at Goldthorn Hill. On 18 June 1962 Guy BT trolleybus 634 (FJW 634) travels down the gentle gradient and passes the impressive Dutch-gabled Royal Wolverhampton School with its nicely proportioned central tower. It was built by lock-manufacturer John Lees, who was appalled at the number of children orphaned in the cholera outbreak of 1849. His first Asylum was established in the old Dispensary buildings in Queen Street, but soon this was too small, so the 2½-acre site on Goldthorn Hill was purchased in 1852. Opened as the Royal Orphanage in 1853 to the design of Joseph Manning and costing nearly £40,000, its wings, which included a chapel and an infirmary, were added ten years later. The fountain

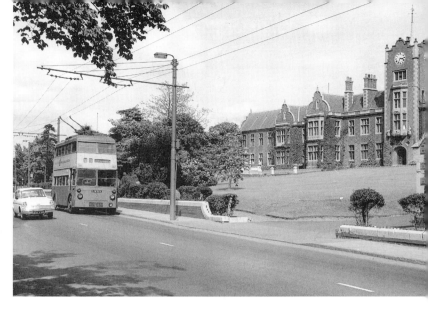

on the extensive front lawns was built as a memorial to the wife of one of the Orphanage's first chairmen, W. H. Rogers. Two of the more famous pupils of the school were Gilbert Harding, the morose critic, writer and early BBC television personality, and a man who was his exact opposite, Eric Idle, writer, humorist, and *Monty Python's Flying Circus* team member. The trolleybus is being overtaken by a brand-new Ford Anglia 105E car, a model that successfully transformed Ford's share of the British small car market. To the left are the grounds of Graiseley Old Hall, dating from about 1327. Originally a Tudor half-timbered merchant's house belonging to Nicholas Rydley, a wool exporter, it was clad in brick in the days of Queen Anne and has been owned by the Royal Wolverhampton School since 1930, although for most of the intervening years it has been retained as a private residence. *J. C. Brown*

Below Having reached the junction with Goldthorn Hill, the 32 service to Oxbarn Avenue turned right into Coalway Road and terminated at a turning circle at the junction where Oxbarn Avenue became Warstones Road. This short spur off Penn Road was opened on 11 February 1934, some 14 months after the Penn via Penn Fields and Stubbs Road route was opened. It replaced a motorbus service, also numbered 32, which had started on 10 April 1932, and terminated only just over a quarter of a mile from the terminus of the Merry Hill (13) route. There was obviously a design to link the two services, but it never got beyond the planning stage. During the temporary suspension of the 4, 9, 11 and 32 trolleybus routes on 22 January 1961, caused by the construction of pedestrian subways at the junction of Salop Street and Victoria Street, the trolleybuses were substituted by 20 hired GOE-registered Daimler CVG6s from Birmingham City Transport. Unfortunately, when the trolleybuses resumed on 22 May, it was without the 32 Oxbarn Avenue service, which was replaced by an increase in service frequency of the 46 bus service to Warstones and Underhill by way of Penn Road and Coalway Road. Some years earlier, on 15 June 1956, the driver of outward-bound Sunbeam F4 623 (FJW 623) makes the turn off the tree-lined Penn Road into Coalway Road. Carrying an advertisement for the long-forgotten Black Satin Milk Stout, the trafficator is switched on to warn the following Austin Seven Ruby's driver of the manoeuvre. This trolleybus had the unfortunate distinction of being one of the first of its class to be withdrawn after being involved in an accident in Penn Road in January 1962. *J. Hughes*

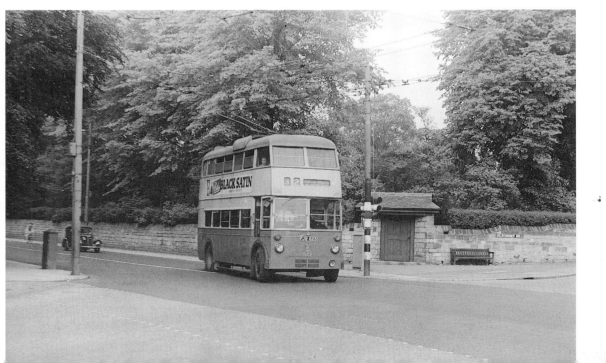

Below Because of the shortage of motorbuses when the trolleybus services along Penn Road, Lea Road and Jeffcock Road were temporarily suspended in 1961, Wolverhampton Corporation had to look elsewhere for replacements. Neighbouring Birmingham City Transport was approached, which as it happened had a surplus of buses that were coming to the end of their second seven-year Certificate of Fitness cycle. These were offered to Wolverhampton for hire at a rate of sixpence per mile. They were Gardner 6LW-engined Metro-Cammell-bodied Daimler CVG6s dating from between November 1947 and, with one exception, February 1948, and were arguably in better condition than the indigenous trolleybuses that they were temporarily replacing. They were fitted with route number blinds made at Midland Red's Carlyle Road Works, although why they could not have had even a single word of the route's destination seems a pity, as it makes the whole effect look pretty cheap. This example, 1606 (GOE 606), displaying the uninformative but correct 32 destination number, has travelled along Coalway Road and reached St Michael's Roman Catholic Church, almost at the Oxbarn Avenue

terminus, beneath de-energised trolleybus wires that were destined never to be used again. The bus will turn around the island in about 50 yards and return to park at the terminus loading-up stop, almost opposite where the Daimler is standing. Lining Coalway Road are early post-Great War 'Arts and Crafts'-designed semi-detached houses, which look as if they should be in a 'garden suburb' such as Letchworth, Port Sunlight or Bournville. *W. A. Camwell*

Bottom In 1960 Guy BT trolleybus 639 (FJW 639) stands at the in-bound loading-up stop in Coalway Road. The driver has already turned the destination blind from the outward 'OXBARN AVENUE via COALWAY ROAD' to the more obvious single word 'WOLVERHAMPTON'. Just visible in the background are the turning circle wires, with Oxbarn Avenue on the right where the Belisha beacon is located. Turning right behind the trolleybus is a Stoke-on-Trent-registered Hillman Minx Phase 1, briefly introduced in 1940 and having the distinction of being Hillman's first unitary construction car. Re-introduced in August 1945, it cost £474 in its de-luxe form. It is apparently being used as a wedding car if the ribbons tied to the 'alligator' bonnet are anything to go by. *J. C. Brown*

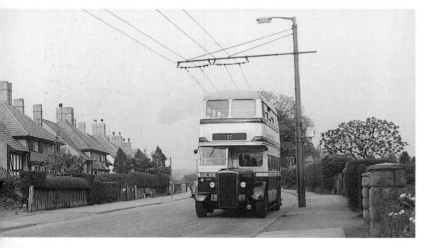

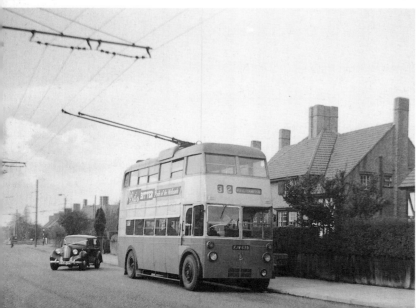

Right Meanwhile, back on Penn Road, trolleybus 626 (FJW 626), a Sunbeam F4 with the usual Wolverhampton standard style of Park Royal body weighing in at 7 tons 19 cwt, travels into town on the 11 route. It is passing through the Coalway Road traffic lights opposite the bottom of Goldthorn Hill on 23 June 1962. Following the trolleybus is a British Road Services Leyland Comet articulated lorry. By this time, the Oxbarn Avenue trolleybus service had been abandoned for over a year and the wiring for the 32 route had been dismantled, leaving only the traction poles in Coalway Road as barren reminders of former trolleybus operation. The Penn Road trolleybus service was one of the many out of the town that was ideally suited to this mode of public transport: it was long, straight and allowed for fast running, conditions under which trolleybus operations thrived. Unfortunately, by the early 1960s it was being described as 'the most congested suburban road in the country'. Today, the traffic jams are even more horrendous! On the corner of Coalway Road are a variety of buildings of different ages; the corner premises of ironmongers Price & Co date from the 1920s, considerably more recent than the shops being passed by the trolleybus. One nice touch on the front of the ironmongers are the two sets of wooden slats, which, when raised up, form an outside bench on which to display goods. *J. C. Brown*

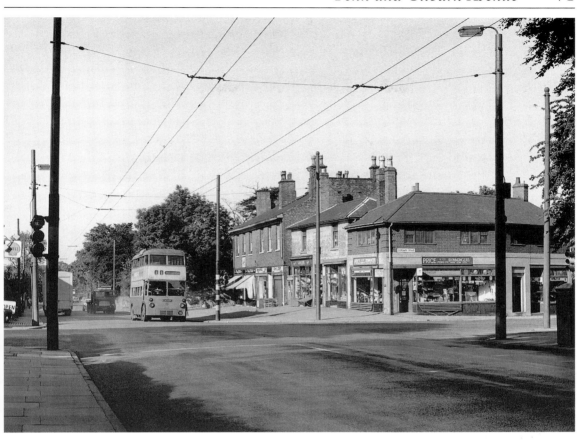

Right The outer part of Penn Road from Coalway Road to Penn House Avenue, where the road becomes a dual carriageway, has hardly altered in more than 40 years. Travelling into Wolverhampton is 611 (FJW 611), a Sunbeam F4 trolleybus with a Park Royal H28/26R body. It is Saturday 8 June 1963 and the penultimate day of trolleybus operation on Penn Road. On this summer's day three of the shops have their canvas blinds pulled down, including the Co-operative shop, still Co-op-owned today, albeit as an undertaker! Beneath the Co-op's awning is an Austin A35 four-door saloon, presumably parked there to keep the interior cool. On the left, beyond the warning sign for Woodfield Avenue School, is Alexandra Road, whose name nicely dates these Edwardian shops and houses. A long cul-de-sac, it is lined with mainly Edwardian semi-detached villas, many of which have excellent examples of terracotta tiling in their porches. Beyond the two pedestrians on the left are the iron barriers protecting the corner of Mount Road. *J. C. Brown*

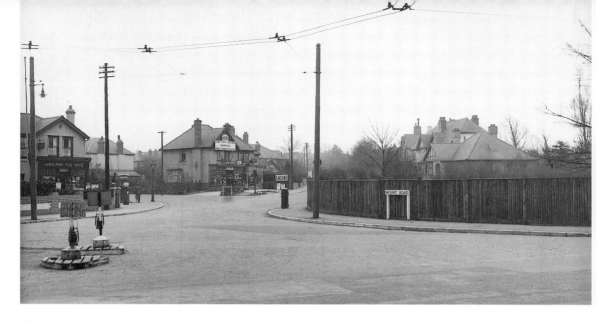

Above At Mount Road, Upper Penn, there was a trolleybus turning circle, enabling Penn-bound trolleybuses to turn back to town. The route number was 11 and the trolleybuses showed 'MOUNT ROAD' in their destination boxes. On the left, just inside Mount Road, is Upper Penn Post Office, while on the far side of Belmont Road is Lacon's shop, selling everything from grocery to underwear. Belmont Road is, like the previously mentioned Alexandra Road, a long cul-de-sac leading to the back of the houses in Goldthorn Avenue. Behind the wooden fencing on the right is the site for The Mount public house, which had been started just before the outbreak of the Second World War but had only reached first-floor level when construction work was brought to a halt. As a temporary measure a roof was put on the unfinished structure and throughout the war the pub operated as a single-storey hostelry. It wasn't until well after the war that the building was completed, and today one would never know its interesting history. The trolleybus turning circle survived through the war but was removed

during 1946, leaving behind it an opening to Mount Road that today looks, apparently for no good reason, unusually wide. *J. Hughes collection*

Below Travelling out of Wolverhampton in October 1958 is Guy BT trolleybus 484 (FJW 484). This 8-feet-wide Park Royal-bodied vehicle is in Penn Road in the days immediately before it was made into a dual carriageway, when the oldest part of Penn still retained the look of a village with many original pre-Victorian premises, although their long-term future was beginning to look somewhat bleak. Viewed from the old Post Office, the trolleybus is about to pass the building owned by Rodens, the main undertaker in Penn. Rodens were also farriers, and that aspect of their business took place in the yard on the extreme right. Next door, and just in front of 484, is the barber's shop owned by J. Ayres, who later moved to new premises in the 1930 block of shops at the Spring Hill trolleybus terminus. Behind the trolleybus is the butcher's and grocery provisions shop belonging to the well-established family firm of Fergusson. In the distance, on the left, is the sign for the Roebuck public house, which stood opposite Manor Road. The houses on the left have survived but are unrecognisable today with their new shop frontages. Nearby was a row of late-18th-century cottages that included the original Penn Post Office, which was next to the old police station. Overtaking the trolleybus is a Hillman Minx Phase III, while behind it on the other side of the Belisha crossing is an early Bedford CA Mark I van. The parked car behind the Penn terminus-bound trolleybus appears to be a quite rare Lancia Appia Series II. *D. R Harvey collection*

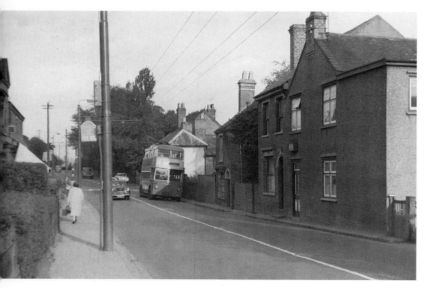

Opposite above Penn Road is part of the A449 road from Wolverhampton to Worcester by way of Kidderminster, and as a result of increased traffic the whole of the road from the Manor Close-

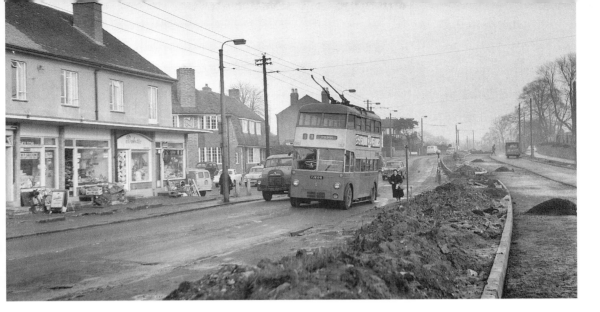

Pennhouse Avenue junction to Pinfold Lane was rebuilt as a dual carriageway during 1961. It was only over this part of the dual carriageway that trolleybuses operated, as the remaining section to Lloyd Hill was not 'dualled' until 1965. On 21 January 1961, the writer's 13th birthday (I wonder what I was doing on that Saturday, which was the day after the inauguration in Washington DC of President John F. Kennedy), Park Royal-bodied Guy BT trolleybus 641 (FJW 641) works along Penn Road on the 11 route towards the terminus. On 19 August 1960 641 had been involved in a serious accident at Eve Hill, Dudley, which, had it occurred 12 months later, would have meant withdrawal. With the new carriageway under construction on the right, the trolleybus has just passed the Roebuck public house and is manoeuvring alongside one of the contractor's 'Big' Bedford 'S'-type lorries parked outside the early post-war block of shops that includes an ironmongers, Babette's ladies wear shop and Penn Post Office. Behind the trolleybus is a Wolseley 15/60, the first of the Farina-styled BMC B-Series saloons to be introduced, being launched in December 1958. *J. C. Brown*

Below By the time that the temporary closure of the Penn Road trolleybus service ended in May 1961, the 'dualling' of Penn Road had been partially completed. Park Royal-bodied Sunbeam F4 trolleybus 625 (FJW 625), on the 11 route, heads in-bound past the shops seen above. Note the traction poles with street lamps attached to the top. In the distance is the mock-half-timbered Fox & Goose public house, while on the other side of the road the land remained as undeveloped open space until the mid-1980s. The dual carriageway has not long opened, and the freshly planted shrubs in the central reservation have hardly had time to develop. The extra line on the new dual carriageway was the last 'big job' carried out on the trolleybus overhead and included the repainting of all the traction poles along Penn Road from the terminus to the junction with Worcester Street, although, perhaps surprisingly, the Lea Road route was not included. Parked outside the few surviving original cottages is an Austin A40 Countryman estate car dating from the early 1950s, while near the Fox & Goose is a Ford Popular 100E car that would be about ten years the junior of the A40. *J. C. Brown*

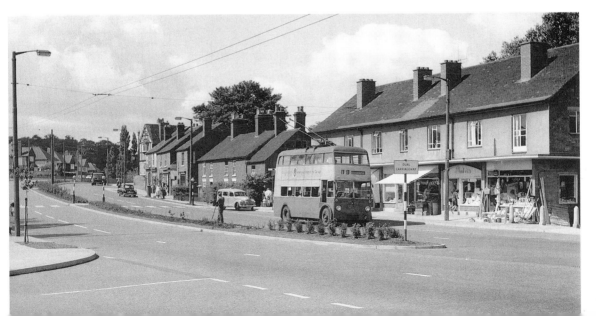

Below Taking its circuitous route around the back streets of Penn is freshly painted double-decker 556 (FJW 556), a Guy 'Arab' III 6LW of 1950 fitted with a composite construction Park Royal body. On 8 March 1954 it is working into Wolverhampton on the 66 service, and is climbing Wakeley Hill, Penn, past Butts Road on its way back from Sedgley. The bus has travelled across Penn Common and travelled down Church Hill, which is where the houses are located in the background, almost to the junction with Penn Road at the Rose & Crown. It has then turned right and climbed up Wakeley Hill almost back to Penn Common., whereupon it will turn left into Mount Road at the terminus of the 62 service and travel downhill again to Penn Road. The houses on the right predate the urban expansion that engulfed Penn Village, while those beyond the pedestrians are typical 'Bayco Building Set No 4'-style 1930s semis. *J. C. Brown*

Bottom One of the two main-horse bus operators in Wolverhampton was Sampson Tharme, who during 1882 began operating on a licensed service to Penn by way of Penn

Fields, terminating at Crowther's Rose & Crown public house on the corner of Church Hill, some way short of the boundary. At the end of the 19th century this was still a country pub, surrounded by trees and open space, and a far cry from its first huge 1920s replacement and the latest smaller building dating from the early 1990s. The pub is advertising Butler's Wolverhampton Ales and carries the encouraging notice that parties are catered for, while 'good stabling & cycle accommodation' is also available. Unusually, the pub also offers facilities for quoits. Leaning against the front wall is a cycle whose rider, perhaps, in view of the advertisement, is looking for a bed for the night! The horse-bus on the right has a leading trace-horse to enable it to climb Church Hill and the nearby Swan Bank. A simpler form of equine power is the two-seat donkey cart on the left with the two young boys sitting in it. *Commercial postcard*

Opposite above Beyond Mount Road, the housing along Penn Road, particularly on the eastern side, newly 'dualled' between Penn House Avenue and Pinfold Lane, consisted of large Edwardian villas that gave way to equally prosperous-looking inter-war detached homes with their own driveways. Perhaps it is surprising that an almost municipal-estate-sized pub design was chosen for the replacement of the original 18th-century Rose & Crown. The old hostelry was rebuilt in the late 1920s as a typical suburban public house that reflected the idiom of the housing estates of the day. Frequently mock-Elizabethan or mock-Jacobean, they were built on green-field sites to serve the needs of suburbia. They had heavily leaded windows, stone-lintelled door and window frames and either Elizabethan-mock black and white woodwork or, as in this case, Jacobean-style brickwork with large decorative chimney stacks appearing from steeply gabled roof-lines. Such 'drinking houses' thrived in the housing estates of Wolverhampton, Birmingham and beyond, but by the mid-1980s were being seen as elephantine, uneconomic and in need of replacement. This second Rose & Crown eventually had to be demolished, precipitated by structural damage caused by subsidence in the nearby Baggeridge Colliery. Something different was called for, catering for a wider range of customers and tastes than these suburban beer halls had been designed for, and it was replaced by a modern 'rustically' designed 1990s pub/restaurant with a large car park. On 15 June 1962, the year before the Penn Road trolleybus abandonment, 607 (FJW 607), a 1949 Guy BT with Park Royal bodywork outbound on the 11 service, is unloading at the Rose & Crown, having passed Church Hill. It is about to be overtaken by Guy 'Arab' IV double-decker 26 (YDA 26) working on the 37 service to Blakeley via

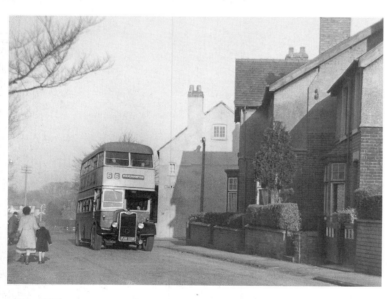

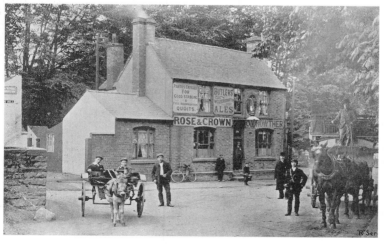

Wombourne, which in 1967 would be converted to one-man-operation using some of the six single-deck Strachan-bodied AEC 'Swifts' and six identically bodied Daimler 'Roadliners'. These 30-feet-long 'Arab' IVs had unusual Metro-Cammell-Weymann 72-seater bodies, not only because of their electrically operated sliding door across the forward entrance, but also because they had a full front concealing the radiator and engine behind a nearside extension to the cab, making their front look at first sight like a trolleybus with a radiator grill. The fact that they were bigger, noisier and had entrances in a different position did not seem to deter the Corporation in this ruse. Subsequently, another batch of 30 similar vehicles were ordered. Nevertheless, only Ribble Motor Services of Preston, Lancashire, and the Ulster Transport Authority in Northern Ireland had similar lightweight Metro-Cammell full-fronted versions of its lightweight 'Orion' body, albeit on Leyland 'Titan' PD3 chassis. *J. C. Brown*

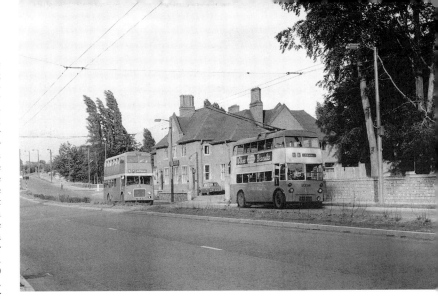

Right At Spring Hill trolleybus terminus, Penn, the main A449 road widened out into an almost triangular shape. Looking towards Wolverhampton in 1945, the tree-lined Penn Road is still a single carriageway, and the pre-war semi-detached houses have failed to reach the turning circle before war stopped all house-building, not getting much further than Hollybush Lane and the Holly Bush pub on its corner with Penn Road. Passing the tall hedges in front of these distant houses is a horse and trap carrying two large milk churns. The shops at the terminus were built in the mid-1930s and have the typical Bauhaus-inspired metal-framed windows set in a squared-up concrete-faced frontage. The small Morris-Commercial lorry is delivering wooden crates full of milk bottles to the end shop, whose window displays a Victory Union Jack. Between the lorry and the trolleybus is a Talbot 10 two-door saloon. This 1185cc-engined car was something of a rarity, with fewer than 1,750 being made during the three-year production run that ended in 1938. In front of the trolleybus, parked alongside a traction pole carrying an 'Air Raid Shelter' sign, is an early 1939 Leicester-registered Singer Ten, while facing it is a rather battered Ford Y-type 8hp Fordor saloon, still carrying one wartime headlight mask. Further remnants of wartime lighting restrictions are the extra shading masks on the street lights, introduced at the end of 1944 to allow a better beam of light to illuminate the road. Standing at the 'BUS FOR TOWN' stop is a trolleybus displaying all the necessary wartime white edging paint and dark-painted camouflaged roof. Surprisingly, since its last repaint was in December 1944, it

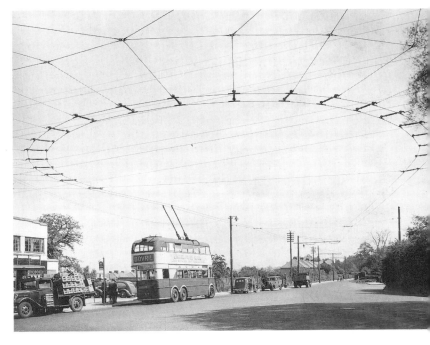

is painted in the pre-war layout of green and primrose, rather than the all-over green that was applied to certain vehicles during the war. It is 226 (JW 7326), a six-wheeled Sunbeam MS2 with a very modern-looking Park Royal H33/25R metal-framed body fitted with a straight staircase, which entered service on 5 August 1935 as one of a batch of four. Slightly unusually for wartime, it is displaying two commercial advertisements, for the *Birmingham Mail* – strange, since the local *Express & Star* might have been a more logical choice – and Bovril, the hot beef tea drink that in those far-off days was a prerequisite at half-time at any important football match. Above the turning circle are the recently restrung trolleybus wires which now have a 24-inch spacing introduced during the Second World War in place of the previous 18 inches. *B. Baker collection*

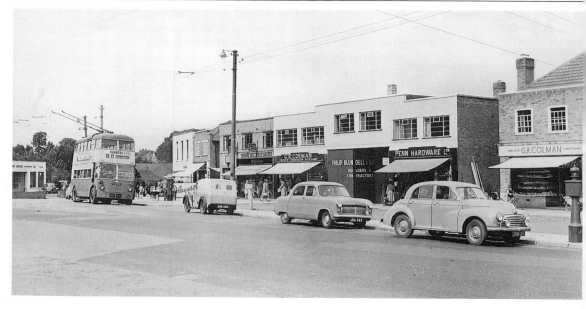

Above The road to Kidderminster seemed little more than a narrow country lane once the Wolverhampton boundary at Penn was passed. It was only after its conversion to dual carriageway in 1963 that Penn Road took on the appearance of a routeway of some importance. The main A449 road forks to the left of Penn Garage, on the corner of Spring Hill Lane, which disappears towards Warstones Road about a quarter of a mile away. The 1930s-built garage, with four National petrol pumps beneath the canopy on the Penn Road side and a workshop with a Morris Oxford MO parked outside it on the Spring Hill Lane side, looks like a child's toy. On the right are the similarly aged shops with their plain-styled geometric fronts. These suburban shops were the 'life-blood' of the area, providing the local community with its daily needs, and include Nettleton's Spring Hill Post Office, G. R. Colman's grocers and

provision merchants and Penn Hardware. Waiting at the 11 route terminus in about 1954, having negotiated the large turning circle, is Park Royal-bodied Guy BT trolleybus 632 (FJW 632). Parked in front, alongside the Penn Road sign, is a Morris Z Series 5-cwt van registered by the GPO in London with a GXK mark during 1943, making it something of a bargain when released in the early 1950s. The two cars in front of Colman's other shop selling 'High Class Confectionery', and advertising 'Fresh Cream Pastries' handwritten on its window, is a 1951 Ford Consul EOTA and another Morris Oxford MO, which is just over a year newer. *Commercial postcard*

Below The 35 service went by way of Chapel Ash, Merridale Road and Oxbarn Avenue before crossing the terminus of the 32 trolleybus route at the Coalway Road turning circle.

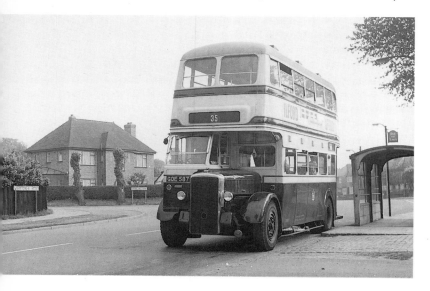

It then continued along the main Warstones Road, in company with the 46 bus for barely a quarter of a mile. Then when the 46 service turned into the Warstones Estate, the 35 continued through 1930s and later 1950s mixed municipal and private housing until it reached its terminus at Spring Hill Lane, to the left of the bus. About 400 yards away, up the hill, was the Penn trolleybus terminus. During early 1961, when the nearby Penn Road and Oxbarn Avenue trolleybus services were temporarily suspended, some of the 20 hired Birmingham City Transport Daimler CVG6 buses were employed on the 35 service, and here 1587 (GOE 587) is seen standing at the terminus on 10 February. Behind the bus Warstones Road curves away to the left to meet the main A449 Penn Road/Stourbridge Road junction at a traffic island about 200 yards distant. *D. R. Harvey collection*

Penn Fields

The town end of Penn Road as far as Lea Road was operated as part of Sampson Tharme's horse-bus service until the Corporation instituted its first motorbus service on 1 September 1905. This began by using a similar, hired Wolseley vehicle before DA 108-110, three Wolseley 20hp double-deck 34-seater buses, were delivered. The buses left their School Street terminus and went via Skinner Street before turning right into Victoria Street and proceeding out of town by way of Worcester Street as far as the edge of the industrial Victorian terraced housing just beyond St Paul's Church in Penn Road. The buses then turned off the main road into Lea Road, which had only been developed during the last decade of the 19th century, and proceeded as far as the Jeffcock Road junction with what was then known as Stubbs Lane. The route then turned away from the fields that lined what is today Birches Barn Road and went south-east along the short length of Stubbs Lane before terminating at Penn Road opposite Rookery Lane (see the map on page 56). These pioneering motorbuses were the first in the country to be operated by a municipal tramway, but over the next three years they became increasingly unreliable. On 10 September 1909 the Wolseleys were replaced by the last new tram route to be opened on the Corporation system, which must have been something of an 'act of faith' by the undertaking as Lea Road's housing petered out into open countryside that was not really developed to any great extent until after the end of the Great War. The tram route followed the former bus route to Penn Road, where it met the more sedate horse-buses of Mr Tharme.

The trams running the Penn Fields (4) route were converted to overhead current collection on 15 October 1921, and again this was the last of Wolverhampton's eight tramcar-operated routes to be so converted. The last tram ran to the now renamed Stubbs Road on 20 March 1927, and after a brief operational period when motorbuses were employed, the Penn Fields service was re-opened for trolleybuses on 11 July 1927, though only as far as the Lea Road junction with Stubbs Road and Birches Barn Road, where a new turning circle was placed. This rendered redundant the section of Stubbs Road up the slight gradient to the junction with Penn Road, but this would later be employed for the initial period of operating the 'main road' trolleybus service to Penn.

The Penn Fields route was extremely straightforward as it hardly altered from when the trams were introduced, let alone the later trolleybuses. Leaving Victoria Street's shopping area, the route continued into Worcester Street and passed into a mixed area of mid-19th-century industry and housing before reaching Lea Road. Here it forked right in front of what for many years was a corner dominated by the 1930s Art Deco Midland Counties Dairy, and passed up the gentle three-quarter-mile gradient of Lea Road, lined with mainly late 1890s and early 20th-century housing before reaching the terminus. Here, clustered around the staggered junction that also included Copthorne and Jeffcock Roads, were developed, in the early 1920s, a row of shops.

The 4 trolleybus service then continued unaltered for the next 30-plus years until the temporary closure of the route, together with the associated services to Penn and Oxbarn Avenue and the Jeffcock Road service, caused by the construction of the pedestrian subway on the corner of Victoria Street and Salop Street. The Penn Fields route was suspended on Monday 23 January 1961 and was operated by 20 Metro-Cammell-bodied Daimler CVG6s hired from Birmingham City Transport. The trolleybuses resumed on Monday 22 May on all but the Oxbarn Avenue route, but their return was brief and the Penn Fields (4) service, as well as the nearby Penn (11) route, was abandoned. As became usual with Wolverhampton Corporation's later abandonments, this took place on a Sunday, in this case 9 June 1963.

BIRMINGHAM POST, WEDNESDAY, JANUARY 25, 1961

OFF ITS BEATEN TRACK

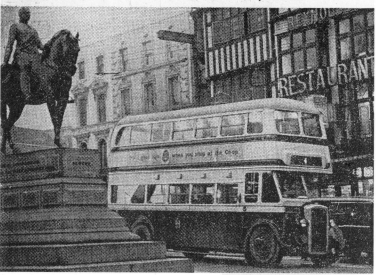

A Birmingham bus in an unfamiliar setting, passing the Prince Consort statue in Queen Square, Wolverhampton. It is one of 20 buses which have been hired from Birmingham City Transport to replace Wolverhampton trolley-buses while traffic is rerouted during work on the £30,000 pedestrian subway in School Street. The work may take up to ten weeks to complete.

Below The Penn and Penn Fields trolleybus services both terminated in Victoria Square opposite Swift's warehouse, in the centre of this view. Off to the left is Railway Drive and next to that is Walsh Graham's timber merchant at the top of Railway Street backing on to the LMS Railway's High Level Station tracks. Turning across Victoria Square is Guy BTX trolleybus 77 (UK 9977), one of the Guy-bodied 59-seaters built in 1931, of which the next vehicle in the batch, 78, resides in the Black Country Living Museum, having been found in a near derelict condition on a farm in Co Carlow in the Republic of Ireland. Standing in front of Swift & Company, who were wholesale meat merchants, is trolleybus 69 (UK 8769), which was also a Guy BTX but was fitted with one of the last of this style of body supplied by Christopher Dodson to Wolverhampton Corporation. This set-back upper deck found favour with the London 'pirate' operators that Dodson, together with Birch Brothers, supplied mainly on Leyland 'Titan' TD1 and TD2 motorbus chassis. Although the batch was homogeneously numbered 62-70, the last four had an earlier style of six-bay Dodson body, whereas the earlier vehicles had the more modern-looking five-bay design. The large building carrying the Wills's Gold Flake cigarette advertisement is the original Queen Street Railway Station, dating from 1849. *B. Baker collection*

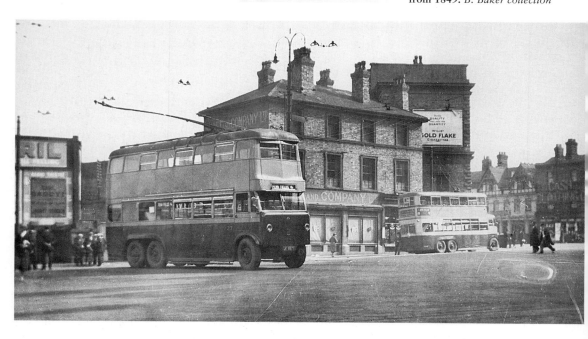

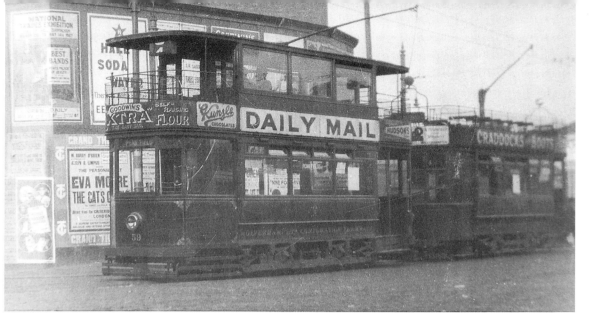

Above Loading up with passengers in Victoria Square is tramcar 59, adorned with advertisements for the *Daily Mail* and, more interestingly, Kunzle, the Birmingham speciality cake-maker. Car 59 is one of the nine English Electric 53-seater trams bought in 1920-21. Seven were covered-top double-deckers with enclosed vestibules and open balconies and were purchased in two numerical batches; 59-61, of the last group, were the first trams bought by the Corporation fitted solely for overhead power collection, rather then for the Lorain Surface Contact system. Next to tram 59 is open-topped car 33, built by Milnes in 1905. A number of tramcars were never top-covered as they were required to run under low bridges such as those on the Bushbury, Wednesfield and Willenhall routes. The well-known advertising hoardings in Victoria Square include one for Eva Moore (1870-1955), a well-known actress who appeared on both stage and screen and who was appearing in a play

entitled *The Cat's Cradle* at the Grand Theatre in Lichfield Street. *D. R. Harvey collection*

Below Turning across Victoria Square in 1966 in front of where the old Swift's warehouse used to be is an almost new Guy 'Arab' V, fitted with an MCCW H41/31F body. To the right of the bus is the splendid Victorian frontage of the Prince Albert hotel and public house in Railway Street, with a Commer Superpoise van belonging to the local Goodyear Tyre Company passing in the opposite direction. In front of the Danish Bacon advertisement is a line-up of three black and white taxis where the trolleybuses used to park before the war. The furthest taxi is an Austin A55 Farina, while the two nearer ones are the later A60 model. It was at about this time that new street lighting was being installed in Victoria Square, which would quickly replace any redundant traction poles. *M. Fenton*

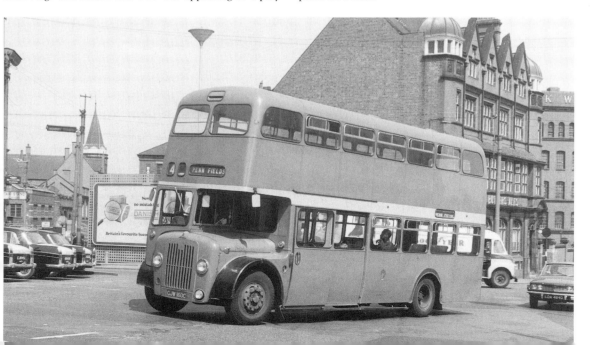

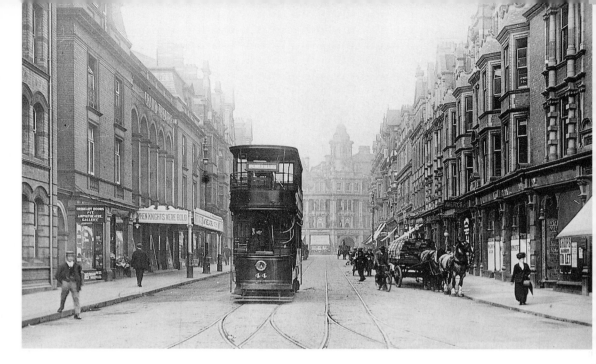

Above UEC-built open-top tramcar 44, of 1908 vintage and fitted with a top cover after 1911, travels up Lichfield Street towards Princes Square. It has just left the town terminus near the entrance to the railway station in Victoria Square working on the Penn Road route. In the foreground the tram tracks converge, those on the right coming from Victoria Square and those on the left from Lichfield Street and Piper's Row. Noticeable is the lack of overhead wiring, although as is regularly the case with Wolverhampton Corporation tramcar scenes, the Lorain system studs that were situated at intervals between the tracks also cannot be seen. Car 44 is passing the Grand Theatre, built in brick in 1894 to the design of C. J. Phipps and showing the play *When Knights Were Bold*. It had opened on 10 December 1894 with a production of the Gilbert & Sullivan operetta *Utopia Ltd*. Between the theatre's main sign and its canopy is a five-bay loggia of arcading. To the right of car 44 are the large premises of the Wolverhampton District Co-operative Society, which remained at this site, albeit in modernised premises, until the store closed down in 1987. Beyond the theatre is the multi-gabled post office, while at the Princes Square end of the street is the Royal London Buildings with its unusual dormer windows. *D. R. Harvey collection*

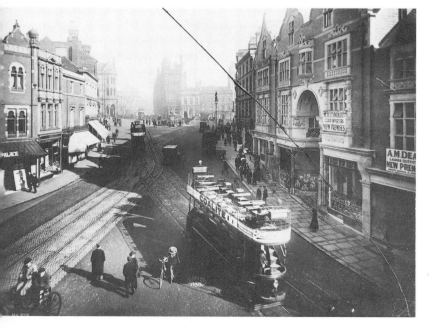

Left In about 1909 tram 48 has travelled up the Victoria Street hill on its way into the town centre from Penn Fields, and is about to cross the points at the junction with Darlington Street, which is where all the services running in from Chapel Ash and beyond entered the town. In the background is Queen Square, which as late as the 1870s was a Georgian square surrounded by elegant town houses. The tall building with the unusual dome is the Gothically styled Midland Bank, built at the end of the 1870s. In front of the bank is the statue of Prince Albert on his horse that originally faced towards Dudley Street rather than, as here, pointing down the hill towards Darlington Street. Just visible in the square is the centrally located cabin occupied by horse-cab operators, a few of whom can be seen plying for hire. The Penn Fields tram route opened on 10 September 1909 and tram 48 was built in that year by the United Electric Car Company as an open-topped 51-seater using the usual

Lorain Surface Contact system. Just how steep this hill is can be measured by the stepped drops of the roof-lines of the buildings coming away from Queen Square. On the extreme left is the Empire Palace Theatre, opened in 1898 and until the late 1920s *the* Music Hall in Wolverhampton. It was renamed the Hippodrome in 1921, and spent one year in 1931 as a cinema while the old Agricultural Hall in Snow Hill was converted to the Gaumont Palace. The Hippodrome burned down in 1956 after a period of being reduced to showing what in the USA would be called 'burlesque', and after rebuilding it re-opened as a furniture store. To the right of the tram are almost brand-new shops begun in 1906 and completed in 1909, including Queens Arcade. W. H. Hinde proudly proclaims that it has just moved into these newly opened premises, as does the owner of the ladies' outfitters next door. *B. Baker collection*

Below One of the four Guy-bodied Guy BTX trolleybuses delivered in November 1931, 81 (JW 581), turns from Victoria Street into Queen Square working on the Penn Fields service. In front of it is the Hippodrome Theatre, the former Empire Palace. In its heyday such stars as Cockney comedian Harry Champion and Charles Coburn, whose career spanned over 70 years, appeared here. George Formby Senior, 'The Wigan Nightingale', also appeared many times at the Hippodrome. He had a terrible hacking cough that he used to his own advantage by saying on stage, 'Ee, I'm coughing better t'night'. Unfortunately he had terminal TB, which killed him at the age of only 44. There was also Mark Sheridan, one of many comedians who

graced the stage wearing ludicrous clothing with his absurd bell-bottom trousers, tight coat and tall black hat. His big songs were 'I Do Like To Be Beside The Seaside' and 'Who Were You With Last Night?', but despite his success at the age of 51 he committed suicide in a public park in Glasgow after successfully opening in a revue. Slightly later, in 1928, the great Max Miller appeared at the Hippodrome, as did on other occasions Billy Bennett, Robb Wilton, Arthur Lucan, better known as 'Old Mother Riley', and a young Peter Sellers. Almost the last comedian to top the bill just before the theatre burned down was Arthur English, doing his Cockney 'wide boy' act. Next door to the theatre on the corner of Queens Square and North Street is Baker's seed shop, which advertised itself on its blind variously with 'Baker's Seed and make the most of your garden' and, in this case, 'Baker's Seeds "come up" to expectations!'. Incorporated into the front of the theatre and next to the seed store was the luxurious Hippodrome Lounge Bar.

Behind the Keep Left sign and the impressive Automobile Association finger-posts is North Street, and halfway along the French-styled roof of the Town Hall is just visible. Designed in 1869 by Ernest Bates, it was opened on 9 October 1871 at a cost of nearly £20,000. Behind the trolleybus, from the corner of North Street and down the Darlington Street hill, are many late-18th-century Georgian properties that have survived to the present day. The building on the corner of North Street was for many years the Pearl Assurance Company and sported a rather attractive clock, which is just visible above the trolleybus in the curved corner brickwork. *B. Baker collection*

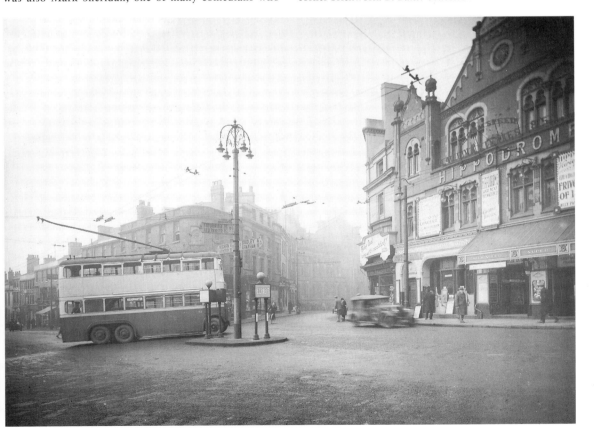

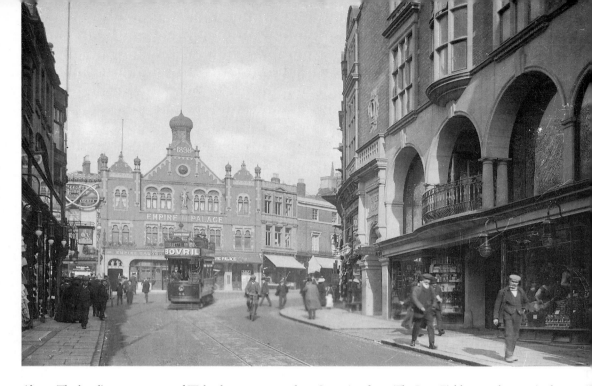

Above The bustling town centre of Wolverhampton around the end of the Edwardian era suggested that this important urban centre might in due course be elevated to city status. It had all the attributes of a city: the large St Peter's Collegiate Church, most of which dates from the 15th century, in Lichfield Street, three important squares, Princes, Queen and Victoria, associated with the reigning House of Saxe-Coburg-Gotha, two large railway stations, an industrial base that was the envy of many smaller places in the country, and a prosperous shopping centre supported by an equally important wholesale market area. In addition, it already had important civic buildings, a number of large theatres and its own somewhat idiosyncratic municipally owned tramway system. It also had, in Wolverhampton Wanderers, one of the 1888 founders of the Football League, who had moved into their Molineux ground on 2 September 1889 from a previous site near Fighting Cocks. City status was finally achieved in December 2000. This evocative photograph of the top of Victoria Street, with Queen Square beyond, captures a pre-First World War summer's day in Wolverhampton. No man is without a hat and the few women and the one young girl in the picture are all wearing long dresses. Even the conductor on the back platform of the disappearing tram 44 is wearing a small cap. Without the obligatory trolleypole, the tramcar is clearly operating on the Lorain system; in the foreground, between the tram tracks, are the studs from which it is obtaining its power. Tram 44 was the first of the 1908 trio of open-top trams built by UEC and mounted on Mountain & Gibson 21EM trucks. Beyond the tram is the Empire Palace, while on the right is the recently opened Queens Arcade block of shops and arcades, on which today is built the Mander Centre. *D. R. Harvey collection*

Opposite above The Penn Fields motorbus service began on 1 September 1905 and ran from the town terminus in School Street, turning left into Skinner Street before turning into Victoria Street just above the Cleveland Street junction. It then continued into Penn Road, before forking right into Lea Road, passing Graisley Old Hall and terminating at the Stubbs Lane-Jeffcock Road junction, which in 1905 was still undeveloped open countryside. O-WY-39, painted in green and yellow and bearing the legend 'Wolverhampton Tramways' on its rocker panel, is standing alongside a horse-bus with a third trace-horse in Skinner Street on the first day of operation. The choice of petrol buses, which at this time were still something of an unproven quantity, was made because in order to operate tramcars the roadway had to be wide enough to comply with Board of Trade Regulations. In 1905 Lea Road was still, in part, a country lane, so a motorbus service seemed the obvious choice of public transport. This bus was hired from the Wolseley Company of Birmingham to open the service on that Edwardian Friday and its unusual registration was an early form of trade plate, having white letters on a blue background. It was issued by Birmingham BC to Wolseley as a dealer's plate at the end of 1903; WY was for Wolseley, while Birmingham also issued AY to Alldays and LR to Lanchester. This 20hp double-decker demonstrator remained in service until 21 October 1905, when the three buses of a similar type ordered from Wolseley became ready for service. They were registered DA108-110 and their entry into service made Wolverhampton Corporation the first municipal tramway operator in the country to use buses, although Eastbourne Corporation had been the first municipal operator of buses in Britain some two years earlier. Although only seating 18 upstairs, 16 downstairs and two alongside the driver, each bus weighed around 4 tons, which meant that its horizontally opposed, flat-twin-cylinder engine over which the driver sat would have been working quite hard with a full load up the hill at the start of Penn Road. *O. Wildsmith collection*

Below Travelling into Wolverhampton on the Penn Fields service is open-topped tram 36, which has just left the Mander Street stop on Penn Road. On the corner of Mander Street is the Penn Road Grocery & Provision Stores, in the doorway of which white-aproned Mr G. Colman is standing proudly. Hanging above his head appears to be a number of unplucked chickens, while his window display includes rows of neatly stacked tins. Coincidentally, one of Mr Colman's painted signs above the shop is for Colman's 1/7 tea. Next door to the Colman emporium is a Circulating Library, while further down the block is A. Tandy's family butchers shop. This view of Penn Road was taken during the early months of the operation of the Penn Fields electric tram service, not long after it had opened on Friday 10 September 1909. The tram, as usual working on the Lorain Surface Contact system, is car

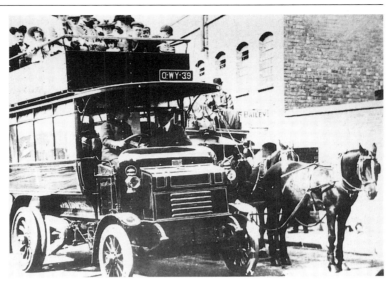

36. This open-top tram was built in mid-1905 by UEC to the designs of the recently taken over G. F. Milnes & Co, trambuilders based at the Castle Car Works at Hadley, Shropshire. The horse and cart was still the most common way of moving goods about, which is further reflected in the positioning of a horse post on the corner of Mander Street. On the right are elegant, stone-faced early-19th-century houses that contrast with the distant grim-looking Victorian tunnel-backed terraces and the chimney of the Phoenix Lock Works in Great Brickkiln Street. Beyond the elegant houses, towards the town, are the twin pinnacle towers of St Paul's Church on Penn Road before the Worcester Street junction. The church was built in 1835 to the designs of Robert Ebbles, a local architect who specialised in churches. It was built in a mixture of 13th-century and 15th-century Gothic styles, its impressively tall nave having a large clerestory. Unfortunately the two twin west towers rather lacked the necessary gravitas, though the Bishop of Lichfield, at the church's consecration, said that it was 'a noble and well-accommodated edifice'. The first vicar was the Rev William Dalton; appaently the church was largely funded by his wife's estate in order for him to have his own church. *Commercial postcard*

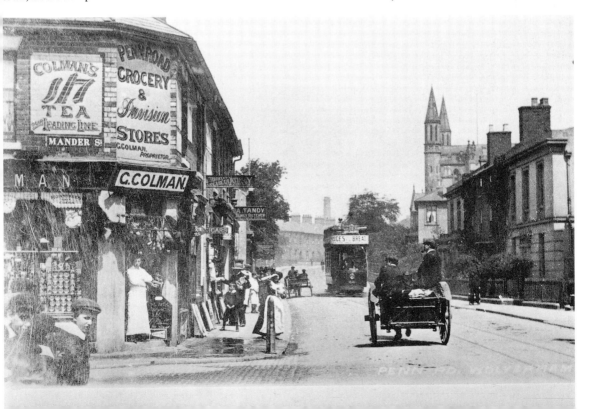

Below In the distance the tea advertisement on Colman's shop can be seen on the corner of Mander Street. The houses along Penn Road between Mander Street and Lea Road, on the left, were built by speculative builders in the 1880s and were therefore of different styles and sizes. This was about the limit of Victorian urban growth along the main road, as after this point, behind the photographer, there was just a series of large houses at the edge of the town. Lea Road was being developed at this time and many of the side roads had been laid out, but not all the plots had been filled by the time this photograph was taken in about 1910. The Penn Fields tram route turned off Penn Road here, leaving, somewhat surprisingly, the main road unsullied by the tram system. This was despite electric trams having been authorised under the 1899 Wolverhampton Corporation Act along Penn Road as far as Stubbs Lane, which was rather confusingly later renamed Stubbs Road. As planned, there was originally to have been the Lea Road route, a second short section along Stubbs Lane and a third along Penn Road to complete a triangle (see the map on page 56). Only the first two were

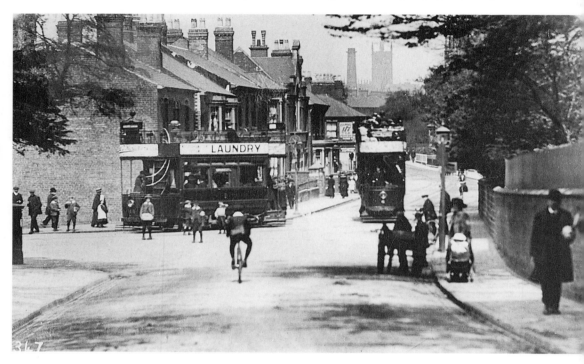

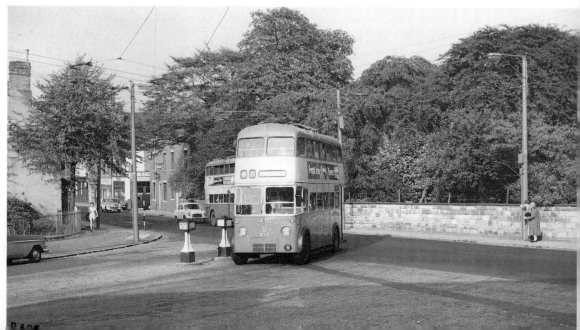

constructed, and the Lea Road route opened on 10 September 1909, making it the last complete tram route to be built on the Lorain stud system. Car 45, the tram with the Wolverhampton Steam Laundry advertisement on its side, is about to turn from Lea Road into Penn Road on its way into town; it was the second of six open-top trams built by UEC and mounted on Mountain & Gibson 21EM trucks. Delivered in the winter of 1908, together with the other five it was used for many years almost exclusively on the Penn Fields service. Coming out of Wolverhampton along Penn Road is car 6, one of the original four G. F. Milnes-constructed open-top, reverse-staircase double-deckers that had been part of the original Corporation system of 1902. *Commercial postcard*

Below left More than half a century later, on 2 September 1961, Roe-rebodied Sunbeam W4 433 (DUK 833) turns into Lea Road, passing a pair of splendid pre-war Keep Left bollards, while working on the 4 route. Wolverhampton's post-war standard destination number display was in two distinct boxes, and single route numbers appear to have been fairly arbitrarily displayed in either. In later years 433 would have the distinction of becoming the only active preserved Wolverhampton trolleybus of the four that have survived. The turning into Lea Road took the trolleybuses, like the original trams, to Penn Fields. After the tram service was converted to trolleybuses on 11 July 1927, after a brief interregnum of buses, it was another five years before trolleybuses got to Penn, and even this was by way of Penn Fields and Stubbs Lane on 10 October 1932. The direct service, straight along Penn Road, was not instigated until 8 April 1935, leaving the original part of the tram route along Stubbs Road to be closed for trolleybuses on 13 October the following year. After that date the Penn Fields trolleybus service effectively became a branch line off the main Penn Road route. To the rear of 433 is a Park Royal-bodied 8-feet-wide trolleybus working straight on towards Goldthorn Hill and distant Penn. Behind is a very

late side-valve Ford Popular 100E two-door car. Through the trees along Penn Road, on the corner of Sidney Street, is the furniture repository of Pickfords, being passed by a Hillman Minx Phase VIIIA 'Gaylook' two-tone-paint de-luxe saloon. *J. C. Brown*

Below For many years the junction of Penn Road and Lea Road was dominated by a large house called 'Hillside', which stood in its own grounds and had a lodge on the Penn Road side and large glasshouses near the Lea Road flank of this triangular site. At the end of the 1920s the house was demolished and with it went the lovely wooded garden. The site was bought by Midland Counties Dairy, and in about 1930 construction of the new dairy building is well under way. It was an Art Deco-styled, pre-stressed concrete, two-storey building built by E. C. & J. Keay, engineers and builders based in Darlaston. The Midland Counties Dairy Building outlived the trolleybuses, but was closed in 1984 and demolished in 1988 when further redevelopment included changing this section of Penn Road into a dual carriageway. At the apex of this junction today is a MacDonald's Drive-Thru restaurant. Speeding down Penn Road is what at first sight looks like a pick-up van, but is in fact a large two-door Star Sportsman's coupé. Behind it is a piece of street furniture that has hardly changed in a century, a post-box. One of the Guy BTX trolleybuses, 57 (UK 6357), has turned into Lea Road on its way to Penn Fields. This large Dodson-bodied 61-seater six-wheeler dated from May 1929 and was one of a batch of five. Although they had an antiquated front profile, they were among the first double-deck trolleybuses in the country to have fully enclosed staircases and rear platforms. Coming towards Penn Road in the distance is one of the slightly later 62-70 class, which is passing the house numbered 242 Lea Road on the corner of Retreat Street. The traction pole on the right-hand corner carries a bus stop, a location that today would be considered dangerous. *B. Baker collection*

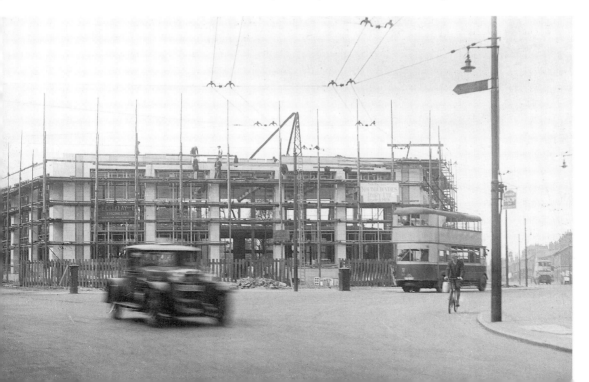

Below Viewed looking towards Penn Fields, Lea Road is lined with older 1890s bay-windowed terraces on the right and larger villas on the left. Halfway along, where Oaklands Road on the left and Owen Road on the right cross Lea Road is where Lea Farm was situated. Many farms were swallowed up in this rapid period of urban expansion, not only because of the growth of urban engineering industry but also because of the appalling conditions in which farmers had to work during the latter part of the 19th century. Therefore when a farm was faced with the encroaching houses of an expanding town, where better paid work was available, and the land came under threat from prospective developers, it was easier for the struggling farmer to 'take the money and run'. Old country lanes, like the one to Lea Farm, became main roads, including briefly an undeveloped section in Lea Road that gained the nickname 'The Khyber Pass'. Meanwhile, side roads such as Oaklands Road, Lonsdale Road and Claremont Road followed the lines of old field boundaries and remain as reminders of long-forgotten farmland patterns. On 22 June 1961 empty Sunbeam F4 trolleybus 624 (FJW 624) is being overtaken by diesel-engined Guy 'Arab' III bus 559 (FJW 559); both have similar composite-framed Park Royal 54-seater bodies. The Guy bus is operating on the 4 service because the town end of the trolleybus power supply has failed; beyond the power feeder cables above the bus, the overhead in Lea Road is still 'live'. The driver of 624 has managed to park his trolleybus properly against the kerb and, although 'beached' like some helpless whale, it is not causing a traffic obstruction. No doubt elsewhere in the town there were chaotic scenes before powerless trolleys could be man-handled out of the way; unlike many other systems, Wolverhampton's trolleybuses were not equipped with traction batteries for manoeuvring purposes. Where the corner shop is glimpsed between the bus and the trolleybus is Owen Road, along which, only 200 yards away, is the Jeffcock Road trolleybus route. *J. C. Brown*

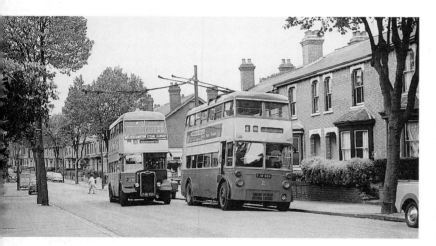

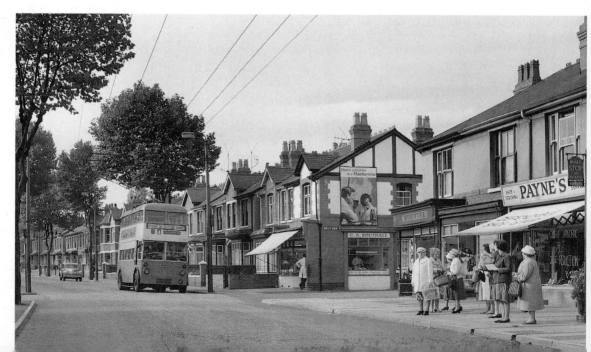

Below Further up Lea Road on 20 September 1961 trolleybus 640 (FJW 640), a Guy BT that entered service in December 1949, is passing the Bruford Road junction, followed by a pre-1952 Morris Oxford MO. One wonders if the ladies standing at the trolleybus stop have taken advantage of Harry Payne's 'Great handbag sale' with '20% reductions'. The shop on the corner of Bruford Road is G. A. Southall's butcher's business, which served the area for many years. Mr Southall did not live above the premises but owned a house further up Lea Road towards the trolleybus terminus. He can be seen through the shop window butchering a piece of meat. Opposite Bruford Road is Carlton Road, which leads to the hidden 16th-century gem of Graiseley

Old Hall, part of which is considerably older. On leaving the stop, the trolleybus will pass the United Reform Church on the corner of Claremont Road. The church was consecrated in 1905 'to serve the growing suburb', as was stated at the time, and it was extended in 1932. A decline in the congregation and the need for repairs led to the original building being used for the last time on 17 July 1994, after which it was demolished. However, unlike many other places of Christian worship that become time-expired, the United Reform Church consecrated a new House of Worship on the same site on 24 February 1996. *J. C. Brown*

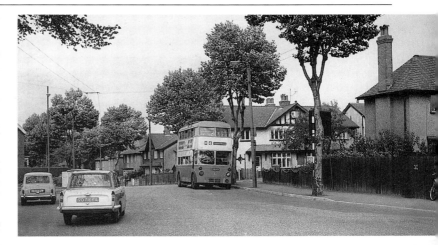

Above right Having reached the end of Lea Road, Guy BT trolleybus 499 (FJW 499) also approaches the end of its journey from Wolverhampton and enters the short section of Jeffcock Road in which the Penn Fields terminus was located. The trolleybus is passing the junction of Copthorne Road on the right, and is slowing down for the stop at the terminus opposite Jeffcock Road, into which the Mini is turning. The West Bromwich-registered Triumph Herald of June 1961 is about to follow the trolleybus wires into Lea Road towards the town centre. It is Saturday 16 September 1961 and the trees in this part of Wolverhampton's 1920s suburbia are still in full leaf. The Park Royal-bodied trolleybus still looks smart after its final repaint, which was completed during the previous February. The petrol station on the corner of Stubbs Road has not yet been extended as far as Copthorne Road, and the occupiers of the house on the right are presumably still in blissful ignorance of the future fate that will befall their property. *J. C. Brown*

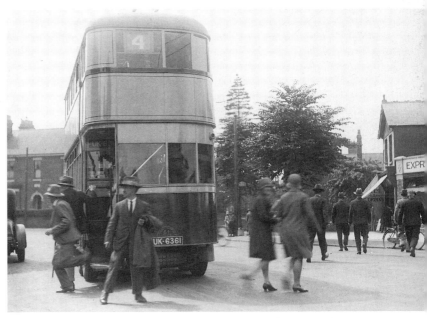

Above right With Duke Street beyond the trolleybus and Birches Barn Road to the right, one of the first generation of Guy BTX trolleybuses with Dodson bodies stands at the arrival stop opposite the sweet and tobacconists shop at the terminus of the 4 service to Penn Fields at Jeffcock Road. Trolleybus 61 (UK 6361), an almost new six-wheeler fitted with a Rees-Stevens 60hp motor, has not pulled into the kerb because of the large parked car on the left – nothing is new! The passengers appear not have read the script notice just below the platform bulkhead window, stating that 'Passengers entering or leaving … do so at their own risk' as they alight into the road and cross towards the shops with scant regard for the approaching cyclist. In this evocative 1929 scene, a reflection on etiquette and society norms of the day is that everyone in the photograph is wearing some sort of headgear. Once empty, the trolleybus will do a U-turn at the island and reload for the journey back into the town centre outside the shops, where, underneath the bus

stop, there are already two women waiting. Trolleybus 61 was bodied by Christopher Dodson of Willesden and, as the Hackney Carriage licence plate displays, it was a 61-seater. It was also the last trolleybus in the fleet to have two steps on to the rear platform, which although enabling the floor-line into the lower saloon to be on the same level, meant that the two young women with their fashionable cloche hats and shapely calves would have had to be careful not to have revealed more when negotiating the second steep step. Twenty-eight similar trolleybuses were delivered to the Corporation between 8 July 1927, when Guy BTX 34 (UK 634) entered service as the first trolleybus in the fleet to have an enclosed staircase, and the arrival of this vehicle on 15 May 1929. It survived in use until 31 October 1940 together with trolleybus 60, but in company with 59 and 60 remained in store at Park Lane garage until sold in August 1943 to Cashmores of Great Bridge for scrap. *B. Baker collection*

Below One of the five Guy BTX trolleybuses of February 1934, 201 (JW 3401), with a Birmingham Corporation-style Metro-Cammell 58-seater body, is parked at the terminus at the inbound stop in the short section of Jeffcock Road outside Edmunds stationery, newsagent, tobacconist and confectioners shop. The trolleybus is virtually new, judging by the excellent condition of the paintwork. At the end of its career, together with all the other Birmingham-style-bodied trolleybuses with the exception of 99, it was painted in the wartime economy all-over green livery, which looked, when compared to this view, very drab. This trolleybus had Electric Construction Company (ECC) 75hp traction motors with regenerative braking control, enabling excess electrical current to be returned to the overhead when the trolleybus braked. This made the system more economical, but presented difficulties with voltage power-surges that could cause damage to the contractors, resistances and even the traction motors as well as making light bulbs burst! As a result of these problems, alternative braking methods, such as rheostatic, vacuum and air, were employed as regenerative control fell out of favour. Inbound trolleybuses and motorbuses did not display a route number, so 201 has its destination blind set for 'WOLVERHAMPTON', where all trolleybuses ended their journeys. These trolleybuses, with their metal-framed bodies, were a great improvement in terms of looks, equipment and passenger comfort over trolleybuses built even only three years earlier. *J. Hughes collection*

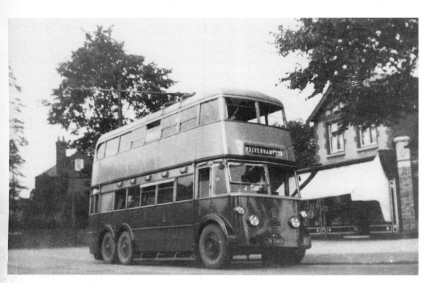

Below A late 'high-headlight' Morris Minor MM travels along Duke Street towards the traffic island at the Penn Fields trolleybus terminus. In the days before road signs became standardised, various bodies combined to produce the necessary information. In this case, the RAC was responsible for the roundabout sign next to the traction pole, while the local authority put up the direction sign, black with an orange background, next to the tree. Spring bulbs decorate the traffic island beneath the powerless trolleybus overhead, as this was during the four months in early 1961 when the 20 hired Birmingham City Transport buses were covering for the temporarily suspended trolleybuses. As in years gone by, the canvas sunblind of the shop on the corner of Jeffcock Road and Birches Barn Road is pulled down as Birmingham Daimler CVG6

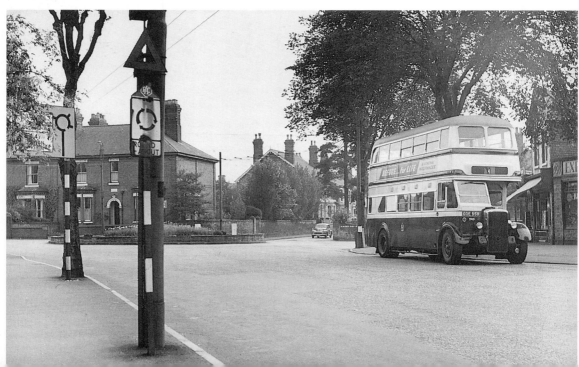

1559 (GOE 559) stands empty at the loading-up stop waiting for custom before heading back to Chubb Street in the town centre. This bus was numerically the first and the oldest of the hired Daimler CVG6s, but despite its age the condition of the bodywork and paintwork are remarkably good. The Birmingham MCCW-style bodywork has a distinct 'family resemblance' to that of trolleybus 201 built some 13 years earlier. Shortly the bus will move away, and on 21 May 1961 it will move away for good, leaving the trolleybuses to resume the 4 route. *W. A. Camwell*

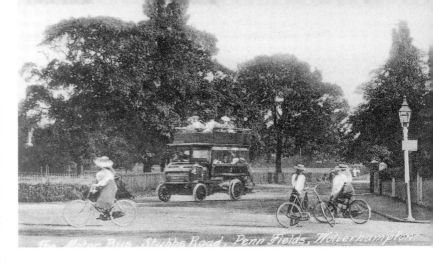

Top right The Penn route to the Rose & Crown was served by local operator Sampson Tharme's horse-buses from 1882. A new route, by way of Lea Road and Penn Fields, began in about 1890, but after the Wolverhampton Corporation Act of 1899 had included the Penn Fields route, Tharme's service seemed continually under threat. Because of problems in widening the road to Penn Fields, the Corporation, realising the need to rid themselves of the old-fashioned horse-bus services, utilised its powers under the Wolverhampton Corporation Act of 1904 to operated 'mechanically propelled' omnibuses. A three-week trial using a Wolseley demonstrator began on 1 September 1905. Similar Wolseley double-deckers, with their high driving position over the two-cylinder horizontal engine, rather like a Paris-operated Renault single-decker of the late 1920s-1940s, were also supplied to London General, the GWR and CBT. Such was the demonstration vehicle's success that three identical 20hp Wolseleys were purchased,

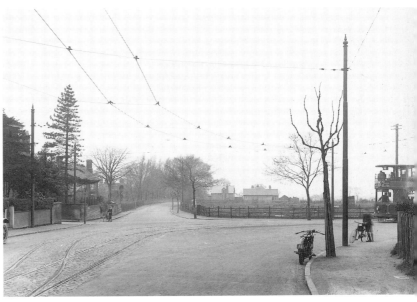

registered on 24 October as DA108-110, and painted dark green and deep yellow. They entered service on the Penn Fields route in November 1905, and ran for nearly four years until 20 July 1909 when the necessary road improvements allowed the long-delayed tram route to be constructed. This gave the Penn Fields service the unusual sequence during municipal operation of motorbuses, trams and trolleybuses before finally reverting to bus operation. Here one of these Wolseleys is coming down Stubbs Lane from Penn Road, and travelling on the open top deck are a number of women wearing large-brimmed summer hats. Riding in front of the bus, in Birches Barn Road, which was then a country lane, are three emancipated young Edwardian ladies on their bicycles. A garage was subsequently built on the open space on the left. *J. Hughes collection*

Above right The 4 tram route to Penn Fields was converted to overhead operation on 15 October 1921, making it the last of the original Lorain Surface Contact system to be replaced. Tram 59 waits to leave the stop at the top end of Lea Road before taking the tracks in the foreground into

Stubbs Road and standing in the only loop in that road. There the driver could see up to the terminus at the Penn Road junction and wait until the tram at the top of the hill had descended Stubbs Road and entered the other side of the loop. This tram was numerically the first of three to be ordered from the English Electric Company on 10 August 1920. These double-deckers were top-covered with open balconies and seated 22 in the lower saloon and 31 in the upper, and were the first to be equipped solely for overhead current collection. They arrived in early 1921 without trucks and were fitted by the Corporation with reconditioned trucks from scrapped single-deckers, car 59 getting a DuPont truck from the old Milnes combination car 4 of 1902. For such a comparatively new tramcar, it is a pity that they only had a life of about 7½ years. Parked against the kerb is a locally built and registered early-1920s motorcycle. Disappearing into the trees is the largely undeveloped Birches Barn Road before the construction in 1926 of Beckminster Methodist Church, and the rows of houses built not long after the trams were abandoned on 20 March 1927. *B. Baker collection*

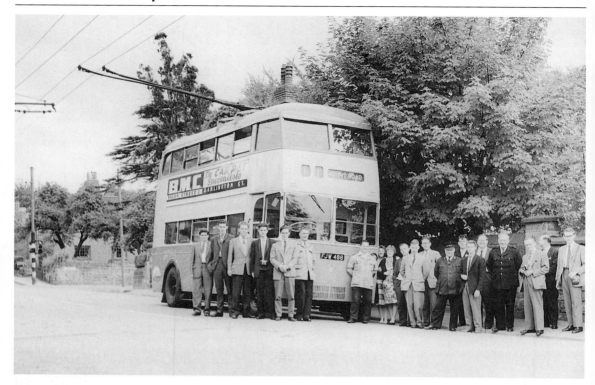

Standing near the traffic lights at the junction of Stubbs Road and Penn Road on 7 August 1961 is Park Royal-bodied Guy BT trolleybus 488 (FJW 488). This vehicle had only completed a repaint on 31 July, and because of this was chosen as the trolleybus for a TMS tour of the Wolverhampton system. Beyond the traffic lights is Rookery Lane, leading to Goldthorn Hill. The original Stubbs Lane tram terminus was located at the Penn Road junction, and when the Penn Fields route was converted to trolleybus operation on 11 July 1927 the quarter-mile of Stubbs Road, as it was then called, was not used for any services. Then, from 10 October 1932 the Penn Fields trolleybus service was connected up for the new 'trackless trolleys' to reach the new terminus at Spring Hill Lane, Penn, via Stubbs Road. However, after 13 October 1936 the link between the Penn Fields terminus and Penn Road was taken out of use at either end of Stubbs Road. The wires were finally severed about 1946, although the road remained fully wired and capable of being energised; it therefore had workable wiring for more than 25 years, but no physical means of getting on to it! As a precaution, a motorbus, Daimler CVG6 509 (FJW 509), met the TMS party with an extra set of trolley retrieval poles in case they were needed for manoeuvring 488 at either end of the unconnected overhead. In the event they were not required because of the skill of the trolleybus driver, Harry Palmer, who used the momentum of his acceleration across the junction at the top of Stubbs Road to reach the Penn Road wiring. After that, all the other wire exchanges could be undertaken using gravity to propel the 7 tons 17 cwt trolleybus on to the next set of live wires. This was the last time that the Stubbs Road wiring was energised, and within a few days it was isolated from the Penn Road and Penn Fields overhead, being finally dismantled in 1963. In front of the trolleybus are the members of the tour and Corporation Transport Department staff. The late Cliff Brown, whose excellent photographs are found in this volume, is on the extreme left, while his wife Iris is standing to the right of Pam Hughes, both of whom are next to the nearside of the trolleybus. Next to Inspector Howard Davies is co-author John Hughes, while Driver Harry Palmer stands with conductor Wally Cox at the front of the trolleybus. This is also a Cliff Brown photograph and was taken with a camera on a tripod with a time-delay shutter, which is why he is in the picture and not behind the viewfinder! *J. C. Brown*

Thompson Avenue

The Thompson Avenue bus service opened in November 1927 as the 14 route, and was linked to the Claregate service that had begun just under two years earlier on 26 November 1925. Eventually the routes were differentiated by the addition of the letter 'A', when buses worked north-westwards to Claregate. In addition, the service extension to Codsall was numbered 15 when it began on 10 December 1934. By June 1953 there were also journeys from Thompson Avenue across the town to Blakeley Green, numbered 34. Thompson Avenue then settled down as the terminus of two cross-town routes for the next 12 years. An

experimental one-way-street system in the town centre was tried out for a week, beginning on 18 October 1965, and this necessitated the cutting of the cross-town routes. As a result, the Queen Street to Thompson Avenue section operated as the 97 service, leaving the route as little more than a shuttle service.

The route itself, bearing in mind that it followed for its latter part the main A4123 road to Dudley and Birmingham, was one of the most disappointing main exit routes from any town in the West Midlands. On leaving Queen Street with its lovely early-19th-century buildings, the route turned left into Market Street and across Bilston

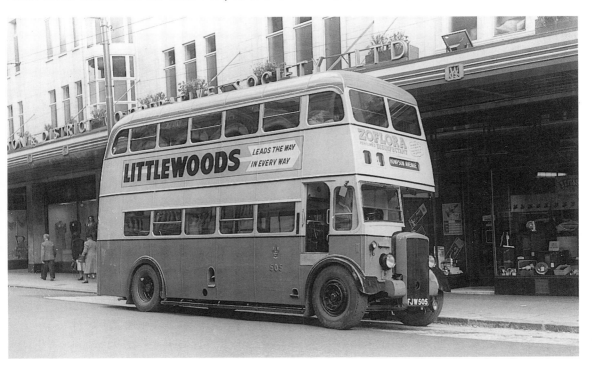

The cross-town 14 service passed along Lichfield Street from Princes Square as it went to the main picking-up point in Victoria Square, before leaving on its journey to Thompson Avenue. Dominating Lichfield Street on the opposite side from the Grand Theatre is the Wolverhampton & District Co-operative Society building. This dates from the end of the 1930s, although it was not fully completed until after the war, and had an Art Deco look about its canopy, with the WCS motif on its outer edge. Smartly repainted Brush-bodied Daimler CVG6 505 (FJW 505), which entered service in the spring of 1948, with its original dark grey roof now in the later green livery to match the lower saloon panels, stands in front of the Co-op department store in 1954. It is strange that while a number of these buses, including 505, would be taken out of service as early as 1961, identical vehicles would remain in use for another ten years, some two years after the West Midlands PTE took over the Corporation bus operation on 1 October 1969. *S. N. J. White*

Street at the ABC Cinema in Garrick Street. Here it turned left towards Cleveland Road depot before turning right into Vicarage Road alongside the former Wolverhampton & Staffordshire General Hospital. Passing through an area of late Victorian streets, the 14/97 service then turned on to Birmingham Road by way of Brown Street. At the time of the opening of the bus service, the extension of Birmingham Road, which beyond Napier Road became Thompson Avenue, was being developed with municipal housing. Unlike, for example, the Tettenhall Road, Compton Road or Stafford Road routes, the Thompson Avenue service gently meandered its way towards its terminus at a half-moon-shaped turning circle at Parkfield Crescent via the junction with Dixon Street, on whose corner stands the Jacobean-inspired Black Horse public house, the only significant landmark before the

terminus. The buses turned round just short of Parkfield Road, which was used by the inter-suburban 25 trolleybus route between nearby Fighting Cocks, Bilston and Willenhall.

Beyond this junction lay the dual carriageway of the Birmingham New Road, which led towards Coseley UDC. The road had been opened by the then Prince of Wales on 2 November 1927 and had provided work for a lot of otherwise unemployed men. Coseley was skirted into by the Corporation's buses from Bilston, but the main A4123 road link, which must have looked so enticing to the Corporation's Transport Committee, was always the domain of Midland Red. This therefore left the Thompson Avenue service, despite its apparent importance, always doomed to be something of a cul-de-sac for the Corporation's bus services.

Below Travelling out of Wolverhampton's Victoria Square and turning into Piper's Row in about 1950 is an almost new Corporation bus, Guy 'Arab' III 6LW 391 (FJW 391), with a Brush H28/26R body, working on the 15 service from Codsall to Thompson Avenue, which, since it opened on 10 December 1934, was the only cross-town bus service to pass through the town centre. Before the route renumberings of June 1949 this had been the old 14 route in this direction, though confusingly it could have come from either Codsall or Claregate. On the right is the former grand entrance to the carriage drive of the High Level Station, built in 1849 in grey brick in an Italianate style by the LNWR, while behind it, in the shadow of the bus, are the premises of Swift's, the wholesale meat merchants. In the distant Victoria Square, facing towards Lichfield Street, is Sunbeam F4 trolleybus 459 (FJW 459), working on the 1

route to Tettenhall; like the bus it has a dark grey-painted roof, a style that had been retained from the days of wartime camouflaging as part of the fleet livery. Above the advertising hoardings on the far side of Victoria Square is the towering gable end of the Prince Albert Hotel. Guy 391 is displaying an advertisement for Cephos headache tablets, which might be needed after indulging in the Littlewoods Football Pools being advertised on the trolleybus. The trolleybus was withdrawn prematurely in late February 1961 after having been involved in an accident in First Avenue, Bushbury, while the Brush-bodied 391 was not withdrawn until late 1968. Brush composite bodies were not known for their longevity, but this particular vehicle managed 18 years of service, being eventually withdrawn when its platform rotted away and it was not considered an economic proposition to repair. *A. B. Cross*

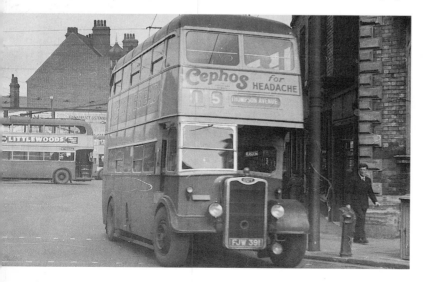

Opposite above By the time Wolverhampton Corporation's first 30-feet-long double-decker was photographed passing along Piper's Row in the early 1970s, it was in the ownership of the WMPTE, but was still in the old Corporation green and yellow livery. It had been a 1958 Commercial Motor Show exhibit on the Burlingham body-builder's stand; it had a forward-entrance 68-seater body, and was to be the first of many in the Wolverhampton fleet equipped with a sliding entrance door. The bus was also unusual for a Guy in having a fully automatic epicyclic gearbox, but the 1958 show saw far more revolutionary vehicles, of which the rear-engined, large-capacity Leyland 'Atlantean' would be the most influential. No 19 (WUK 19) was equipped with a full-front-style body

that was very similar to the 105 supplied by the Blackpool-based coachbuilder to Ribble Motor Services at about this time. Wolverhampton never went back to Burlingham's for another bus body, and although it was influential in future body layouts, it was never repainted into the blue and cream livery of the WMPTE before its withdrawal in 1974.

Piper's Row led away from the junction of Walsall Street and Bilston Street, and was opposite the churchyard of the elegant, classically styled St George's Church, designed by James Morgan in 1828 and completed in 1830. To the right of the bus is a new multi-storey car park being constructed on the corner of Castle Street by the Lift Slab Company. This had been the site of the builders' yard owned by Toobys, who were for many years one of the major house-builders in Wolverhampton. The pre-stressed concrete and steel-framed car park, with its petrol filling station on the Piper's Row forecourt, was ideally placed for the bus station, the railway station and the Grand Theatre, but it fell down in the early hours of the morning during the pantomime season at that theatre in early 1997. *A. J. Douglas*

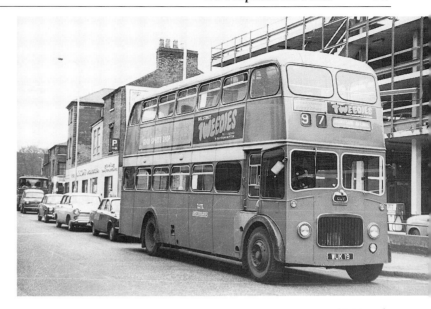

Right Having turned left from Piper's Row, near to the entrance to the High Level Railway Station, the service to Thompson Avenue turned into Queen Street, where it had arguably its most important pick-up point in the town centre. The bus stop was outside the old Dispensary building of 1826, and the empty cab of the bus suggests that it has been waiting for some time as it fills up with passengers. After leaving Queen Street it will eventually reach the Central Library before turning turn left into Cleveland Road, then right opposite the Corporation bus garage into Vicarage Road alongside the Royal Hospital. The bus is 580 (KJW 580), a locally produced Guy 'Arab' IV fitted with a lightweight Metro-Cammell 56-seater body that was given the name of the Greek mythological hero Orion. He was a handsome and mighty hunter, son of Poseidon, god of the sea, and lived on Crete as the huntsman of the goddess Artemis, who eventually killed him in a fit of jealousy because of his affection for Aurora, goddess of the dawn. Artemis then placed him in the heavens as a constellation, and Orion is the most brilliant star group of all. One wonders how the name of a Greek mythological hero got mixed up with a factory in the suburbs of Birmingham making bus bodies! Anyway, someone thought up the name 'Orion' after the solitary 'Aurora' body was not developed by Metro-Cammell. Unfortunately, the 'Orion' body was nothing like 'celestial', as although the design had a certain basic simplistic charm, it apparently came with a series of 'inbuilt' rattling body components! It was also

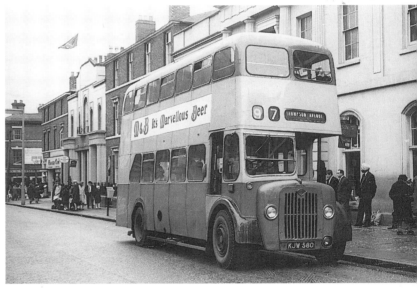

poorly insulated and badly ventilated, with any luxuries being either omitted or frequently pared down to the minimum, having for instance a single-skinned roof and side saloon panels. The front and rear domes were among the first from a bus body-builder to be made of glass-fibre, and even this was unlined – the internal handrail fixing brackets, just visible on the offside front corner of the upper saloon, were bolted through from the outside. Although the bodies were somewhat basic when compared to earlier double-deckers, they were usually about 30 cwt lighter, which obviously gave a better fuel consumption. Yet despite this, the Wolverhampton Corporation bus order specified a sliding door to the cab as well as a non-standard straight staircase, which accounts for the triangular lower rear offside window. *D. R. Harvey collection*

Below On its way into Wolverhampton town centre, turning from Vicarage Road into Cleveland Road, is 544 (FJW 544), a 1950 Park Royal-bodied Guy 'Arab' III 6LW double-decker, working on the cross-town 14 route from Thompson Avenue to Claregate. Alongside it is an old Baker's boot and shoe factory, which today is divided into small factory units, while behind it is a 1953 motorcycle with a retrospectively fitted streamlined fairing. In front of the bus is the Corporation's Cleveland Road bus garage, while to the left of Vicarage Road is the Wolverhampton Royal Hospital, which has been closed since 1997 when extensions to the town's main hospital at New Cross made it redundant. It is a Grade II Listed Building, but faces an uncertain future as various proposals for a change of use, notably into a night-club/restaurant/bar, have been turned down. *R. F. Mack*

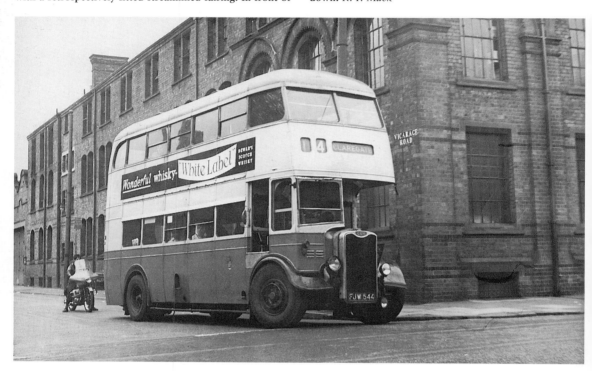

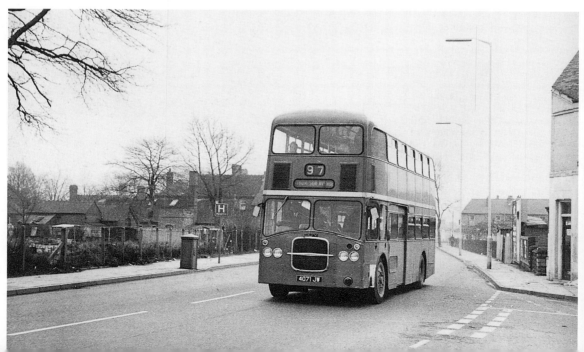

Bottom left Travelling into Wolverhampton along Thompson Avenue from the Birmingham New Road terminus at Parkfield Crescent on the 97 service is the unique Guy 'Wulfrunian' FDW, 71 (4071 JW). It has an East Lancs forward-entrance, 71-seater body that looks more like one on an 'Arab' IV and masks the inadequacies of the 'Wulfrunian' chassis. The strange angle of the nearside front wheel is a clue to its independent front suspension, which was to prove so troublesome for these advanced vehicles in their usually short lifespans. The bus is at the Curzon Street stop, and has just passed the old Borough Hospital, opened as an

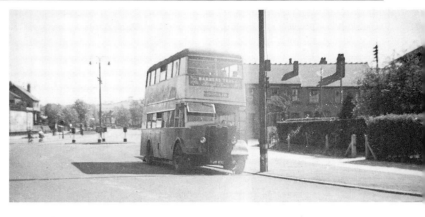

isolation hospital for cases of scarlet fever and smallpox in 1885, and by the mid-1960s known as the Fever Hospital. The houses in Curzon Street date from about 1900, while those in neighbouring Byrne Road and Napier Road were constructed over the next three years. All of these side streets of terraced houses led into Cockshutts Lane, which was later to be renamed Thompson Avenue. *L. Mason*

Above right In July 1946 a Guy 'Arab' II 5LW, with a Park Royal 'utility'-style body of 1944, stands at the Parkfield Road stop of the 15 service in Thompson Avenue, with the Birmingham New Road, the A4123, disappearing beyond the traffic island. This road, opened on 2 November 1927, linked Wolverhampton and Birmingham and created an express dual carriageway road route between the two at a cost of £600,000. In the far distance is an approaching Midland Red SOS FEDD double-decker, still with a silver-coloured roof. The 'Arab' is 375 (DJW 875), and is in its original state; it ran for over six years with its first body before receiving a new Roe H31/25R body in 1951. It has turned round at the traffic island, where trolleybus overhead traction poles can just be seen; these took the 25 route to its terminus at nearby Fighting Cocks to the

right, and towards Ettingshall, Bilston and Willenhall to the left. Thompson Avenue was unusual for a main road route out of Wolverhampton in that it was never operated by trolleybuses, and was seldom photographed, this slightly ghosted print being a rare example. *B. Baker collection*

Below Standing in the lay-by in Parkfield Crescent at the end of Thompson Avenue is a bus that has worked on the 34 route from Blakeley Green, to the north-west of the town. The whole of this area was developed in the early 1920s as municipal housing with distinctively designed terraced properties. Although the development appeared to be very dense, it was in reality little more than a ribbon development along Thompson Avenue out to the Parkfield Road boundary. The bus is 582 (KJW 582), a Guy 'Arab' IV fitted with a Gardner 6LW engine. It was delivered in June 1954 with a Metro-Cammell 'Orion' lightweight body, whose straight staircase, although a Birmingham bus feature, was for many years a prerequisite on many of Wolverhampton's buses and trolleybuses. This was the only member of this batch fitted with opening ventilators in the upper saloon front windows. *R. F. Mack*

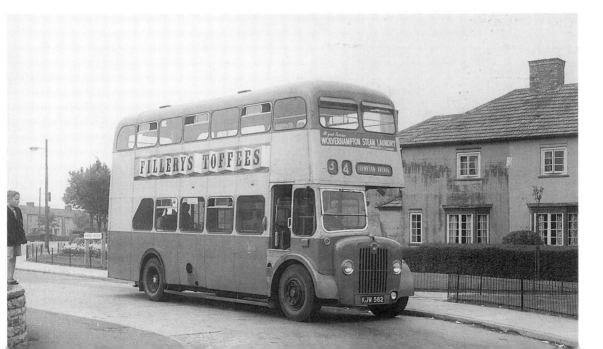

Wombourne and beyond

The large village of Wombourne lies to the south-west of Wolverhampton beyond the Penn Road boundary. It cried out to be linked to Wolverhampton by public transport during the 19th century, but missed out on the railway developments that might have brought the settlement within the range of Victorian commuters. By the time the ill-timed railway line from Oxley Junction to Kingswinford had been opened in May 1925, it was too late for it to be a success and it was closed by 1932.

A horse-bus operator called Sheldon began operating to Wombourne from Victoria Street in 1900, and by 1905 had been joined by Frederick Hughes. By 1912 these two operators had ceased working to the village due to competition from a new motorbus service introduced by C. L. Wells on 13 March 1911. He used a grey-liveried Albion single-decker, and by August 1913 was operating not only his Wolverhampton to Kingswinford service, but had also developed a service to Trysull. In April 1917 this pioneering Wells operation sold out to Midland Red. Frederick Hughes, the former horse-bus operator, applied as late as 1919 to operate motorbuses to Wombourne, but this was refused by Wolverhampton Watch Committee, which was empowered to license bus operators and their services, as the Corporation had designs on its own bus route to the village. Midland Red, however, had 'got its foot in' with its inherited former Wells service, which had begun on 2 April 1917. An agreement with Midland Red as part of the 'Wolverhampton Transport Area' was made on 19 November 1927, which protected the Corporation services within the municipal boundary by levying a 50 per cent tariff on all fares. Midland Red began to operate to Swindon on 15 March 1924 and from Sedgley to Wombourne on 21 August 1927. Yet by 14 May 1928 the service to Swindon and Wombourne had been taken over by the Corporation. An earlier expansion to the south-west of the town had taken place on 17 November 1923 when the former Great Western Railway bus service to

Trysull and Halfpenny Green was acquired. This route was extended to Claverley on 2 May 1925, later becoming the 18 service, while a variation to Bobbington became the 48. By the time of the 1930 Road Traffic Act, the Trysull service had been numbered 18, that to Claverley 18A, and the Wombourne, Swindon and Smestow the 11B, as an extension of the 11A bus route to Spring Hill, Penn. The Wombourne route was renumbered to 36 when the 'great route renumbering' of 13 June 1949 took place, while the service via Wombourne to The Swan, Blakeley, was numbered 37, becoming the 87 service when the 37 was extended to Brickbridge on 16 March 1953, while the Swindon route to the Green Man public house became the 38. In this form, the routes survived to be taken over by Midland Red on 3 December 1973, by which time the Corporation had been absorbed into the WMPTE.

All the routes followed the Penn Road trolleybus service to the town boundary at Spring Hill before travelling along Stourbridge Road, now the A449, as far as Wodehouse Lane. From there the services covered the village of Wombourne by leaving the main road by a number of different lanes, before going on to the nearby smaller villages of Blakeley and Swindon. In addition, the Midland Red service to Kingswinford and Stourbridge continued, and was inherited again by the WMPTE and still operates today as the 256 route.

Opposite above Parked in the centre of Victoria Square in about 1933, in front of the huge advertising hoarding that stood between the Sir Tatton Sykes public house and Swift's wholesale meat company premises, are three Corporation vehicles. The nearest is one of the three PSV models that AJS built: the normal-control 'Pilot', the forward-control 32-seater 'Commodore', and the 'Admiral', which only had a very short production run before the company finally went into liquidation. Wolverhampton Corporation bought just one of the 'Commodores', and this was numbered 191 (UK 9640) and fitted with an AJS body with a B32D layout. The resultant vehicle, which entered service in 1931, was equipped with a Coventry Climax 36hp six-cylinder petrol engine. It had been used as a demonstrator on the Walsall bus route for about six months prior to being purchased in June of that year for what must have been a 'knock-down' price of

£774. With its attractive body and up-to-date-looking chassis, it is about to work on the Wombourne and Swindon service. Being a 'one-off' vehicle from a defunct manufacturer, 191 only lasted in service until 1937 when it was sold to Morrell, a Leeds-based bus dealer and scrap merchant. It appears to be experiencing a spot of bother as its driver is topping up the radiator.

AJS – A. J. Stevens & Co (1914) – was formed when the local motorcycle manufacturer moved to Graisley. Joe Stevens & Sons' pressed tool company had made its first motorcycle engine as long ago as 1897, and by 1911 was able to enter two AJS motorcycles in the Isle of Man TT races, which although they did not win, they at least finished. The First World War brought a lot of war work, particularly precision components for aircraft, while motorcycle development continued, so that by the Armistice, unlike other manufacturers of motorcycles, AJS was able to offer new models within months. Throughout the 1920s 'Ay Jays' developed a reputation for winning races such as the TTs, and for their speed. Following the death of one of its riders in the 1931 TT and the subsequent calling in of its overdrafts by its bankers, the motorcycle company was taken over by Associated Motor Cycles in 1931. It briefly retained its Retreat Street Works in Wolverhampton and continued making commercial vehicles, in which the company had dabbled since 1927, and the rather expensive small cars in the shape of the 9hp Coventry Climax-engined saloon and tourer. This finally ended in October 1931 when the company went into liquidation.

Next to the 'Commodore' is trolleybus 93 (JW 993), working on

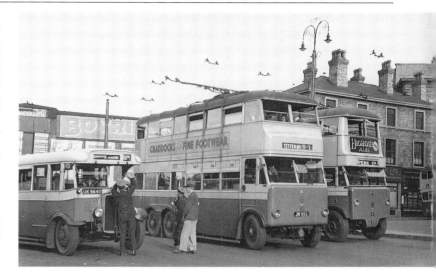

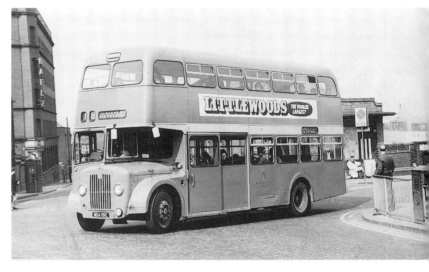

the Tettenhall (1) service. This was the middle of the first three production Sunbeam MS2s that entered service with the Corporation on 1 June 1932. It carries a Weymann H31/28R body that was similar to the MS2s numbered 165-169 (ADH 11-15) in the neighbouring Walsall Corporation fleet. On the right is trolleybus 71 (UK 9971), a Guy BTX delivered during April 1931 with one of Guy's own bodies, which had an identical seating capacity to the slightly newer 93 standing next to it. *C. F. Klapper*

Above right Leaving Railway Drive and its small bus station with a half-full load on an 18 service to the village of Claverley by way of Trysull is another of the short-lived 1967 batch of Strachan-bodied Guy 'Arab' Vs, 191 (MDA 191E). It is crossing Railway Street, with the Chubb Building just visible on the left, and is about to pass through Victoria Square on its way towards Lichfield Street. It will travel out of the town by way of Bradmore and Merry Hill before heading out into the Staffordshire villages of Seisdon, Trysull and Smestow and crossing the county boundary into Claverley. There were only five daily journeys, and this 1968 view is one of the three evening return trips – unless it was taken on a Wednesday, when it could be the 3.00pm departure. The front-engined, half-cab bus, with its forward-entrance sliding door, was a model hastily put into production by Guy Motors after its ill-fated 'Wulfrunian' debacle, and despite its low floor (or should that be lowish floor?) the model was too late to compete successfully against the new generation of rear-engined double-deckers. Wolverhampton obviously felt that it wanted to support local industry, but chose to have the buses bodied by Strachans, whose Metro-Cammell look-a-likes were just an inferior imitation. The class of 31 was prematurely withdrawn between 1972 and 1974 after a pilot overhaul proved too costly. This example is carrying an advertisement for Littlewood's football pools, which perhaps the Corporation might have hoped to win to fund the body repairs that were needed almost from the day the buses were delivered. *D. R. Harvey*

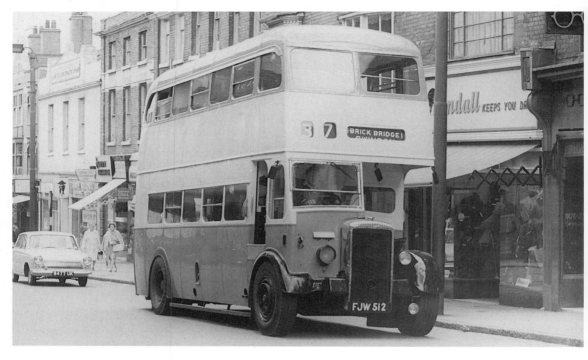

Above A freshly repainted and extremely smart-looking Brush-bodied Daimler CVG6, 512 (FJW 512) of 1948, climbs Darlington Street from the direction of Chapel Ash. In this condition the Wolverhampton bus fleet looked quite splendid, but unfortunately all too often the buses were allowed to deteriorate with dents and unvarnished touching-up, especially on the lower green panels. Passing Randall's coat shop, the bus is working towards the 37's terminus in Victoria Square, having come into town from Brickbridge and Blakeley. Darlington Street's shops were usually family-owned and tended to be the type that had given 'the personal touch' for years, with oak fixtures and fittings, glass display counters and a look of the fictional BBC TV 'Grace Brothers' store! Even the canvas blinds, extended over the pavements behind the bus, remind one of this pre-superstore shopping era. Following the double-decker is a Ford Cortina 113E two-door saloon, in this case an early 1963 example. The Cortina and 105E Anglia transformed Ford's share of the family saloon market by taking it out of the side-valve-engine era that had survived since the first British Dagenham-built Fords of 1931 and which, by the end of the 1950s, was costing Ford a lot of sales. *Vectis Publications*

Below This is a rare view of a bus working on the Wombourne route. Travelling along Penn Road towards the town centre, it is opposite the Rose & Crown public house near Church Hill. The driver, with his open-neck shirt, is seen on Monday 26 April 1954 driving bus 340 (BJW 140), a 1938 Daimler COG5 wearing the attractive early post-war livery of three yellow bands; it would survive in service until 1957. The Brush bodywork, although fitted with distinctly Wolverhampton-specified features, was supplied during the late 1930s to a number of other operators by the Loughborough-based coachbuilder, including the Coventry and Derby municipalities. The Wombourne bus route went beyond the Penn trolleybus terminus at Spring Hill before travelling along the A449 Stourbridge Road as far as Wodehouse Lane before turning off into Wombourne. *J. C. Brown*

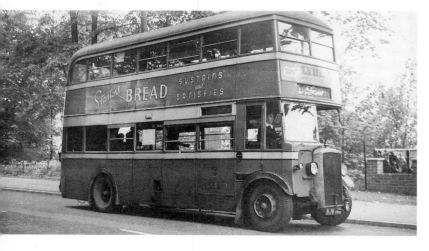

Opposite page One would have thought that if anyone was to buy examples of the products of Guy Motors, it would be the local Corporation. The awful effects of the Depression of the 1930s had a knock-on effect when municipal bus

operators put out tenders for new vehicles. The need to support local industry led, for example, to Manchester Corporation purchasing the less than successful products of Crossley Motors, based at Trafford Park, while Birmingham operated 51 of the 83 Morris-Commercial 'Imperials' built, before losing patience with their frail petrol engines. Even then the city went 'just down the road' and ordered Coventry-produced Daimlers. Guy Motors produced its new 'Arab' model in 1933, the first double-decker bus in the country to be listed solely with a diesel engine, in this case the proprietary Gardner 5LW 'oiler'. Wolverhampton Corporation did its best to support local trolleybus builders throughout the 1930s,

ordering both Guys and Sunbeams to the exclusion of other manufacturers' products. Yet as far as double-decker motorbuses were concerned, it purchased the only Sunbeam DF2 ever made, which was effectively an AEC 'Regent' fitted with a different radiator, but more surprisingly only bought one of the new 'Arab' chassis. Although 'Arabs' could be fitted with a French-designed Cotal pre-select gearbox, more usually they had crash gearboxes. 'Arab' 312 (JW 8112), built with a Brush H28/25R body in 1936, was never popular nor reliable, and spent 1943-46 in dusty store at the back of Bilston Street garage before being put out of its misery in 1949. Here it is parked outside Wombourne Parish Church in Church Road, during the darkest days of the Second World War. The church is uniquely dedicated to St Benedict Biscop, and the west tower and spire date from the 14-15th centuries, although the body of the church is from the mid-1860s. It stands in a prominent position on the one side of the large village green, which impressively serves as the ground for Wombourne's cricket club.

It is precisely 12.36 on 10 July 2000 by the restored, gold-faced clock on Wombourne's Parish Church. This was a miserably wet Monday, which did nothing to make the church look particularly appealing, while the churchyard and village cricket pitch looked nothing other than a soggy, verdant, impenetrable swathe. Travel West Midlands 2835 (B835 AOP), a 17-year-old Mark II MCW 'Metrobus', has just left the stop outside the village's community hall and is about to swing right in front of the church as it proceeds towards Stourbridge on the 256 service. Wombourne used to be served by five Wolverhampton Corporation services, the local 36, the 37 to Brickbridge, about a mile south of Wombourne alongside the Staffordshire & Worcestershire Canal, the 38, which went on about another mile to serve the village of Swindon, and the 86 and 87, which both also served Brickbridge. Yet the present-day bus service operated by Travel West Midlands is the direct descendant of the old Midland Red 256, which more or less served the same places as today. What is surprising is that the Midland Red 256 was a Saturday-only service, which had just six trips in each direction, and as the run from Stourbridge Town Station to Railway Drive, Wolverhampton, took just 49 minutes, the service could be operated by one bus. Today the route is operated with 49 journeys in each direction every day, each taking 55 minutes. *D. R. Harvey collection/D. R. Harvey*

Compton Road, Pattingham and Bridgnorth

Compton Road leaves Chapel Ash and heads westwards to Compton, then to Pattingham, Ackleton, Perton, Shipley, Worfield and eventually to the Severn-side town of Bridgnorth. Today's A454, it is very similar to the nearby splendid Tettenhall Road, being lined with refined Regency and early Victorian houses hiding behind avenues of mature plane and elm trees until Merridale Lane is reached. The Wolverhampton Grammar School, founded in 1512 by Sir Stephen Jenyns, was originally sited between Cock Street, later Victoria Street, and St John Street, where the Mander Centre is situated today, but moved out of this squalid area to Compton Road in 1875. Urban development through St Mark's Ward remained very patchy until Compton Hill was reached, close to the present-day location of the Compton Park campus of the University of Wolverhampton above the open land surrounding the valley of Graisley Brook. Once beyond The Cedars, an impressive old house on a bluff at the top of Compton Hill, Compton Road descends rapidly from the Tettenhall Ridge to Compton Village, nestling beneath sandstone cliff-like exposures in the deeply incised valley of Smestow Brook.

The road then ducks beneath the still extant former Great Western Railway link between Wolverhampton, Wombourne and Stourbridge Junction. Here was situated the small Compton Halt, which opened in May 1925, just a few months after the railway line was opened to freight traffic. The ill-fated line closed for passenger traffic on 31 October 1932, having latterly been served by eight trains per day in each direction, and finally closed for freight trains on 27 February 1965. Immediately west of the railway line, though 150 years older, is the bridge over the Staffordshire & Worcestershire Canal. The Brindley-designed S&W was opened in May 1772 and, unusually, has outlived the railway, but not as the originally conceived

narrow-boat goods link between the River Severn at Stourport and the Trent & Mersey Canal, but as a routeway for pleasure craft. Compton Village even boasts a 'ship's chandlers' and a boat-building yard alongside Compton Wharf.

Just beyond the Oddfellows public house in the centre of Compton, the Bridgnorth Road forms part of a three-way junction. To the north-east is Henwood Road, leading to the bottom of The Rock in Newbridge, while to the left the A454 continues towards Bridgnorth by way of Shipley and Worfield. As it leaves Compton, the main road turns in a south-westerly direction and immediately reaches the Georgian Swan public house on the corner of The Holloway, which takes traffic up very steeply from the valley of Smestow Brook through a tree-lined climb to the large post-war housing estates at Tettenhall Wood and Perton.

Thereafter Bridgnorth Road travels through an area of interesting geological history. Once beyond Wightwick, the A454 traverses a sequence of low undulating hills. Close examination reveals that these hills are vaguely whale-shaped with a short, steep end facing towards the west and a long gentle end facing Compton. These are drumlins, a flow feature formed from unsorted glacial till beneath the Pleistocene ice advances that reached the West Midlands from mid-Wales. Coupled with similar features near Rushford Slang traffic island on the A449 between Penn and Wombourne, these form the southern-most limit of these impressive sub-glacially formed low hills to be found in England.

Once beyond The Fox at Shipley, the main road approaches the junction with the B4176 Himley-Telford road at Rudge Heath, just beyond the Staffordshire-Shropshire border. The Pattingham and Ackleton service left the main road just after the Mermaid at Wightwick. The main Bridgnorth road skirts through the village

of Worfield, passing the Wheel O' Worfield public house before reaching the top of the Hermitage Hill. To the south-east of this was where Bridgnorth's Stanmore RAF Camp was situated. Today it is an industrial estate, but it was here that many National Servicemen, including co-author John Hughes in 1956, did their 'square-bashing' and basic training. Despite its various static 'gatehouse' aeroplanes, this RAF base never saw an aeroplane take off or land.

The Bridgnorth bus route then descended Hermitage Hill into the Severn Valley before reaching Low Town, Bridgnorth. After negotiating the narrow buildings in St John's Street, the buses emerged from the shadows of the Georgian shops and burst on to Thomas Telford's graceful bridge built over the River Severn in 1823. Having passed the old quayside, the original bus route followed Underhill Street before swinging beneath Pampudding Hill and turning on to the forecourt of Bridgnorth's railway station. Once the GWR gave up its pioneering bus service, the replacement Wolverhampton Corporation bus service, which commenced in 1923, did not use the railway facility, turning instead up the steeply inclined New Road before reaching the cottages that lined West Castle Street. Within sight of High Street and the timber-framed Town Hall straddling the street, the bus service from Wolverhampton terminated by reversing and turning round at the entrance to East Castle Street. The much later 31 bus service to Bridgnorth, inaugurated on 5 November 1930, arrived in the town via Perton, Pattingham and Ackleton, before travelling to Newton Bank and travelling down the A442 alongside the River Severn. This service terminated in High Street at North Gate.

There was intense resistance by the residents of Compton Road to the Corporation's desire to operate initially tramcars and subsequently trolleybuses, and the powerful local lobby successfully prevented any form of electric traction being operated, so the service changed directly from horse-buses to motorbuses. The first horse-buses ran in 1871 between Queen Square and Tettenhall Wood five times per day. A further service to Bridgnorth via Compton village ran a further single return trip soon afterwards.

The inimitable Sampson Tharme began his operation of horse-buses to Compton Holloway early in the next decade and continued until his retirement in 1912. His service was briefly taken over by Thomas Bakewell, but it had ceased running by 1913. The first motorbuses to Bridgnorth via Compton Road were those of the Great Western Railway, a service that began on 7 November 1904 using a trio of single-decker Clarkson 20hp steam-buses, which burned paraffin under pressure. The buses picked up and set down passengers as required, and within the boundary of the town charged the princely sum of 2d. The steam-buses were unable to easily climb Hermitage Hill and were quickly replaced by 20hp Milnes-Daimlers in January 1905. Two further services to Bridgnorth via Pattingham and to Claverley were also operated for five and three an a half years respectively. Latterly post-First World War single-decker AEC 45hp buses, fitted with GWR rear-entrance bodies, worked on the service until the Corporation successfully applied to operate its buses outside the Wolverhampton boundary in 1923.

The first Corporation service along Compton Road began on 10 February 1914 and was numbered 10. It used Tilling-Stevens TS3 single-deckers and remained virtually unaltered until 17 January 1949 when it was extended to Mill Lane, Tettenhall Wood; it was further altered on 6 October 1958 when a new route was opened to Regis Road, numbered 80. The Corporation's service 17 along the main road to Bridgnorth opened on 1 July 1923, and a new service 16 opened up the village of Pattingham on 17 November 1923, going via Wightwick and Perton. The 17 route to Bridgnorth remained as one of the Corporation's more important country routes for the next 45 years, surviving to be taken over by the WMPTE on 1 October 1969; but when Midland Red's 'heartland' operations inside the PTE operating area were taken over on 3 December 1973, the Bridgnorth route, together with most of the other Wolverhampton country services, was transferred to Midland Red, becoming its 890 route. Today it is operated by Arriva Midlands North using single-deckers that have nearly the same seating capacity as the Corporation double-deckers of 40 years earlier.

Below The Great Western Railway's 20hp single-decker Clarkson steamer 36 stands beneath the canopy of Wolverhampton Low Level Station before leaving for Bridgnorth and the town's Severn Valley Station. The buses burned paraffin under pressure, and these 'mobile blowlamps' were quickly seen to be unable to compete with the GWR's far more economical Milnes-Daimler buses. The route to Bridgnorth opened on 7 November 1904, when three Clarksons entered service, but was quickly abandoned by the end of December as the steam buses frequently failed on the climb out of Bridgnorth on Hermitage Hill. The service resumed in January 1905 when petrol-engined Milnes-Daimlers were introduced. Clarkson steamer 36 was registered DA 81 and was one of three in the early GWR bus fleet, numbered 34-36. What was surprising about these buses was that they had a full windscreen, with quite considerable protection for the driver. They had an entrance at the rear and a seating capacity of 18. After withdrawal the trio went to the Cheddar area of Somerset, where they remained in use for a number of years. *D. R. Harvey collection*

Bottom The old GWR Low Level Station saw its last express train in March 1967 when the Paddington to Birkenhead service was withdrawn, ironically the same weekend as the trolleybus system closed. However, the station remained connected to the rest of the network as a terminus for a Birmingham Snow Hill to Wolverhampton diesel multiple unit shuttle, until this remnant closed on 6 March 1972. The Low Level Station was then used as a parcels depot, finally closing in June 1981. Today this Grade II Listed Building is mothballed and boarded up, despite a proposal to use it as a railway museum, then as the terminus for the original route of the Midland Metro. The station's wall towers above the bus loading shelters in the station yard, used by the Corporation service to Bridgnorth, as the prototype Daimler 'Fleetline' CRG6, 7000 HP, waits during its 10-day period of demonstration in August 1961, working on the 17 'main road' service to Bridgnorth. It is in Birmingham Corporation livery, but was never owned by that city, although its Weymann body specification was to BCT requirements. It was returned to Transport Vehicles (Daimler to everybody else!) on 26 August 1961, and just two days later a second BCT-painted bus, Leyland 'Atlantean' PDR1/1 460 MTE, was also pressed into another period of abortive demonstration service. Despite the success of this famous and revolutionary 'Fleetline' bus elsewhere in the country as it toured various Corporations and BET Companies collecting substantial orders, it had no success at all in Wolverhampton, which immediately resumed ordering the reliable but intrinsically old-fashioned Guy 'Arab' front-engined model, albeit in the Mk V form. This was a semi-low-height double-decker, but had to be operated throughout its career as a conductor-crewed bus. It was only in 1969 that the Corporation ordered some 25 33-feet-long Daimler 'Fleetlines', which when they arrived became the WMPTE's 3980-4004. Beyond the bus are an Austin A35 and a Vauxhall 'Victor' Series F. *S. N. J. White/ R. Marshall collection*

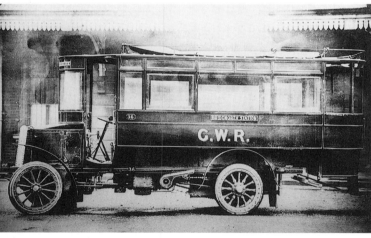

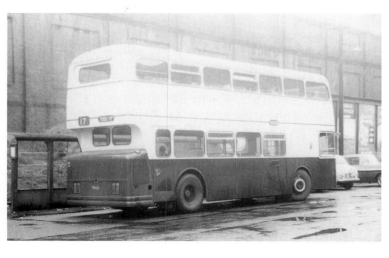

Opposite top The driver of the 1952 Nottingham-registered Alvis TA21 sports saloon watches the green bulk of the almost new 30-feet-long Guy 'Wulfrunian' FDW thunder out of the Low Level Station forecourt as it starts its journey to Bridgnorth on the 17 route. The bus is 70 (4070 JW), of 1961, and of the two 'Wulfrunians' owned by Wolverhampton Corporation, it was the only one that looked like a 'Wulfrunian', having an entrance at the front and, visible through the open electric doors, a nearside staircase. It is being worked by the usual crew of driver and conductor, though in later years this service might have been one-man-operated with buses that looked superficially like these front-engined vehicles. The difference was that the heavyweight 'Wulfrunians' required Herculean efforts from the sweating driver as he sat alongside the hot, oily bulk of the Gardner 6LX engine, struggling with this East Lancs-bodied vehicle. On the left, parked outside the station entrance

with its boot open, is a Morris Oxford Series II, being passed by an Austin FX3 taxi-cab. Beyond the distant gates in Bayley Street is the Great Western public house, which in later years would be transformed from a 'back street boozer' into a characterful CAMRA Real Ale hostelry, selling both Holden and Batham beers. The interior of the pub is adorned with GWR memorabilia and nostalgic reminders of the past glories of Wolverhampton Wanderers FC. *L. Mason*

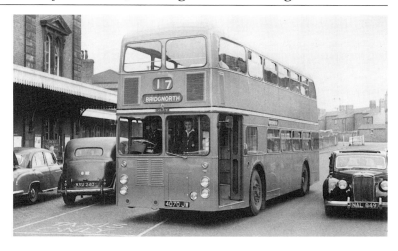

Middle During the Second World War the 17 service to Bridgnorth via Compton, Shipley and Worfield began in Railway Street and was frequently operated by the latest single-deckers in the bus fleet. These were six Daimler COG5/40s that had entered service in 1939, replacing the last petrol-engined single-deckers in the pre-war bus fleet. They had attractive 34-seater bodywork by Beadle, the last bodies supplied by this Rochester-based bodybuilder to the Corporation. This example, 356 (BUK 556), is standing in the deep shadows of the warehouse-lined Railway Street, and has only one wartime headlight mask, which suggests that this photograph was taken about 1941. The buses were only to last in service until March 1950, when they were all withdrawn and sold to Erdig Motors of Wrexham, which re-registered them, 356 becoming HCA 105. Behind the bus is a Guy BTX trolleybus with a six-bay Dodson body belonging to the 67-70 batch of vehicles supplied in 1930. Trolleybus 70 was frequently used as a spare vehicle about this time, so this might be it. It does not have a khaki roof, again suggesting that this is the early part of the war. Trolleybus 70 would remain in service until 1944, being replaced by 'utility'-bodied Sunbeam W4s. *S. L. Poole*

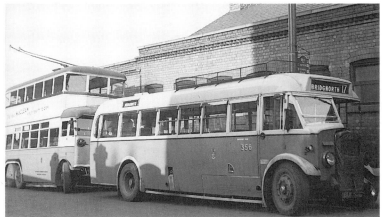

Bottom Passing from Piper's Row into Victoria Square when working on the 16 service to Pattingham in late July 1967 is one of the 'new generation' of Wolverhampton Corporation single-deckers, 708 (NJW 708E), the first of the six AEC 'Swift' MP2Rs with Strachan dual-entrance 54-seater bodies. In the distance, on the corner of Queen Street, is an MCCW-bodied Guy 'Arab' V, working on the 2 service to Whitmore Reans, while on the left is the entrance to Railway Drive, leading to the High Level Station. Perhaps it was a merciful release that Wolverhampton went out of existence only two years later, so that no more unreliable, poorly bodied and unpopular buses could be ordered. The bus has passed the premises of

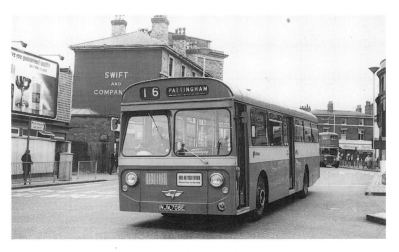

the long-established meat dealers Swift & Company on the left and the entrance to Berry Street on the right. Towering over Swift's is the original grand entrance to Wolverhampton High Level Station, which was eventually restored after being left as an eye-sore for many years. *A. J. Douglas*

Below The bustling scene in Queen Street shows two mothers carrying their young children while another couple appear to be struggling with a pram that they may be folding down so that it can be put on the parked double-decker. Fortunately the struggle, with all its attendant knuckle scraping and under-breath cursing, need not be done in too much of a rush as there is no driver in the waiting bus, 345 (BJW 145), a 1938 Daimler COG5 with a Brush body adorned with a front advertisement for Reade's Express Powders. The bus is standing at the 16, Pattingham, bus stop, although the lazy destination blind in the box is indecipherable; it has therefore been equipped with a paper sticker in the front window of the lower saloon, which states that it is only going as far as Perton. To the left of the bus is a row of mid-19th-century three-storey retail premises. Advertising the terribly strong Turf cigarettes is Harold Perry's Tea Rooms, a feature of Queen Street for many years. Next door is P. H. Davies's bicycle shop, which has hanging outside it a wide selection of push-bike tyres. Leaning casually against the bus stop is a cycle that looks as if it might need the attentions of Mr Davies, while parked beyond is a Birmingham-registered Ford V8 Pilot, which

despite post-war frugalities was, with its 3,622cc side-valve engine, a wonderful example of a total disregard for the contemporary economies of motoring! *R. Hannay*

Bottom Queen Street is probably the best street in Wolverhampton as regards the quality of its Regency buildings. The Army Recruiting Office behind the bus was originally the Athenaeum, built in 1835 with two entrances, five bays and a raised centre. Next door is the brick-built block at numbers 44 and 45, while to the right of the bus is the former Dispensary, which in 1948 was known as Falcon Chambers. This building dates from 1826 and its frontage is graced with seven bays and upper-storey Greek Doric demi-columns. The bus is 1937-built Daimler COG5 324 (AJW 24), fitted with a Brush H29/25R body; it was withdrawn in 1950. It was always painted in the lighter pre-war all-over yellow livery with the green confined to the panels below the lower saloon windows, and never received the wartime all-over green livery. It is working on the 16 service to Pattingham, which passed through Compton and Perton. Although Wolverhampton was the home of both Guy Motors and Sunbeams, neither played any significant part in the motorbus orders placed by their home Corporation. The result was that from the mid-1930s onwards, the new Gardner-diesel-engined Daimler COG5 model was favoured, which must have been a bitter pill to swallow, especially for Guys, whose 'Arab' chassis had a very similar specification, but extremely disappointing sales. *R. Marshall*

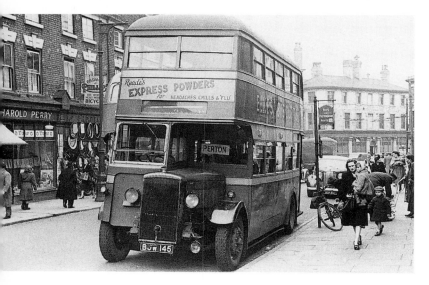

Opposite top The County Court building in Queen Street dates from 1813 and is one of the most impressive structures in this grand street of late Georgian, Regency and William IV houses and municipal buildings; it has a rather splendid-looking two-storey pedimented portico, with the Tuscan style on the ground floor and Ionic unfluted columns on the first floor. It is perhaps a shame that the bus that graces the Tettenhall Wood stop cannot enjoy the same epithets. It is 212 (MDA 212E), one of the ill-fated Strachan-bodied Guy 'Arab' Vs ordered as Wolverhampton's last double-deckers. Looking very much like a Metro-Cammell body, it was known as the 'Paceline', but was built 'to a price', resulting in many corrosion problems and structural failures around bulkheads and wheelarches. This bus entered service in April 1967, but, in common with most of the batch of 31, was considered to be in such a poor state that it was never repainted into WMPTE colours, being withdrawn in 1973. *R. F. Mack*

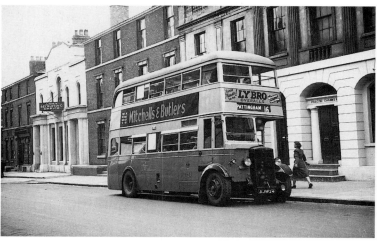

Opposite middle Wolverhampton's unique and quite attractive-looking Guy 'Wulfrunian' FDW, 71 (4071 JW), the only one built to the length of 28ft

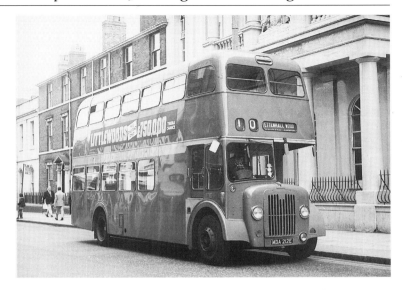

6in with a forward entrance, emerges from the dark summer shadows of Queen Street. This was Wolverhampton's most important 19th-century street, leading from the railway stations straight into Queen Square. However, when Lichfield Street was realigned after the demolition of its sub-standard half-timbered housing in the late 1870s, Queen Street's former importance was usurped by this 'new' thoroughfare. All the important town buildings in the street were somewhat passed by as the parallel Lichfield Street grew in stature, but the result was that a large number of the elegant buildings of Regency Wolverhampton survived intact here. The bus is about to turn right into Princess Street when working on the 80 service to Tettenhall Wood by way of Compton. It entered service in December 1962 and had a 71-seater body constructed by East Lancashire, its forward entrance protected by an electrically operated sliding door. This was more akin to the standard 'Arab' IVs that preceded the pair of 'Wulfrunians' and the 'Arab' Vs that succeeded them. Unfortunately the bus still retained the independent front suspension and troublesome disc brake layout, and while far more reliable than a 'standard' 'Wulfrunian', it was not deemed a success and remained in service for just over ten years. This might have been a more appropriate product for Guy Motors to concentrate their imaginative efforts on, but unfortunately the 'Wulfrunian' debacle brought the locally based company to its knees, and it reverted to the much more orthodox low-height 'Arab' V model. *R. Marshall*

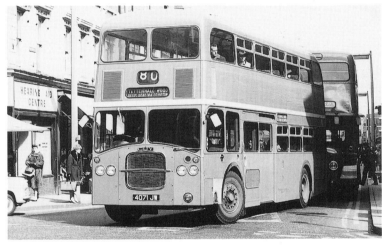

Bottom Coming into Wolverhampton at the Albany Road junction in Darlington Street is 561 (FJW 561), the first of five handsome Guy-bodied 34-seater Guy 'Arab' III single-deckers of 1949 vintage. Behind it the early Victorian premises of L. Gordon Flint, who was an optician, would soon fall victim to the Wolverhampton Ring Road scheme, and this location would become part of the traffic island at the bottom of Darlington Street. This batch of Guy single-deckers was bought for the Cheslyn Hay area services, but they were grossly underused. The roads beneath the low bridges they were designed to pass beneath were lowered, and the routes were converted to double-deck operation as passenger numbers began to demand a bigger vehicle. *S. N. J. White*

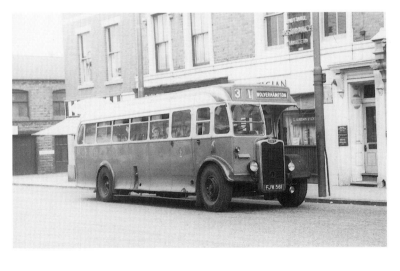

Below On leaving Darlington Street, the 10 service to Tettenhall Wood crossed the St Andrew's section of the Ring Road before entering the by now isolated section of Darlington Street that led into Chapel Ash. This had been an area of tightly knit terraced houses and tiny insanitary courtyards with communal privies clustered between the small factories and a solitary foundry, all swept away by the Ring Road. Although seen soon after the take-over of the Corporation bus fleet by the WMPTE on 1 October 1969, this bus, in common with the rest of the fleet, remained in the Corporation green and yellow livery and just had Fablon 'WM' logo stickers applied to the lower saloon panels. In fact, 126 (126 DDA) was never repainted into the mid-blue and cream livery of the PTE and went to the scrapyard of Hartwood Exports of Barnsley in January 1976 as seen here. It did, however, have a more interesting afterlife, as the body was removed and the 'Arab' V chassis sent to China Bus of Hong Kong, where it received a ckd Alexander FH54/35D body and became LX216 (BU 2258) in that fleet. *W. J. Haynes*

Bottom The start of Compton Road was less impressive than the gracefully lined Tettenhall Road. Having just turned into Compton Road is one of Wolverhampton's early post-war stalwarts of the bus fleet. With its radiator covered with a muff, Park Royal-bodied Guy 'Arab' III 549 (FJW 549) is working on the 80 route to Tettenhall Wood. This was one of the 22 Park Royal-bodied 'Arab' IIIs that entered service with the Corporation in 1950, and is in the bright mid-1950s livery that had most of the upper area of the vehicle painted in primrose, with a green roof and upper saloon windows. With Police 'NO WAITING' plastic triangle signs lining Compton Road in this late 1950s scene, the street furniture is still painted with black and white stripes, a feature that had originated during the Second World War and which remained for many years the standard for warning motorists. The large orange road sign on the left would have been put in place by the local authority, and although such signs lasted for years they looked temporary and usually became very shabby in a remarkably short time. *R. F. Mack*

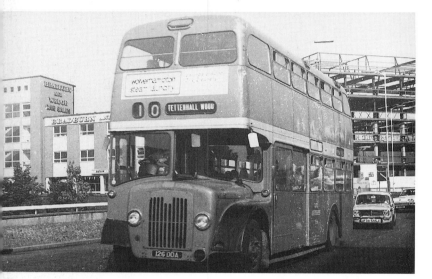

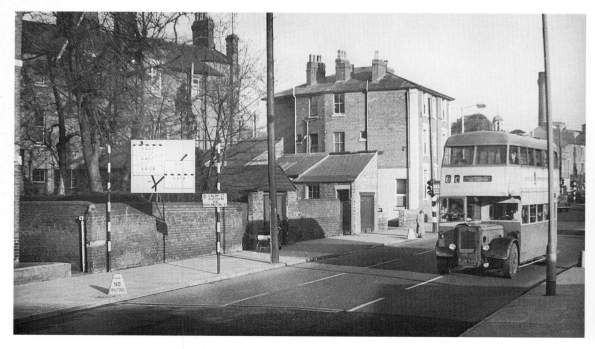

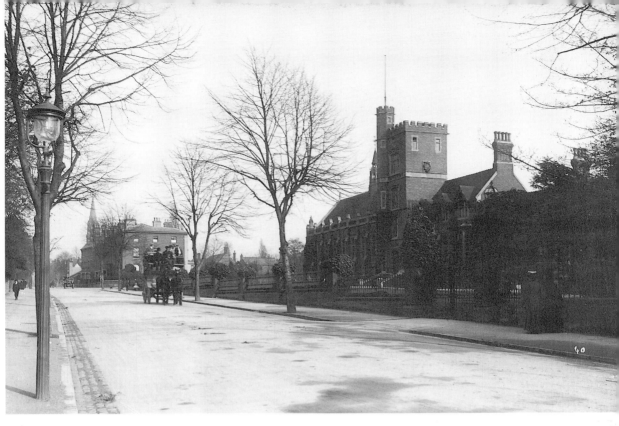

Compton Road was one of the few arterial roads running from Wolverhampton that saw neither form of electric traction. Originally it was served by Tharme's horse-buses, which were to run on Compton Road until 1912, when an operator called Bakewell briefly ran the service for a little over a year. Thus the horse-bus service to Compton became the last to operate in Wolverhampton. Having just passed the large block of three-storey 1830s-built houses on the corner of Merridale Lane, one of Tharme's double-deck horse-buses trots past the impressive buildings of Wolverhampton Grammar School in Compton Road in the early years of the Edwardian era; it has left the distant Chapel Ash and is on its way towards Compton. The school, founded in 1512, moved here in 1875. On the left is the wall of a large Regency house called Westlands, which together with the Grammar School marked the limit

of 19th-century development along Compton Road, as from here to Compton Village was open countryside at this time.

Compton Road has managed to retain its fine architecture, with the majority of the Regency and early Victorian terraces and houses, rather like those along Tettenhall Road, having survived, although many have fallen out of residential use and are now converted into offices. One such conversion is the Ashton Court Hotel, which now occupies the building on the corner of Merridale Lane. Westlands has long since been demolished and the site is now filled by a number of smaller, but desirable, detached houses dating from about the 1960s. The only remnant of the old house is part of the roadside wall. The bus routes along Compton Road on Saturday 3 June 2000 are being operated by Travel West Midlands, Arriva Midland North and Midland Choice. One of the latter's Optare XLs, S2 CLA, travels out of Wolverhampton on the 510 service to Perton, in about the same spot as the horse-bus nearly a century before. *J. Hughes collection/D. R. Harvey*

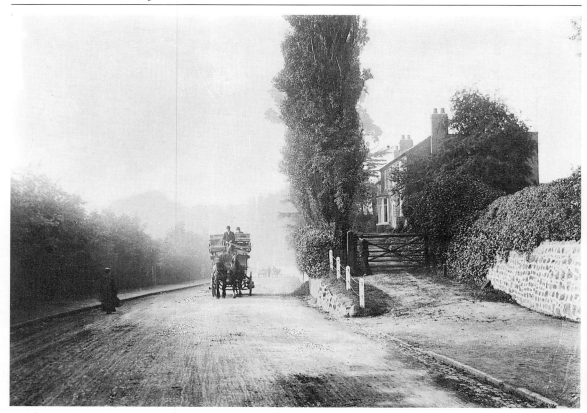

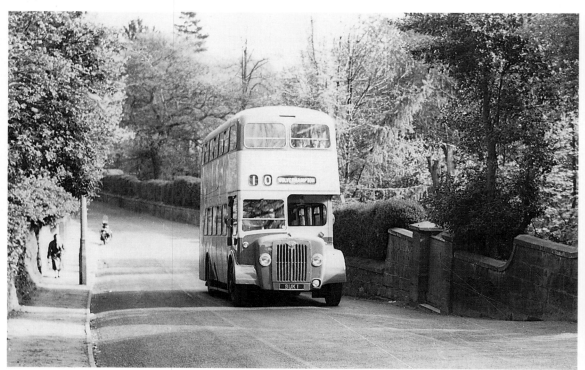

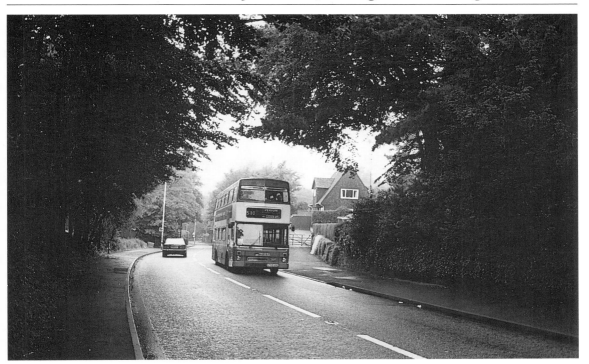

Above left Trotting up Boat Hill, Compton Road, is a horse-bus belonging to Samuel Tharme, who operated a service that began on 17 March 1890. It is surprising that, given the length of this climb out of Compton, the horse-bus is not using a third 'trace' horse, although on this day the bus is not exactly overburdened with passengers. The trees on the right, lining this section of the hill, are tall graceful cedars, after which the house, 'The Cedars', with its private driveway, is named. Standing by the six-barred gate is a smartly dressed young man who appears to be watching the bus, which at this time was still something of a novelty. Yet within ten years horse-drawn vehicles would be eclipsed by the 'newfangled' internal combustion engine vehicles, and scenes such as this would seem very old-fashioned by the time the Great War broke out and changed everything for ever. In the distance, at the bottom of the hill, is the Boat Inn, located near Finchfield Hill, the other steep hill leading out of the River Smestow valley to the south. Cutting through the valley are two earlier modes of transport. Running beneath the road is the Staffordshire & Worcestershire Canal, surveyed by James Brindley and opened in 1772, while the much later Great Western Railway line, opened in 1925, has an overbridge that cuts through the centre of Compton. By the turn of the century, housing developments were beginning to link Wolverhampton with Compton village, although it would be the 1960s before the last of the intervening farms would fall victim to the advancing urban growth. *J. Hughes collection*

Left Motorbuses rarely made light work of the climb up Boat Hill, that is until Wolverhampton Corporation invested in the locally manufactured engines of Henry Meadows. In the post-war period Meadows engines were Guy Motors' preferred alternative to the usual Gardner 5LW or 6LW unit, and in fact the Corporation purchased 12 buses fitted with them. The Meadows 6DC.630 was a huge 10.35-litre engine that was immensely powerful, but was extremely difficult to maintain due in part to all the auxiliaries, such as the fuel pump, injectors and electrics, all being extremely inaccessible. The first Meadows-engined post-war bus to enter service with the Corporation was 1 (SUK 1), which arrived in March 1957. It was a Guy 'Arab' IV fitted with a Metro-Cammell 'Orion' body, which, although featuring a Birmingham-style straight staircase, was one distinctly built 'to cost' – in other words pared down to the basics. SUK 1 storms up Boat Hill on the 10 route as it leaves Compton village on its way to Wolverhampton in its first few months of service. What is perhaps surprising is just how little the road has changed since the days of horse-buses. *R. Hannay*

Above The damp undergrowth and tree canopy over Compton Road on a wet Saturday 3 June 2000 are considerably more dense than they were when Boat Hill was still part of the countryside between the expanding Wolverhampton and the village of Compton. At the top of the hill, behind the camera, is the site of the present-day University of Wolverhampton's Compton Park Campus. On the right is the drive up to where the old 'Cedars' stood, replaced in the early 1960s by a large detached house, while much nearer the road, the spare land where the young lad stood watching the horse-bus all those years ago now has on it a modern bungalow. The open land towards the bottom of the hill was only built up in the early 1970s, when a rather exclusive housing development was built based on Ashfield Road, near where the old Boat Inn was located just before the junction with Finchfield Hill. Coming out of Compton on its way to Wolverhampton is Travel West Midlands MCW 'Metrobus' Mk II 2705 (A705 UOE), making short work of the steep hill as it works on the 510 service from Perton. *D. R. Harvey*

Below The village of Compton stands on the Smestow Brook, which, although quite small, has cut a deeply incised valley through extensive but quite soft glacial deposits laid down in the Weichselian period, the third glaciation of the Pleistocene era. The boulder clay, gravels and sands deposited by the re-invasion of the Irish Sea glaciation were cut into by rivers such as the Smestow, and this rejuvenation led to the formation of overdeepened, narrow, gorge-like valleys. A final remnant of the glaciation is the large number of 'esker' and 'drumlinoid' features, residual, regularly formed, low rounded hills associated with the retreat of an ice sheet. This area was the southernmost limit of the Weichselian glaciation in Britain, and the resulting landscape in this area to the west of Wolverhampton is unique in the West Midlands. Such steep-sided, post-glacially eroded river valleys were ideal for the development of routeways, and that of the Smestow was used to reach the western side of the West Midlands from the Severn Valley. Passing through Compton, the valley was used as a medieval packhorse route, but the settlement first came to real prominence when

the great pioneering canal builder, James Brindley, chose to construct the Staffordshire & Worcester Canal, opened 10 1772, alongside Smestow Brook, linking the new canal town of Stourport-on-Severn with the Birmingham Canal Navigation at Aldersley Junction on the outskirts of Dunstall Park. Alongside Bridge 59 at Compton, over which the Bridgnorth Road passes, is the thriving Limekiln brokerage and chandlery shop and its boatbuilding yard, which constructs highly desirable leisure vessels fully equipped for touring the English canal system.

Still bisecting Compton is the long-abandoned GWR girder railway bridge. The GWR rather belatedly built the Oxley Junction, Wombourne and Kingswinford Junction line to provide a by-pass around the western side of the West Midlands conurbation, but although it was first proposed in 1905, its construction was delayed by the success of the GWR bus services introduced during the previous year. Further delayed by the First World War, it was finally opened on 11 January 1925 for freight, and four months later for passengers. Although its primary objective of providing a

freight line was successful, it was a financial disaster as far as passengers were concerned. As a result, passenger services were withdrawn on 31 October 1932, while it was finally abandoned between Oxley and Baggeridge in 1965 and is now a public footpath and bridleway. As a result of its geomorphological siting, roads to Bridgnorth, Wolverhampton, Penn and Tettenhall all converge on the 'Compton Gap', and are all single-carriageway roads carrying a considerable amount of traffic, especially from the Severn Valley area into Wolverhampton and the West Midlands conurbation. In this summer 2000 photograph 299 (T299 UOX), an Optare 'Solo' single-decker, passes over the canal bridge as it works through Compton on the 534 service to Wolverhampton. *D. R. Harvey*

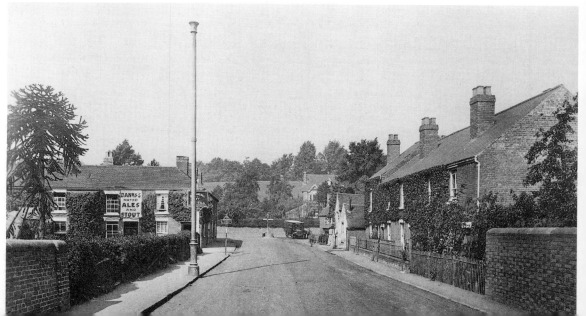

Opposite below Before Compton Village was bisected by the GWR bridge, it was very much a 'village beyond the town'. Looking from the Smestow Brook bridge towards Tettenhall Wood, what is amazing is that today very little of this scene remains. The most notable feature is the Georgian-built Oddfellows public house on the left, a site occupied today by a mock-rustic public house of the same name, which although attractive, looks architecturally more suited to the Austrian Alps than the centre of what is now a suburb of Wolverhampton. Between the tall sewer venting pipe and the public house is an interesting road sign warning early motorists of a 'DANGEROUS CORNER'. The ivy-covered mid-19th-century terrace of cottages, behind their iron railings, have been replaced by a row of 1960s shops, while the much older cluster of whitewashed premises towards the crossroads have also succumbed to the developer's bulldozer. Standing at the crossroads, to the right of the finger-post, is a solid-tyred Tilling-Stevens TS3 single-decker. This unidentified Corporation bus, probably one of the 1920 or 1921 batch of Dodson-bodied vehicles, has turned round at the road junction and is waiting for passengers before returning to Wolverhampton via Compton Road. *J. Hughes collection*

Above right Tettenhall Wood was the first post-war municipal housing estate built by Tettenhall UDC, and contains solid-looking semi-detached houses built mainly in the 1950s. Suburban development was summed up beautifully in an Alan Simpson and Ray Galton script for *Hancock's Half Hour*; in the episode entitled 'The Wild Man Of The Woods', Tony Hancock's attempts to get away from it all and live the life of a hermit, initially in a trolleybus shelter on Clapham Common, are quickly usurped when hordes of people, also looking for solitude, begin to arrive, tearing off their clothes and 'chopping all the trees down and digging holes all over the place'. After six weeks of this invasion, Hancock packs it in as the call of the wild for the thousands of hermits is 'wearing off – they've got four pubs and a cinema up already!' It seems that one of the primary prerequisites of bringing civilisation to any development is the building of a public house. Tettenhall Wood is no exception, and by about 1957 the Bird In Hand had been constructed; this is the large building on the extreme right occupying the corner of School Road, where the Tettenhall Wood bus terminus was situated, and Mill Lane, which is the road running from left to right in the background. The large 19th-century steeply gabled house is on the corner of Mill Lane and Dippons Lane, a bridle-path leading to Perton. The bus is Wolverhampton Corporation 513 (FJW 513), a 1948 Daimler CVG6 with a powerful Gardner 6LW 8.6-litre engine coupled to a Wilson pre-select fluid flywheel gearbox, enabling quick, crunch-free gearchanges. It has a Brush 56-

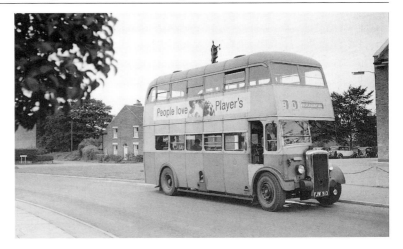

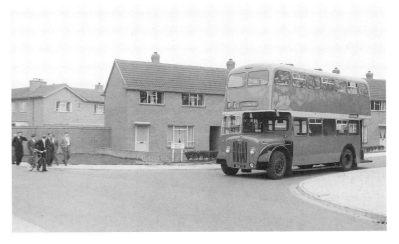

seater body, which was quite a rare combination; Maidstone Corporation was one of the other main recipient of this chassis/body coupling. The bus is working on the 80 service back into Wolverhampton by way of Regis Road. *R. Taft*

Above Standing at Tettenhall Wood's second bus terminus in Cornwall Road on 24 April 1960 is 13 (SUK 13); the 80 service arrived in this large housing estate by way of Woodhouse Road North. The bus is one of the 18 double-deckers delivered to the Corporation in 1957, the last year in which rear-entrance, 27-feet-long buses were specified. Of these Metro-Cammell-bodied Guy 'Arab' IVs, no fewer than 12 were equipped with the Meadows 6DC engine. Henry Meadows's factory had been set up in 1920 in Park Lane, Wolverhampton, to manufacture gearboxes, although about a year later it was using its engineering skills to make engines. As already mentioned, the 6DC was splendidly powerful and used by Guy as an alternative to a Gardner 6LW from 1948 to 1952 in the 'Arab' III. Unfortunately, its Achilles' heel was its high fuel consumption and having its auxiliaries all on the cab side, making maintenance and repairs very expensive. It was surprising therefore that these 1957-built buses were fitted with the Meadows engine, which was generally not available in the 'Arab' IV. *R. Taft*

Top Standing above the floor of the valley of Smestow Brook is the impressive mock-Tudor Wightwick Manor. Now owned by the National Trust, it was built by Theodore Mander, the paint and varnish manufacturer, in 1887 and has some fabulous 'Arts and Crafts' interior furnishings by William Morris. Nestling below the half-timbered house at Wightwick on the A454 Bridgnorth Road about half a mile beyond Compton village is the old Mermaid Inn. The bus parked outside during the deep winter of 1926 is, despite its destination blind display, facing Wolverhampton. The building behind the bus is an old smithy, which was demolished in order to widen the A454 and also to provide the public house with a car park. The snow-covered bus is Guy 3¾-ton single-decker 38 (DA 9038) fitted with a locally manufactured Fleming B31R body. It entered service in 1925 and had a working life, despite its modern appearance, of only five years. These 1925 Guys were the first buses in the fleet to be fitted with pneumatic tyres. *R. Marshall collection*

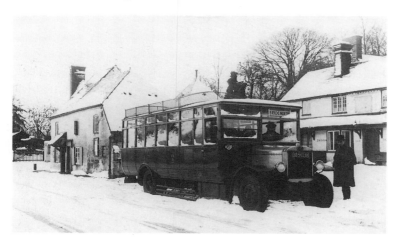

Middle The 16 service to Pattingham was introduced on 17 November 1923 in succession to a former GWR bus service, whose Wolverhampton to Bridgnorth bus route had been diverted into Pattingham in May 1906, although Pattingham was last served by the GWR on 10 July 1915. The terminus was outside St Chad's Parish Church beneath the trees alongside the stone-walled churchyard. The elegant Early English 14th-century church was tastefully altered in 1871 by the addition of a spire, which, unlike many Victorian additions to ecclesiastical buildings, actually improved its appearance. Behind the bus is the large Victorian lychgate, and one can easily imagine the funeral cortège of a villager, in the pouring rain, pausing beneath the shelter of the gate before moving off for the obsequies. The word lych, rather gruesomely, is Anglo-Saxon for a corpse, so that there is no doubt as to the original purpose of the covered gate. The 16 service travelled out of Wolverhampton through Compton and Wightwick as far as the Perton crossroads, before dropping down into Nurton and terminating nearly 2 miles down the road. Parked alongside the churchyard is the first of Wolverhampton's full-fronted, forward-entranced Metro-Cammell-bodied Guy 'Arab' IVs. The imposing-looking 20 (YDA 20) entered service in December 1959 and occasionally might have been somewhat underused on this route with its 72-seater capacity. The driver, Norman Wedge, is sitting in his cab talking to the conductor, Bill Stockford, on this bright sunny day in the early 1960s. *C. Jeavons*

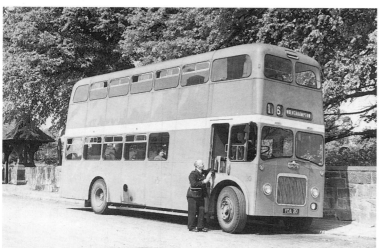

Bottom St Chad's Church, in the little open space known as the Bull Ring at the top of High Street, has hardly altered since the middle of the 19th

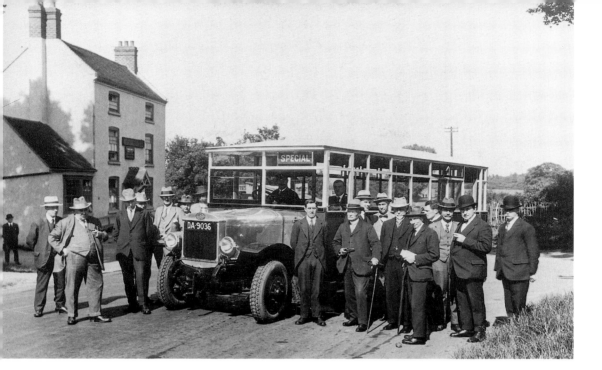

century, let alone in the 40 years since the previous photograph. On the left is the Georgian Pigot Arms, and the village centre still has its old shops next to the church, although behind the camera, just off the attractive village green, the only major alteration to the village is a block of 1960s shops that post-date the Guy double-decker. Although looking out of place architecturally, they include a very comprehensive newsagent that includes a delicatessen and grocery section. In July 2000 Pattingham was to be entered again for the best village in the area competition. *D. R. Harvey*

This page Beyond the Mermaid Inn at Wightwick is the collection of houses that make up Shipley, on the Shropshire county border. The hamlet is focused around a minor crossroads on the A454, which is dominated by the Fox public house. This large, three-storey Georgian building has been the local hostelry for many years, as evident in this 1926 scene. When bus routes were extended, revised or re-scheduled, or even if new vehicles were about to be introduced, it was a regular occurrence in Wolverhampton for the General Manager and the Transport Committee to ride out to sample the new initiative. Posing in front of their bus are members of the Transport Committee, led by Alderman Joe Clark, undertaking a survey of the Wolverhampton to Bridgnorth route. Their mode of transport is newly delivered petrol-engined bus 36 (DA 9036). With its shiny, unpainted bonnet – ideal for dazzling the driver in sunny weather – this Fleming-bodied, rear-entrance, 27-seater single-decker has a Guy 3¾-ton normal-control chassis. In 1925 this was one of Guy Motors' first forays into the full-sized PSV market, although within a year of its delivery Guys would

be building 26-feet-long three-axle double-deckers with a seating capacity of 62!

On a June Saturday in 2000 the weather has closed in, the rain is falling and the approaching car has had to switch on its headlights. Your intrepid photographer just got out of his car in the road on the right when the only bus for an hour, an Arriva Midlands North single-decker, stormed past on its way to Bridgnorth – so no bus in this present-day view. The public house is now called The Fox at Shipley, but in the intervening 75 years the basic structure of the building has remained remarkably unaltered. The original side entrance has been replaced by a small extension, while a large conservatory containing a restaurant has been recently added to the Wolverhampton side of the original 18th-century building. This area around the Shropshire border has remained stoically rural with even the main A454 Wolverhampton-Bridgnorth road looking remarkably unaltered. *B. Baker collection/D. R. Harvey*

Below In the early years of the 20th century the pioneering nature of the Great Western Railway was best exemplified, rather idiosyncratically, by its willingness to use alternative modes of transport. These included the use of some of the earliest motorbuses in the British Isles. Although Cornwall, parts of South Wales and the Slough, Windsor and Ascot areas are perhaps better-known recipients of early GWR motorbuses, villages between Wolverhampton and Bridgnorth. It is facing Wolver-hampton, having made the somewhat breathless climb up Hermitage Hill, and has been rebuilt with a normally positioned front-mounted radiator, replacing the original Renault-style bulkhead-mounted example. *J. H. Taylforth collection*

One of the GWR's first 20hp Milnes-Daimler petrol-engined single-deckers, DA 118, stands outside the Fox at Shipley with its driver and conductor posing in front of their charge. This 19-seater bus entered service on 24 July 1905, some six months after the opening of the original steam-bus service between Wolverhampton and Bridgnorth also had very early services. One of the GWR's first 20hp Milnes-Daimler petrol-engined single-deckers, DA 118, stands outside the Fox at Shipley with its driver and conductor posing in front of their charge. This 19-seater bus entered service on 24 July 1905, some six months after the opening of the original steam-bus service between Wolverhampton and Bridgnorth. It is facing Wolver-hampton, having made the somewhat breathless climb up Hermitage Hill, and has been rebuilt with a normally positioned front-mounted radiator, replacing the original Renault-style bulkhead-mounted example. *J. H. Taylforth collection*

Above right GWR 20hp Milnes-Daimler 19 (DA 117), which also entered service on 24 July 1905, waits outside the Wheel-O'-Worfield Inn on the main road between Wolverhampton and Bridgnorth, about 3½ miles distant, in the late summer of the same year. These tiny-engined buses began a fashion continued until the early 1960s by Wolverhampton Corporation of having a luggage roof-rack; they were extremely advanced for their time and were remarkably reliable. Unfortunately, the final drive to the back axle was by way of live drive-shafts that engaged teeth cut into both rear wheel rims. This system worked, but because it was open the grease used on the gears attracted road dirt. This caused wear on the gears and in turn made the rear axle extremely noisy. These early buses were really at the cutting edge of PSV technology, thrusting petrol-engined buses to the forefront of road passenger transport usage in this country; breakdowns were frequently caused by the inferior quality of the roads rather than the buses' own fragility. However, by about 1910 the era of the Milnes-Daimler was over, but they had trailed a pioneering path over which more advanced buses would drive, linking, as in this case, hamlets and villages in rural areas that had previously been reliant on the horse and cart. *B. Baker collection*

Below right In March 1944, with the tide beginning to turn in the war in Europe but with the D-Day invasion still three months away, wartime restrictions on travel were still at their worst. With reduced bus services and frequencies, and vehicles being worked until they broke, without much chance of replacement, the situation for the travelling public was fairly bleak. By this date Wolverhampton was manufacturing most of the new double-deck bus chassis output of this country, with Guy and Daimler motorbuses and Sunbeam and Karrier trolleybuses being made within its boundaries. Industrial towns like Wolverhampton required extra buses to move their many reserved occupation factory workers. In addition, the town's rural services meant that the numerous RAF camps such as Bridgnorth were served by the Corporation's existing services, and the 17 service went sufficiently close by to serve the station without need for a diversion. As a result of the town's increased operational needs, the Ministry of War Transport allocated to the Corporation no fewer than 24 Guys, two Daimlers and 38 trolleybuses. The fourth and last of the Guy 'Arab' to be delivered was 361 (DJW 561), seen here working on the 17 service at Worfield. This was an example of the original 'Arab' wartime model, which would later be known as the 'Arab' Mk I. Powered by a Gardner 7.0-litre 5LW engine, it could be distinguished from the later Mk II model by having straight rather than 'curly' front wings. Built in March 1943 and fully equipped with headlight masks and white edging paint, 361 had Wolverhampton's first 'utility'-style body to be built by Park Royal. The woman on the left is approaching the road junction that leads into the village centre at Worfield. The main part of the Wheel-O'-Worfield has hardly altered in the 40 years since the Milnes-Daimler was seen at the same spot. Perhaps the most noticeable difference is the condition of the road surface, although as a concession to the blackout it has only a thin central white line. The Wheel public house is still recognisable today, although it has had a number of additions including, at the time of writing, the construction of a new restaurant detached from the original buildings and larger than them. *B. Baker collection*

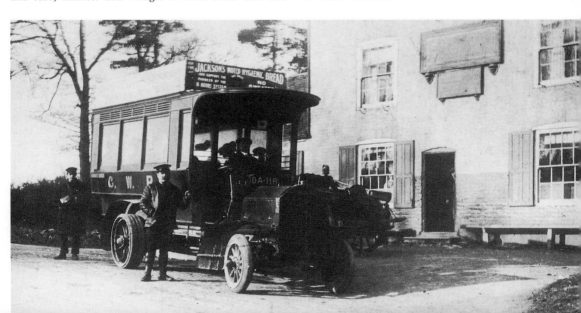

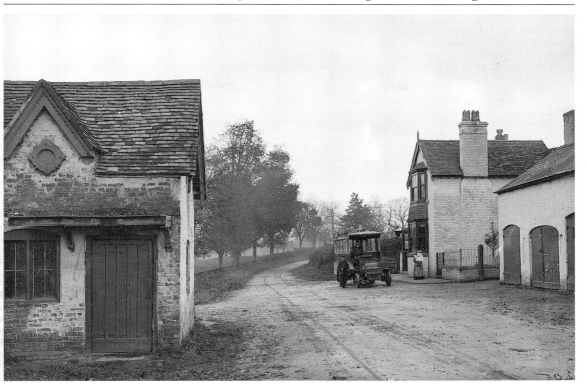

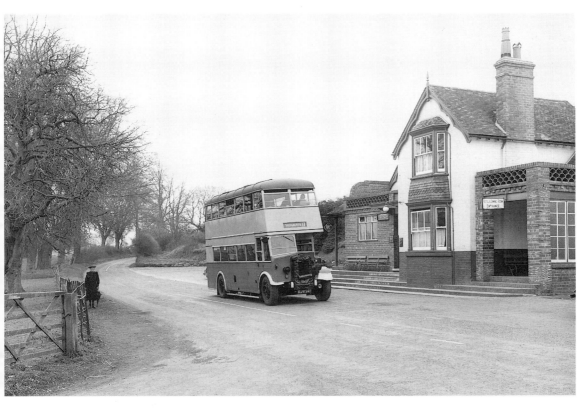

Below RAF Bridgnorth was located on the plateau above the town between the top of Hermitage Hill on the Wolverhampton Road and the main road to Stourbridge via Enville and Kinver. This was a 'square-bashing' camp where young National Servicemen did their eight weeks basic training before being sent off to other operational stations. It did not even have an airstrip, yet it always had an aircraft outside the gate, including the one whose wing is just visible behind the bus. The wooden hut on the left is typical of the barracks that young servicemen had to endure. The 'escape' from any military establishment when leave was due was always akin to the departure from a football ground after the home team had just lost an important match. Buses and coaches were brought in to shift the 'squaddies' on their 48-hour or 72-hour furloughs so that an orderly exit might be made. On the far side of the parade ground are two Burlingham-bodied coaches of about 1961 vintage, which

will also be taking Air Force personnel on leave. Les luxurious, the Corporation bus leaving the station is Brush bodied Daimler CVG6 502 (FJW 502), which entered servic in 1948. To mix service metaphors, the bus is 'loaded to th gunwales', to such an extent that the body is almost rubbing on the tyre. *R. F. Mack*

Bottom The domed tower of Thomas Telford's St Mary Magdalene Parish Church in Bridgnorth can be glimpsed i the distance just to the right of the bus standing o Hermitage Hill in this view across the Severn Valley in 1929 This main road demonstrates that, even by this date, th condition of A-class roads left a considerable amount to b desired – just imagine what the pot-holes would have bee like after the winter snows! Hermitage Hill was a steep climb out of the deeply incised Severn Valley and pose considerable problems for the bus service betwee Wolverhampton and Bridgnorth Brand-new Guy FC 73 (UK 5973 entered service in 1928 with a Guy B35R body, and has been newly introduced on the Bridgnorth service. I was one of several unusual single deckers purchased about this tim specifically for the 'country' routes; a well as six of these Guy FCs, two Tilling Stevens B10As, four Sunbeam 'Pathans and a solitary AJS 'Commodore' wer purchased. The bus was renumbered 173 in 1934 and taken out of service i July 1936, although it was kept as runner until the Royal Agricultura Show at Wrottesley Park on 6-10 July 1937, when 12 extra Birmingham Corporation double-deckers had to b hired to cope with the additiona passengers on the 1A shuttle servic between the railway stations, Tettenhal and the showground. *J. Hughe collection*

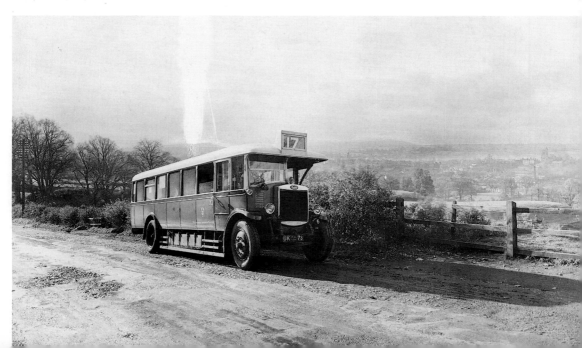

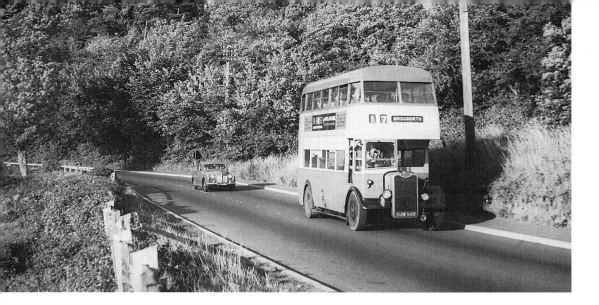

Above Hermitage Hill descends steeply into Bridgnorth through the thick deposits of Triassic Bunter pebble beds; these consist of coarse-grained, brownish red sandstones, flanking the Severn Valley and through which the deeply incised River Severn passes at Bridgnorth. Travelling down the hill towards Bridgnorth near the local beauty spot known as High Rock is Wolverhampton Corporation 547 (FJW 547), a Guy 'Arab' III with a Park Royal H28/26R body. This bus entered service in October 1950 and was one of a batch 22 that had this chassis/body combination. All were fitted with 8.6-litre Gardner 6LW engines, which was perhaps surprising, in view of the proximity of the Wolverhampton-based engine-builder Henry Meadows, the main alternative supplier of engines at this time for the 'Arab' III; however, the more economical Gardner engine was a more economical proposition. The double-decker, by this time with a green rather than grey-painted roof, is being employed on the 'main-line' 17 route between Wolverhampton and Bridgnorth by way of Compton and Worfield. Behind the bus is a 1961 Birmingham-registered Rover 100 saloon, one of the last of the type that was given the nickname 'Auntie'. *D. R. Harvey collection*

Below Having passed the ancient rock dwellings set into the sandstone of Hermitage Hill, the A454 descends into the valley floor of the River Severn and meets the A442 from Telford and the Industrial Revolution towns of the Coalbrookdale area around Ironbridge. The finger-post on the island has an additional sign for RAF Bridgnorth, from which direction the Wolverhampton Corporation double-decker has travelled. Almost new 64 (4064 JW) is a 1961 Metro-Cammell-bodied Guy 'Arab' IV of the sort delivered as the first batch of motorbuses bought specifically to replace the last of the wartime buses and a few of the early post-war Daimler CVG6s and Guy 'Arab' IIIs, whose Brush bodies had succumbed to the dreaded rot that afflicted many vehicles of this period. The bus has passed Cann Hall Road and is heading for Mill Street, in the Low Town area of Bridgnorth, before turning into St John's Street and on to the bridge over the river. In the background the old cottages at the bottom of Hermitage Hill have mainly survived the road widening schemes that have enabled traffic to pass alongside the River Severn through Low Town on the A442 between Telford and Kidderminster. *R. F. Mack*

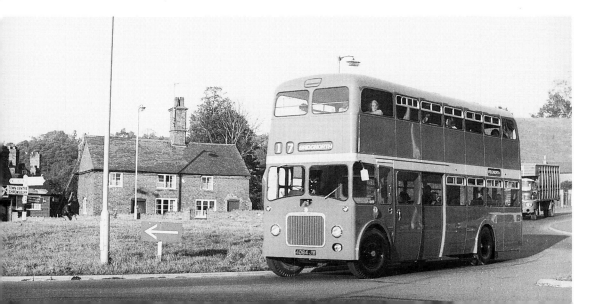

This page The six-arch bridge over the River Severn, built in 1823 to the design of Thomas Telford, was the successor to numerous bridging points over the years, the earliest having been built about 1100AD. This linked the pre-medieval riverside port with the defensive site of Bridgnorth Castle, which stood on a sandstone bluff about 100 feet above the River Severn. The Norman castle was contemporary with the first bridge and was significant in the defence of the area against the Welsh. Dominating the skyline is the 95-feet-high tower of St Leonard's Parish Church. The original church dated from the middle of the 13th century, and although it survived the damage inflicted

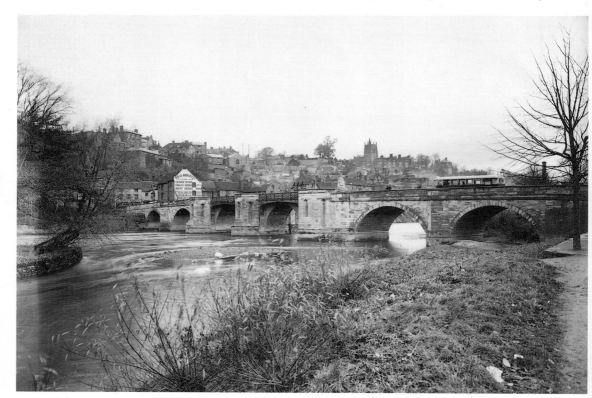

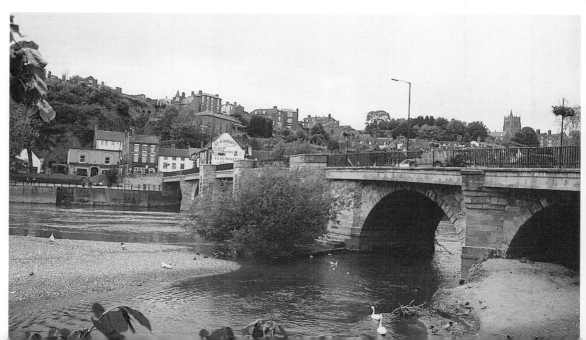

on it during the Civil War siege of the town on 31 March 1646, in 1860 the majority of the fabric was replaced by a new sandstone structure. Crossing the bridge is Guy FC 73 (UK 5973), built in 1928, which is working on the Bridgnorth service from Low Town into High Town. This almost new single-decker seems to have been used at this time for a series of Corporation publicity photographs. On the far side of the bridge are the well-known three-storey premises of Ridley's, the seed merchant.

There is an almost timeless quality about the view from Low Town towards the terraces of old buildings that spill over the skyline in High Town and almost cascade down to the river's western bank. With the swans gliding beneath Telford's bridge, the scene looks remarkably unaltered from this angle, although there is the constant rumbling traffic; although the bridge was widened as recently as 1960, most of Bridgnorth's through traffic was taken from it when the A458 bypass was opened in the early 1980s. Nearby, next to the Quayside, at the turn of the 19th century, stood Hazeldine's foundry. It is perhaps forgotten that Bridgnorth, for all its appearance as a market town, was also at the edge of the Coalbrookdale area and as a result had a small but thriving and prominent engineering industry in the 18th and early 19th centuries. It was here in 1808 that the Richard Trevithick locomotive *Catch-Me-Who-Can* was constructed; this loco's claim to fame was that it was the first steam engine to pull a set of waggons loaded with passengers, which it did around a circular track set up near Toddington Square, Euston, London. The 8-ton engine achieved a speed in excess of 12mph and its novelty value and speed were as much of an attraction to Regency London as the more scary rides at, say, Alton Towers are today. What it did lead to was the slow acceptance of steam power as a method of propulsion, though the technology of the day was beginning to pass by the Bridgnorth-Ironbridge area, so that *Catch-Me-Who-Can* was one of the few engines to be constructed locally. *B. Baker collection/D. R. Harvey*

Below Crossing the elegant Severn Bridge is 538 (FJW 538), one of the unusual Brush-bodied Guy 'Arab' IIIs, which is leaving Bridgnorth on its way back to Wolverhampton. This was numerically the last of 18 with this chassis/body combination, although, strangely, the last three were numbered after a batch of 35 similarly bodied Daimler CVG6s; 538 entered service in May 1949 and was the only one of this trio to be operated by the WMPTE after October 1969, lasting for most of the PTE's first year of operation. To the rear of the bus is the whitewashed wall of S. E. & A. Ridley, the famous Bridgnorth-based seedsmen; the company was founded in 1616, the year of William Shakespeare's death, and occupied the premises on the north-west corner of the bridge for many years. It is now a fruit-machine emporium. Following 538 is a Wolseley Eight of 1947-vintage; this small four-door car was based on the Series E Morris of 1938 and was due to be introduced in 1940, but when production eventually started in Washwood Heath the car had the traditional Wolseley bonnet and radiator rather than the Morris's 'waterfall'-styled grill, and a 918cc OHV engine rather than the identically sized Morris side-valve unit. It was in production for just three years, and only 5,344 were built. Other than its rarity value, the car's only other claim to fame is that, in his old age, it was Lord Nuffield's (William Morris's) favourite car! Behind and above the bus, almost on the skyline, is the famous Bridgnorth Castle Hill funicular railway, with one of its 1955-built carriages standing in the Top Station. The funicular was opened on 7 July 1892 and rises 118 feet in a length of 201 feet linking Low Town with High Town. The pair of 'streamlined' cars were constructed locally by a Stourbridge company called Fildes, and replaced the original wooden stock. To the left of the bridge, on the Quayside, are some Georgian buildings including the Severn Arms Hotel, reflecting the days when the Severn was the second most trafficked river in Europe and the Quayside was lined with merchants' warehouses, forges and manufactories. *R. F. Mack*

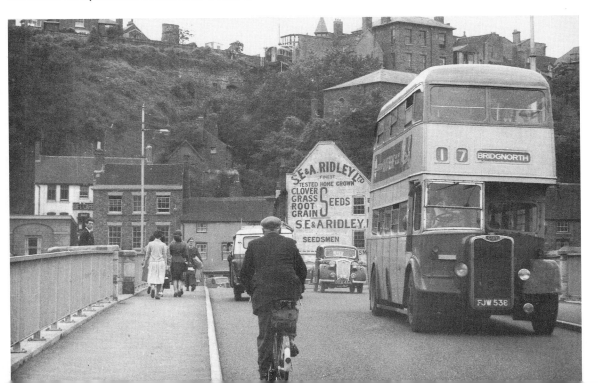

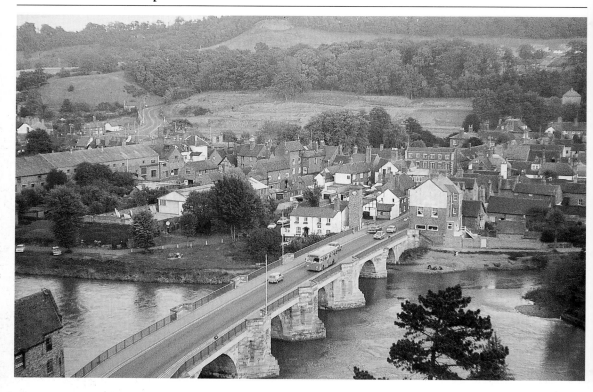

Above The wooded sandstone hills to the east rise steeply away from the River Severn and its valley, while the mainly Georgian area of Bridgnorth's Low Town occupies the narrow flood plain. About one-third of the way over the bridge, having come out of St John's Street in Low Town, which, with Mill Street, was by about 1960 one-way, is one of the three rather plain-looking Park Royal-bodied AEC 'Reliance' 2MU2RA single-deckers delivered in September and October 1963 and numbered 705-707 (705-707 CDA). Although they were fitted with front entrance and centre exit doors, they were also equipped for One Man Operation; at least the driver had the use of the AEC 'Monocontrol' epicyclic gearbox. These buses were originally purchased to work on the 55 and 56 routes to Cheslyn Hay and Churchbridge, which included low bridges, but after a short period they began to turn up elsewhere, and the long route to Bridgnorth suited them admirably. The bus is working on the 17 service and will terminate in West Castle Street in High Town. Behind it, beyond the Italianate clock tower, is the Bull Inn, which supplied refreshment for the doughty traveller before he crossed the bridge and found another hostelry on the west bank. At the base of the hill on the left is the bottom of Hermitage Hill, the A454 leading to RAF Bridgnorth, Compton and Wolverhampton. *P. Roberts*

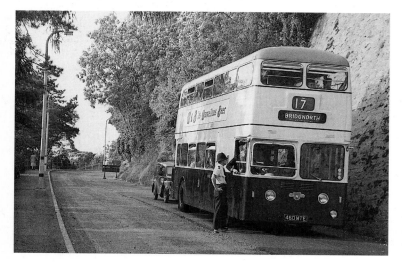

Left At the end of August 1961 roadworks in New Road, the steep hill between High Town and Low Town, posed some problems as one side of the carriageway was closed for resurfacing. This was at the time when Wolverhampton Corporation had on loan the former demonstrator 460 MTE, one of the revolutionary rear-engined Leyland 'Atlantean' PDR1/1s with an MCW H39/33F body. It had been built specifically to try to entice orders from Birmingham City Transport, but although by this time it had become 3230, BCT only ever purchased ten more. In the distance the street lamps of New Road curve away

towards West Castle Street, from which the bus has just departed on its journey back to Wolverhampton on the 17 service. In the shadow to the right of the bus is the exposed sandstone that was cut when New Road was built. Off to the left is the original footbridge that linked Bridgnorth railway station with New Road and gave quick access to the station from High Town. The footbridge, opened in 1895 and standing on its three rather flimsy looking pylon-type legs, cost £1,400, which was met by the local Borough Council. By the time the privately operated Severn Valley Railway had been operating for about six years, the devastating decision had to be made to demolish the iron structure because corrosion had made it not just unsafe but in grave danger of collapse. The SVR immediately lost its direct access to High Town – intending passengers now had to descend about 100 feet, cross the main road, then climb back up the long, quite steep ramp into the station yard. Fortunately a new footbridge was opened in 1994, and this miniature suspension bridge once again allows pedestrians to get almost directly into the station yard adjacent to the booking hall, refreshment rooms and the splendid Railwayman's Arms real-ale bar, with, the writer has been reliably informed by one of the employees, its 'splendid bar staff'!
D. R. Harvey collection

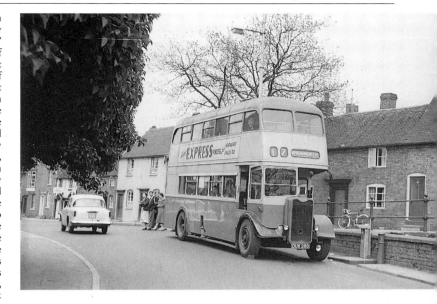

This page In 1958 the quaint Georgian cottages in West Castle Street were not really very quaint at all – run-down and unloved would be a better description – and it would be a number of years before their worth would be realised. Wolverhampton Corporation was unusual among the West Midlands municipal bus operators in deciding to adopt a rebodying policy for nearly all its wartime double-deckers, rather than do what neighbouring Walsall and West Bromwich Corporations did, which was either to undertake body swaps or just rebody quite a small number. One such rebodied bus was 380 (DUK 280), one of 20 Guy 'Arab' IIs that received new Roe 56-seater bodies, in this case in 1952. At the time of writing, identical vehicle 378 (DUK 278) is being restored after spending many years in various locations in open-air storage. The composite-construction body, although in dire need of extensive rebuilding, has survived amazingly well after more than 30 years of neglect. No 380 is seen here parked beyond the bus stop at the terminus in West Castle Street. It has a wheel chock firmly kicked under the front wheel as it waits for its crew to return before leaving for Wolverhampton. Surprisingly the rebodied bus still retains its small wartime, military-style headlights, which must have been *really* useful on the last bus coming back home from Bridgnorth on a wet night!

The importance of West Castle Street as a bus terminus is today considerably less than it used to be. Only the hourly Arriva Midlands North single-deckers working to Wolverhampton on the 890 service stop here, while the local 91 route uses the street, but not as a terminus, which rather makes it a pale shadow of its former self. The solitary bus stop outside the by now much 'gentrified' cottages is a reminder that this is where Wolverhampton Corporation buses used to load up. Very few of the buildings have been replaced in the last 40 years, and it is only the distant block with the white-painted gables, near Bank Street, that has been built in the last ten or so years. The white Ford Fiesta on the right has just entered New Road and is about to begin the semi-circular left-hand curve down the steep hill to the junction with Underhill Street, alongside the River Severn.
D. R. Harvey collection/D. R. Harvey

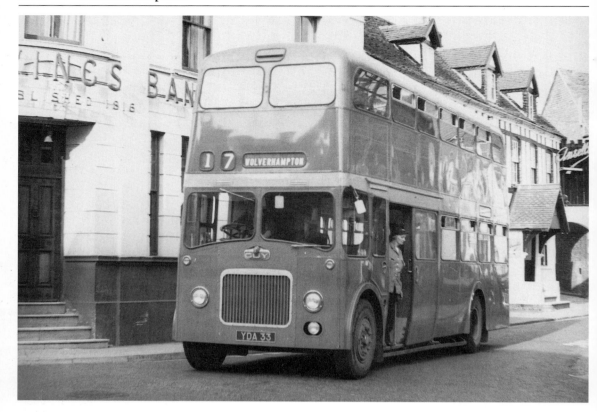

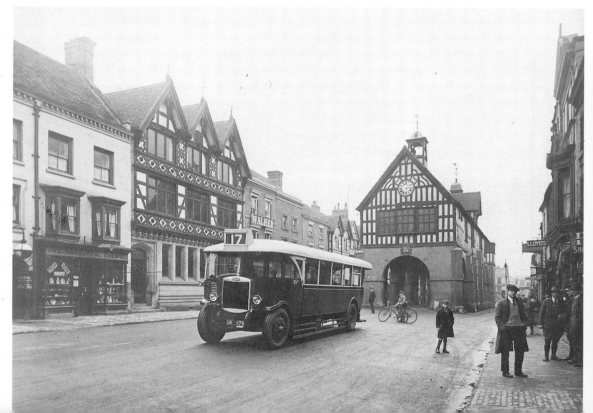

Left Reversing in East Castle Street in the High Town part of Bridgnorth in about 1961 is full-fronted, Metro-Cammell-bodied Guy 'Arab' IV 33 (YDA 33). It was here that the service from Wolverhampton terminated, within a few yards of High Street, the town's main shopping street. East Castle Street was once part of the outer bailey of Bridgnorth Castle, and although it contains the Governor's House, which dates from 1633, the majority of its houses belong to the elegant, late-Georgian period. The conductress stands at the open sliding entrance door of the bus as her driver gently backs up, passing the bank on the left and Castle Tea Rooms on the corner of West Castle Street. The bus will then turn to its left before drawing forward to the terminus pick-up point. Behind the bus is The Ball, an Ansells-owned public house. Beyond the corner of East Castle Street lies St Mary Magdalene Parish Church, whose cupola-topped tower looks along East Castle Street from its position next to the castle. St Mary's was one of only three churches designed by Thomas Telford, the great Scottish civil engineer, this late classically styled Georgian church dating from 1792. *R. F. Mack*

Below left Seen previously on Hermitage Hill and crossing Telford's bridge over the River Severn, Guy FC 73 (UK 5973) is now in High Street, Bridgnorth. Judging by the number of posters in the side windows of the bus, it is inaugurating the new service into High Town, into which the Wolverhampton-Bridgnorth service was diverted from the railway station in May 1928. On the extreme left is the large lamp outside the Cross Keys Inn, which closed in 1930. Behind the bus is the timber-framed Town Hall, believed to have incorporated parts of an old barn that was donated to the bankrupt town by Lady Bartue of Wenlock. This was completed in 1652 on a stone base with arches that could accommodate some of the town's ever-enlarging market. In 1887 the structure was extensively restored as a local commemoration of Queen Victoria's Golden Jubilee, and its

beautiful oak-panelled chambers were illuminated by some splendid stained-glass windows. The half-cab single-decker, with its quite modern-looking Guy rear-entrance 35-seater body, somewhat spoiled by the heavy, antiquated bracket over the nearside of the engine canopy, stands in High Street having negotiated the arch of the Town Hall. The bus was able to pose at this spot in the High Street because the section used as the Market Place was on the far side of the Town hall between it and Listley Street and the distant West Castle Street. *B. Baker collection*

Below On 28 September 1961 Park Royal-bodied Guy 'Arab' III single-decker 563 (FJW 563) pulls away from the stop in front of Northgate in Bridgnorth. The bus is working on the 31 service, which arrived in Bridgnorth by way of Pattingham, Ackleton and Newton Bank, and was one of the last new Corporation-operated routes to be introduced before the recently formed West Midlands Traffic Commissioners began to award, legislate and control the region's PSV Road Service Licences. Northgate was built in about 1260 and guarded one of the five entrances into the fortified High Town. It is the only gate to have survived and was used as the temporary Town Hall from 1646 until the completion of the new building in 1652 after the town was sacked by the Parliamentary forces during the Civil War. Used over the years as a prison, a school and latterly as Bridgnorth Museum, the gate was extended in the 30 years prior to the Parliamentary siege of Bridgnorth by the addition of rooms over the main gateway. Northgate was last altered in 1910, when castellated battlements were added to the Jacobean frontage using funds from the estate of the founder of Friar's Carpet Works. This left the gate as something of an anachronism in the era before historians really began to appreciate what the word 'restoration' actually meant! The height of the central arch, at precisely 11ft 7in, reveals why single-deckers were used exclusively on the 31 service. *C. W. Routh*

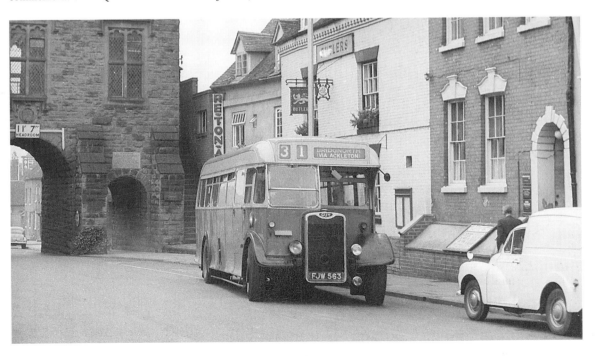

Freshly revarnished and overhauled Brush-bodied Daimler CVG6 531 (FJW 531) was hired by the West Midlands Transport Circle for an enthusiasts' trip on Easter Monday 1968, destined for the Welshpool & Llanfair Railway. It was driven by the late Vic Dunton and was 'road-tested' along the back roads by way of Craven Arms, Clun and skirting Newtown before tackling some of the fearsome hills on the B4389 on the way into Llanfair Caereinion. Such was the steepness of one of the hills within sight of the bus's destination that it failed and the passengers had to disembark and follow the empty vehicle up the hill before they could resume their journey to the Welsh narrow gauge railway terminus. Here the bus is standing on the forecourt of Bridgnorth railway station, with its paintwork positively glinting in the spring sunshine. Seen from the top of Castle Walk, it is opposite the end of the original 1895 footbridge that linked the railway with High Town and whose origins are detailed on page 121. This trip was undertaken in the days when the Severn Valley Railway had purchased the abandoned line but was operating trains on a very modest scale, as it only received its Light Railway Order in 1970. On this day it was carrying passengers on a 'Members-only' basis. *J. Hughes*

Tram and bus drawings and tickets

A 47-49 class Lorain-equipped UEC-built tram, retrospectively fitted with a top cover.

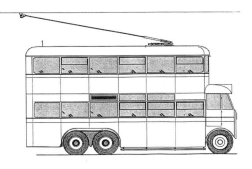

One of the 62-66 batch of five-bay-construction Dodson-bodied Guy BTXs of 1930.

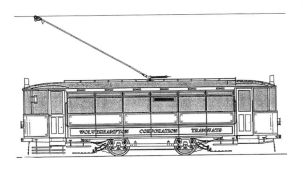

A 62-69 class 'Tividale'-style single-decker built by Brush in 1922.

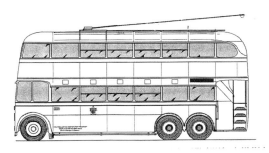

One of the last six-wheelers bought by the Corporation, a Park Royal-bodied Sunbeam MS2 of 1935 from the 223-226 class.

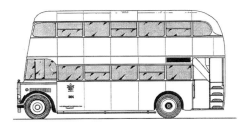

A rare combination of a Guy 'Arab' III 6LW fitted with a Brush H29/25R body in 1948.

Drawings by A. T. Condie

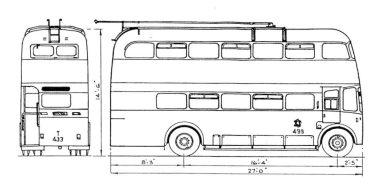

Wartime Sunbeam W4 trolleybus 433 (DUK 833), rebodied with a Roe H32/28R body in 1959; this trolleybus is preserved in full running order at the Black Country Living Museum, Dudley. *T. Russell*

Tickets reproduced at actual size.

Wolverhampton Corporation Tramways 1d Bell Punch

Wolverhampton Corporation Transport 2d Child's Bell Punch

Wolverhampton 5d Ultimate (Hunt)

Wolverhampton 2½d Ultimate (Williamson)

Wolverhampton Almex of 6 October 1962

Wolverhampton Bellagraphic

Index of locations